Understanding Macromed ActionScript 2

Understanding Macromedia Flash 8 ActionScript 2

Andrew Rapo and Alex Michael

AMSTERDAM • BOSTON • HEIDELBERG • LONDON • NEW YORK • OXFORD
PARIS • SAN DIEGO • SAN FRANCISCO • SINGAPORE • SYDNEY • TOKYO
Focal Press is an imprint of Elsevier

Focal Press is an imprint of Elsevier
Linacre House, Jordan Hill, Oxford OX2 8DP
30 Corporate Drive, Suite 400, Burlington, MA 01803

First published 2004
Second edition 2006
Copyright © 2006, Andrew Rapo and Alex Michael.

British Library Cataloguing in Publication Data
A catalogue record for this book is available from the British Library

Library of Congress Cataloguing in Publication Data
A catalogue record for this book is available from the Library of Congress

ISBN-13: 978-0-240-51991-3
ISBN-10: 0-2405-1991-4

For information on all Focal Press publications visit our
website at: www.focalpress.com

Typeset by Charon Tec Ltd, Chennai, India
www.charontec.com
Printed and bound in US

06 07 08 09 10 10 9 8 7 6 5 4 3 2 1

Contents

Acknowledgments

Before getting too far, there are some individuals who have played an important role (directly or indirectly) in the production of this book and who deserve thanks. First on the list is Alex Michael who wrote the first edition of this book and laid the foundation for this new edition. I would also like to acknowledge my colleagues at Warner Bros. Online who consistently create some of the most admired Flash content on the Web. In particular, thanks to Steve Belfer and Sam Ades for their vision and support of high-quality Flash development.

Special thanks goes to Michael Borys who created the excellent artwork for Astro Sweeper, the book's example game, and also to Michael Schipper for many years of collaboration on Flash projects and for reviewing the Astro Sweeper code.

I am indebted to many individuals at Focal Press for their support of this book, including Marie Hooper, Christina Donaldson, Georgia Kennedy, and Paul Temme.

On a more personal level, I would like to thank Tom Evans and Cape Cod Academy, where the first versions of Astro Sweeper were developed. And finally, thanks to Alexis, Grace, Finlay, and Lilly for their support and patience throughout the writing process.

Introduction – Understanding Macromedia Flash 8 ActionScript 2

Programming Isn't Just for Programmers Anymore

There was a time when programmers wrote code and creatives produced assets and the line between the two disciplines was clear. Well, not really – not in the world of interactive application development, anyway. In this arena, programmers have always had something to say about the design of the applications they code, and designers have always leveraged their technical knowledge to ensure that their designs are supported by appropriate functionality. As the interactive industry matures, more and more products require high-end multimedia development. Obvious examples include video games, DVDs, media Web sites, and even appliances, like Tivos. Increasingly, the skill set required to develop these products includes both technical and creative expertise. If the line was blurry in the past, it is practically indiscernible today.

Programming in Design Applications

The list of tools that designers regularly use to create interactive applications includes (among others):

- PhotoShop
- Illustrator
- DeBabelizer
- Maya
- 3DSMax
- Flash

At one point or another, all of these common design tools began to incorporate elements of scripting and programming to help designers work more efficiently. PhotoShop, Illustrator, and DeBabelizer all have rich "macro" languages. Some design tools like Maya have full-featured programming languages. The following example code is part of a Maya program used to rename objects:

```
$MyReplaceName = 'textField -q -tx $replaceName ';
string $nodeToRename[] = 'ls -sl';
string $newNodeName = $MyReplaceName + "_trans";
```

```
string $shapeNode;
string $newShapeNodeName;

rename $nodeToRename[0] $newNodeName;
$shapeNode = $newNodeName + "Shape";
$newShapeNodeName = $MyReplaceName + "_mesh";
rename $shapeNode $newShapeNodeName;
```

This Maya code may not be familiar, but it helps to reinforce the point that programming is no longer the domain of Programmers. Renaming 3D objects in Maya can be done manually. No code like the above example is necessary. But with code, every object in a Maya file can be renamed in seconds. Manually, the process could take hours, even days. To be effective and competitive, designers need to utilize every available tool, and knowledge about coding practices and techniques is an essential tool in every professional designer's arsenal.

Programming in Flash

For many designers, Flash provided an introduction to hands-on coding in the form of ActionScript 1. And in many cases, this introduction took place in the early days of ActionScript – as far back as Flash 4 – when ActionScript was extremely primitive. Even as recently as Flash 6 (MX), ActionScript was in its infancy. Professionally trained programmers were rarely involved in Flash application development, so ActionScript remained the domain of technically savvy creatives. But with Flash 7 (MX 2004) and the advent of ActionScript 2, Flash development changed dramatically. ActionScript 2 provides a development framework that is common in professional programming languages like Java and C++. As a result, many more professional programmers are becoming involved in Flash application development for the first time. This means that Flash applications are getting better and better. It also means that many designers may find that their previous technical knowledge of Flash needs to be updated significantly – and quickly.

This book provides creatives (and new Flash programmers) with a crash course in ActionScript 2 and Object Oriented Programming techniques. Because the examples are carefully explained, no programming expertise is required to begin using ActionScript 2. Also, the examples are all provided online at the book's companion Web site: www.rapo.org/as2book. At the same time, this is not a dumbed-down presentation of ActionScript 2. The early chapters introduce concepts and code that is utilized in a full-featured game application later in the book. The example code is ready to be used in real applications and the style and techniques will be familiar to professional programmers.

ActionScript 1 vs. ActionScript 2

ActionScript 1 is not dead, and it can still be used – even in the latest version of Flash – Flash 8. There may come a day when ActionScript 1 will be phased out, but long before then the benefits of learning ActionScript 2 will have outweighed the time invested to master it. ActionScript 2 code takes longer to set up. It enforces rules about the structure of code that ActionScript 1 did not. But the return is immediate. Enforcing these coding rules while the code is being authored means that the compiler can detect many more bugs – before they ever end up in an application.

This can save countless hours. In addition, ActionScript 2 code is inherently more reusable than ActionScript 1 code. Code written for one application can easily be used in another, often with little or no modification. This also saves time and allows the investment in one application to be shared among many others. When code can be reused it is inherently more valuable. Most developers recognize the value of their asset library. With ActionScript 2, the code library can be just as valuable.

How This Book Is Organized

This book is organized into four sections. The first section, "Flash Fundamentals", introduces the Flash authoring environment and some basic core Flash concepts. The second section, "ActionScript 2 Fundamentals", explains basic programming concepts and terminology, and it shows how ActionScript 2 classes are constructed and used. The third section, "Built-in Classes", describes the built-in ActionScript classes that are available for use in applications. These include the MovieClip class, Key class, Sound class, etc. The fourth section, "Using ActionScript to Build a Game", describes the development process for creating a complex Flash application and presents some commercial-quality game coding examples.

Why This Book Belongs In Your Library

This book isn't the only book on ActionScript 2 and it isn't the only book on the topic that every designer should have. What this book provides is thoroughly developed and explained example code that can serve as the basis for other applications. It also explains important programming concepts in a way that is both accessible to non-programmers and still technically accurate. After digesting the contents of this book, the reader will be able to develop professional ActionScript 2 applications, and communicate knowledgably about current, Object Oriented ActionScript 2 techniques.

Flash 8

Flash 8 is the latest version of the Flash authoring tool, and the Flash 8 Player is the latest version of the player used to run Flash applications. Flash 8 introduces many improvements to the authoring tool, as well as to the player. This book focuses on the new features in Flash 8 that are related to ActionScript coding. Since Flash 8 can be used to develop applications for earlier versions of the Flash Player, making use of these new code features is optional. When Flash-8-specific code is used, it will only run correctly in the Flash 8 player. When relevant, this is noted in the example code.

ActionScript 3 and the Flash Player 8.5

Macromedia has further demonstrated its support for the future of Flash by announcing ActionScript 3 and the Flash Player 8.5. Content that utilizes ActionScript 3 will only run on the Flash Player 8.5. These are core components of the "Flash Platform", a new, broad category of Flash-based technologies. Until recently, the only way to create Flash content in the form of SWF files was to use the Flash authoring tool: MX, MX 2004, Flash 8, etc. Now there are several tools

available for creating SWFs. One of the most important of these tools is another Macromedia product called Flex. Flex has been available for some time and is used primarily by enterprise-level Web developers to create Web sites that utilize Flash technology. With the announcement of ActionScript 3, Macromedia also announced a new version of the Flex authoring tool called Flex Builder 2. Flex Builder 2 will be the first Macromedia product to support ActionScript 3 and the Flash Player 8.5. It is expected to be available in the spring of 2006. Flex Builder 2 is based on the Eclipse Integrated Development Environment (IDE) technology. The Eclipse IDE is also available today for ActionScript 2 development. This is discussed in Chapter 1.

Flex Builder 2 and ActionScript 3 will initially be appropriate for developing interactive Web sites, but not for creating the kind of multimedia animation content that is commonly associated with Flash. Multimedia content will still need to be authored in Flash and then dynamically incorporated into Flex Builder 2 applications. According to Macromedia, the next release of Flash (Flash 9) will incorporate support for ActionScript 3. Full releases of Flash tend to be spaced 18−24 months apart. Until Flash 9 is released, ActionScript 3 and the Flash Player 8.5 will not be fully relevant to most Flash multimedia developers. The most current information about Macromedia's future plans is available at:

http://labs.macromedia.com/

A good article about the future of Flash is available at:

http://www.macromedia.com/devnet/flash/articles/flex2_flash.html

A quote from this article by Mike Chambers of Macromedia states:

> Of course, Flash authoring is also going to get full support for ActionScript 3.0 and we are already planning and working on the next full release of Flash authoring (code-named "Blaze"). Since it is so early within the development cycle, we can't say when Blaze will be released (the normal development cycle for Flash authoring is 18−24 months). However, we will be releasing an alpha version of Blaze in the spring of 2006 that will include ActionScript 3.0 support. This will be a pre-release alpha version (not an update to Flash 8), and will be available to anyone who has purchased Flash Professional 8 and or Macromedia Studio 8.

ActionScript 3 code is very similar to ActionScript 2 code. Under the hood there are many improvements that dramatically improve the performance of SWFs that use ActionScript 3. These improvements require the Flash Player 8.5 which is currently available in alpha form only. Macromedia's goal is that by the time ActionScript 3 is available to all Flash developers, the Flash player 8.5 will already be widely installed. So when Flash 9 is released, developers should be able to begin deploying ActionScript 3 content right away.

For now, the best way for most developers to prepare for ActionScript 3 is to dive in and begin using ActionScript 2. This will make the transition much easier down the road.

The Example Code

The game application that is included with this book (Figure 1) is the result of years of game development with every version of ActionScript from Flash 4 to Flash 8. To be most widely useful, almost all of the example FLAs can be opened and tested using Flash MX 2004. The few

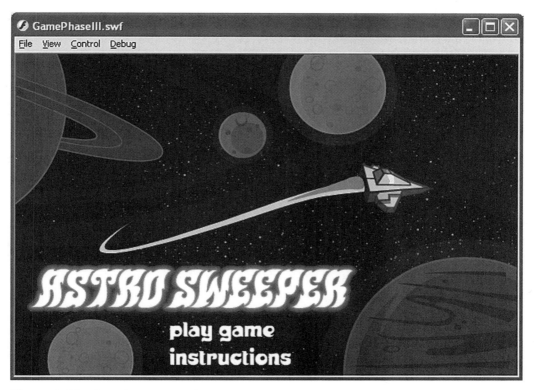

Figure 1 *The Astro Sweeper example game*

exceptions are examples that use features that are only available in Flash 8 for the Flash 8 Player. Flash 8 adds many important features to the Flash authoring environment and to the new Flash 8 Player. For the most part, however, ActionScript 2 is the same as it was in the previous version.

At the time of this book's publication, the best practices for using ActionScript 3 in game development had not been determined. However, the book's Web site will continue to be updated and will provide ActionScript 3 versions of this book's examples as soon as this becomes feasible.

The example code is available at: www.rapo.org/as2book.

Please use the following code to access the full source code: BSB–NBT–300.

Typographical Conventions Used In This Book

When an important term is introduced for the first time, it is displayed in quotes:

Inheritance gives rise to an important object-oriented programming concept: "polymorphism".

The first time a literal name is used (for variables, functions, properties, methods, etc.) it is displayed in quotes (or italicized), as in:

The "roundness" property of the Apple class can have the following values…

Class names are capitalized. This applies to built-in classes like MovieClip, as well as to classes from the example code, like Fruit.

Code examples use the 10-point Courier New font, and are formatted so that reserved words are bold:

```
class ch11.Fruit {

  var name:String;
  var color:String;
  var juiciness:String;
  var sweetness:String;

  public function Fruit(fruit_name:String,
                        fruit_color:String,
                        fruit_juiciness:String,
                        fruit_sweetness:String) {

    name = fruit_name;
    color = fruit_color;
    juiciness = fruit_juiciness;
    sweetness = fruit_sweetness;
  }

  public function out():Void {
    trace("Fruit: " + name);
    trace(" Color: " + color);
    trace(" Juiciness: " + juiciness);
    trace(" Sweetness: " + sweetness);
  }
}
```

Text is output from the examples to the Output Window, is displayed using 12-point Courier New:

```
Fruit name: Apple
Fruit name: Grape
Fruit name: Generic
```

Menu commands are shown in italics, such as:

File->Publish Settings...

Keystrokes and keystroke combinations are written as:

<CTRL><ENTER> for Control + Enter
<CTRL><'> for Control + Single-quote

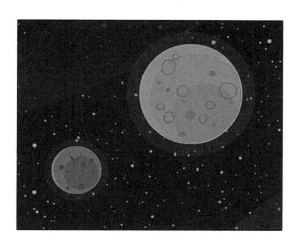

FLASH FUNDAMENTALS

01

1 An Introduction to ActionScript 2 Programming Tools in Flash 8

What is ActionScript?

ActionScript makes it possible to develop Flash movies that are interactive. A designer can build a beautiful Flash movie without ActionScript, but it won't be able to respond to input by the user. In the earliest versions of Flash, there was no ActionScript. In those days, Flash was used exclusively to make linear animations. Its unique ability to render vector-based animations made Flash an instant hit. When ActionScript was introduced, however, the focus of Flash development became "interactivity". Today, Flash is the de facto standard tool for creating media-rich interactive Web applications. Because of its efficient design, it is also becoming a popular development platform for handheld devices – including mobile phones.

ActionScript is a powerful tool because of all the ways it can be used, but in the simplest sense, ActionScript is text: program code in the form of letters, numbers, symbols, etc.:

```
for (i=0; i<5; i++) {
  for (j=0; j<5; j++) {
    var x_coord = i * (size + 5);
    var y_coord = j * (size + 5);
    tempSquare = mySquare(x_coord, y_coord, size);
  }
}
```

Graphics are often created by drawing with a mouse. ActionScript programs are created by typing text with a keyboard, and the essential tool for managing this text is the "text editor". Flash provides a text editor for creating ActionScript programs, but the features of the available editor depend on the version of Flash.

Flash Versions: Pro vs. Non-Pro

The text editor in Flash 8, the "ActionScript Editor", is included in both the Basic and Professional versions. In the previous version of Flash, MX 2004, only the Professional version included an editor for creating ActionScript 2 .as files. This implied that some users wouldn't have any need for ActionScript 2 classes. By including the ActionScript Editor in both versions of Flash 8, Macromedia has opened the door for all Flash developers to begin using ActionScript 2.

Third Party ActionScript Editors

For users of the Basic version of Flash MX 2004, three options are available. One option is to upgrade to Flash 8. The second option is to use a third-party text editor to create .as files. This is actually not a bad option. In fact, some excellent text editors exist, and some have been specifically enhanced to support the creation of ActionScript files. One of the most powerful is the Eclipse IDE (Integrated Development Environment). Eclipse is available at www.eclipse.org. A plugin is required to make it work with ActionScript files. The ASDT (ActionScript Development Tools) plugin can be downloaded from sourceforge.net/projects/aseclipseplugin/. There is even a Flash compiler plugin available for Eclipse that will check ActionScript files for errors and even generate SWF files. It is called MTASC and is available at www.mtasc.org/. Finally, there is a third plugin for Eclipse called Flashout which allows the SWF files generated by MTASC to be previewed in Eclipse. It is available at www.potapenko.com/flashout/. All of these tools are free, so they are available to anyone with the resourcefulness to get them all installed correctly. A good guide is available at:

www.actionscript.com/index.php/fw/1/towards-open-source-flash-development/

Figure 1.1 shows the Eclipse IDE workspace with an ActionScript 2 class open for editing. Eclipse offers the full suite of programming tools that professional programmers have come to expect, including source code control. Most of the examples in this book were authored using Eclipse and then tested in MX 2004 and Flash 8.

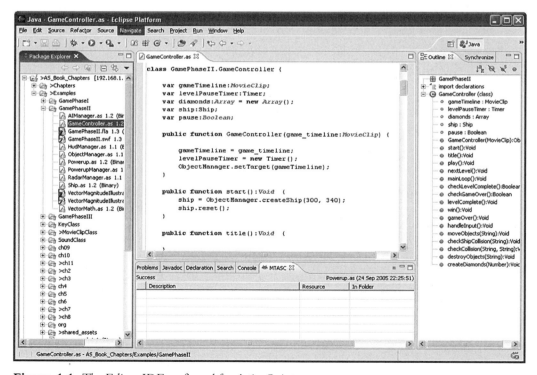

Figure 1.1 *The Eclipse IDE configured for ActionScript*

The third option – available to anyone – is to download a free 30-day trial of Flash 8 from www.macromedia.com. This will make it possible to try the examples in this book and decide whether or not to make an investment in Flash.

This book assumes that the reader has either Flash 8, Flash MX 2004 Professional, or the Eclipse suite described above. This chapter describes the Flash 8 authoring environment, which is very similar to the MX2004 environment. The Eclipse environment is not covered specifically, but for anyone savvy enough to get Eclipse installed, it should be easy enough to follow along.

The Flash Authoring Environment

When Flash is launched, the first thing displayed is a friendly splash screen which presents a variety of options. This can be seen in Figure 1.2. Most often, the user will create a new Flash document or open an existing one. The friendly splash screen is nice at first, but it is easy enough to use the File menu to accomplish the same thing. For those who would prefer not to see the splash screen, there is a "Don't show again" checkbox in the lower left corner.

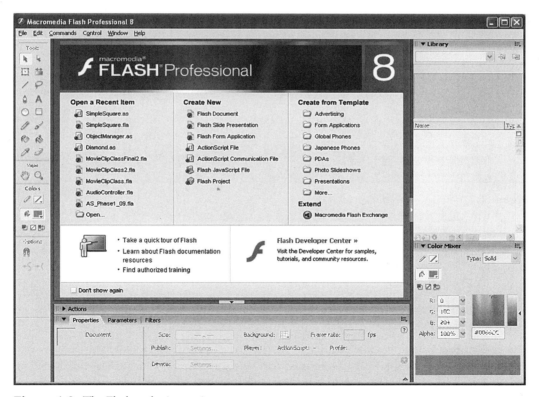

Figure 1.2 *The Flash authoring environment*

The Workspace

The arrangement of windows and panels in the authoring environment is called the "workspace". The Flash workspace can be rearranged to suit any individual's tastes. By default, the workspace shows the Main Timeline at the top of the screen, the Visual Authoring Tools along the left side, the Library and Color Mixer along the right, and the Stage in the middle. Figure 1.3 shows the default workspace layout.

Figure 1.3 *The default workspace layout*

Directly beneath the Stage are the Actions and Properties panels. These can be expanded using the black triangles to the left of the panel names. Expanding the Actions panel reveals any ActionScript code on the currently active timeline frame.

Figure 1.4 shows the workspace with the "SimpleSquare.fla" opened. This example is from the ch6 folder of the examples. The actions displayed in the Actions panel belong to the first frame of the FLA's Main Timeline.

The Actions panel, itself, has three sections: the main Script pane in the middle, the ActionScript Toolbox and Script Navigator panes along the left. There is a control on the bar between the Script pane and the ActionScript Toolbox pane. It has a small, black triangle in it. Clicking on this control snaps the ActionScript Toolbox and Script Navigator panes closed. These panes are helpful when

Figure 1.4 *The workspace with the "SimpleSquare.fla" opened*

trying to find the right class for a use in a script or when trying to locate a script in the FLA file. However, they do take up a lot of screen space. Closing them makes it possible to see more of the Script pane. Of course, on a large enough monitor, screen space may not be an issue.

FLA Files, AS Files, and SWF Files

The three main types of Flash files encountered in this book (and in most Flash development) are FLA files (.fla), AS files (.as), and SWF files (.swf). The first two types are referred to as "source" files because they are used to generate another type of files – namely SWF files. SFW files are referred to as "distributable" files. Source files contain all of the elements and instruction for generating distributable files. As a result they are typically much bigger, and often they contain proprietary content that the author would not wish to share. This proprietary content could be a full-resolution image file or an ActionScript class. Turning source files into distributable files is done by the Flash Compiler. In the process of generating SWF files, the Flash Compiler compresses image and audio files, and it also compresses the ActionScript source code by reducing it to a minimal set of "byte codes" that only the Flash Player can read. In this way, a very large FLA file which uses lots of AS files can be compiled into a very compact SWF. The SWF can then be distributed without having to include any source files and it provides some protection for the propriety of the source material.

A Word About Proprietary Code

The Flash Compiler reduces the ActionScript source code to a compact byte code which is no longer readable by most people. However, there are programs that can read this byte code and reconstitute it as human-readable ActionScript code. These programs are called "decompilers". The output of any compiler – even C++ and Java compilers – can be decompiled. But ActionScript distributables are especially vulnerable and the reconstituted code can be just as readable as the original source code. For this reason it is not reasonable to assume that ActionScript source code can be protected. Developers might as well assume that users will be able to read their code if they want to badly enough. The most important advice about this is: security-related information should not be included in ActionScript code. Passwords, "secret" URLs, contest answers, etc. should be kept out of the code. Otherwise, this information will be discovered. There are techniques that can make this information harder to discover, but there is no way to make it secure in an SWF file.

Making and Distributing SWF Files

The goal of authoring an FLA file is to create an SFW file that can be distributed – either on a Web page or as a standalone application. To distribute an SWF on the Web, it can simply be referenced in an HTML page. To distribute and SWF as a standalone application, it can be opened with the Flash Player and saved out as an executable EXE file. To create an SWF from an FLA, the Flash Authoring environment must be instructed to "publish" the FLA. This is done through the File menu. To publish the SimpleSquare.fla, use the *File->Publish* command. A dialog box will show the Compiler's progress. When it is done, a new SWF will show up in the same folder as the SimpleSquare.fla. This is the default behavior of the Publish command. The desired destination of the SWF can be specified in the Publish Settings dialog. This is accessed through the *File->Publish Settings...* menu command.

Figure 1.5 shows the Format tab of the Publish Settings dialog. The options available on the Format tab allow the destination of the SWF (and other distributable types) to be specified. By default, the Publish command writes the SWF and a companion HTML document to the same folder as the FLA. An alternate destination folder can be specified by clicking on the folder icon. An alternate name for the SWF (and other) file(s) can be specified in the appropriate text fields.

Testing a SWF

During the development process, it is typically necessary to test the SWF over and over again to see how manipulations in the Authoring Environment will turn out. The easiest way to do this is the type <CTRL><ENTER>. This is the same as invoking the *Control->Test Movie* command. The result is that a Flash Player window pops up and displays the running SWF file. The test can be ended simply by closing the Player window.

The SimpleSquare.swf file can bee seen in action by typing <CTRL><ENTER>. The resulting Player window will appear over the workspace, as shown in Figure 1.6:

The code in the SimpleSquare.fla example includes the line:

```
trace("Drawing square (" + i + ", " + j + ")");
```

Figure 1.5 *The Format tab of the Publish Settings dialog*

The "trace" command tells the player to display the specified message in the Output window. In Flash 8, the Output window appears automatically in the same location as the Properties panel – at the bottom of the workspace. It has its own tab, called "Output". When an SWF is tested from within the Authoring Environment, any output by the trace command shows up in the Output panel, as do any messages from the Compiler – including compile time error messages. It is a good idea to check the Output panel every time an SWF is tested to make sure no errors were generated. As mentioned earlier, one of the main benefits of using ActionScript 2 is improved error checking by the compiler.

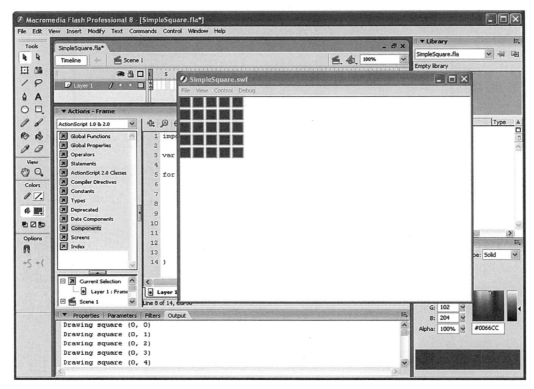

Figure 1.6 *The SimpleSquare.swf file*

The ActionScript Editor in the Actions Panel

Later in the book, the ActionScript Editor will be used to create ActionScript classes in external .as files. This section refers specifically to the process of adding actions to timeline frames. Most of the features, however, are applicable in both cases.

The term, "frame actions", refers to code that is attached to a frame on a timeline. When the ActionScript Editor is used to edit frame actions, it is accessed through the Actions panel. In the SimpleSquare.fla example, there is code attached to the first frame of the Main Timeline. Figure 1.4 shows the Actions panel in the center panel of the workspace, and in this panel is the code attached to the first frame of the first layer of the Main Timeline.

A few important things to observe are:

- The text is color coded.
- There are line numbers in the left margin.
- At the top of the Actions panel is a series of icons – buttons.
- At the bottom of the Actions panel is a tab showing the location of the script.
- Below the tab, a status bar shows the line and column number of the cursor.
- At the top right of the Actions panel is a menu icon, for the Actions panel Options menu.

The text is colored to make it easier to read. Words that appear blue are "reserved" words that are set aside for use by the language. Text that appears green is "literal" text, text enclosed by quotation marks. Comments – lines ignored by the compiler – are pink. This is the default color scheme. It can be customized by invoking the "Preferences..." command in the Actions panel Options menu. This menu is also used to turn the line numbers on and off.

Actions Panel Icons

The icons at the top of the Actions panel (see Figure 1.7) do the following:

Figure 1.7 *A code hint pop-up menu*

The Toolbox Chooser – This icon, shaped like a plus sign, is used to add code to a script by choosing from a list of available classes, methods, and properties. The contents of this list are the same as the contents of the ActionScript Toolbox. This is a handy way to look up the methods and properties of a class without launching the online Help tool.

Find/Replace – This icon, shaped like a magnifying glass, brings up a general purpose Find/Replace tool.

Target Path Tool – This icon, shaped like crosshairs, brings up a tool that makes it easier to specify the path to object in the FLA.

The Check Syntax Tool – This icon, shaped like a check mark, instructs the compiler to analyze the code in the active script. If any errors are found, they are displayed in the Output window. Checking the syntax of code is faster than compiling a whole SWF.

The Auto Format Tool – This icon, shaped like a paragraph of text, instructs the editor to automatically format all of the code in the current script. When invoked, the editor changes the indentation and spacing of the code so that it adheres to rules specified in the "Preferences:Auto Format" command of the Actions panel Options menu.

The Code Hint Tool – This icon, shaped although like a balloon, instructs the editor to display code hints for the selected function or method. When the cursor is inside the parentheses of a function or method call, a code hint pop-up menu appears listing the appropriate parameters that should be supplied. This can be seen in Figure 1.7.

The Debugger Tool – This icon, shaped like a stethoscope, is used to set and remove breakpoints for the Debugger.

Script Assist – This icon, shaped like a wand, activates a panel that provides a form-like interface for specifying function and method parameters, as seen in Figure 1.8. This is in lieu of the

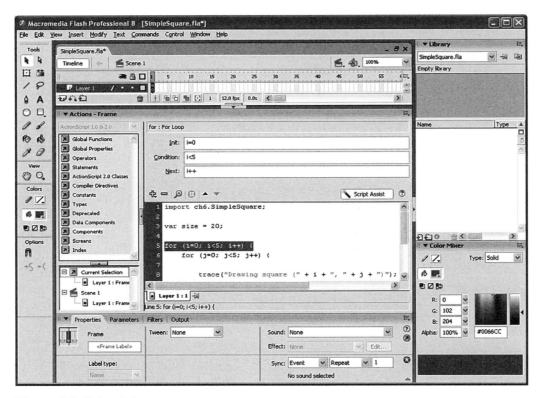

Figure 1.8 *Script Assist*

"Normal Mode" feature that was available in earlier versions of Flash. It is especially useful while learning ActionScript, but eventually becomes unnecessary.

Help – This icon, shaped like a question mark, invokes the Help system. The Help system in Flash 8 is much improved over previous versions. It is better organized, more thorough, and class method descriptions include full signatures, showing the types of all expected parameters. The Help system is context sensitive. As illustrated in Figure 1.9, if the cursor is on a class or function name, the Help system will automatically bring up the most appropriate topic.

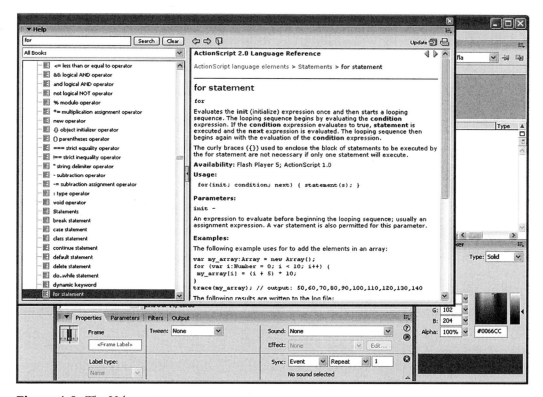

Figure 1.9 *The Help system*

Checking Punctuation Balance

Another useful feature of the ActionScript Editor is the ability to easily determine which parentheses balance each other. This works for standard parentheses (), square brackets [], and braces { }. When the cursor is between any pair of these symbols, typing <CTRL><'> (Control + Singlequote) will highlight all the text between the innermost pair of symbols. It is an easy way to make sure parentheses, brackets and braces match up correctly. Figure 1.10 shows the highlighted block of code between two braces.

Figure 1.10 *The highlighted block of code between two braces*

Displaying Hidden Characters

In earlier versions of the ActionScript Editor, hidden characters were never displayed. These typically include tabs, returns, line feeds, etc. Sometimes unwanted hidden characters can confuse the compiler. It is now possible to display all hidden characters so the author can see exactly what the compiler sees. Choosing "Hidden Characters" from the Actions panel's Options menu toggles them on and off. Figure 1.11 shows the example code with the hidden characters displayed.

Pinning Scripts in the Actions Panel

Whenever a new frame is selected, its code is displayed in the Actions panel and the previous code disappears. Selecting the previous frame brings back the previous code. This is easy enough. But if scripts exist on different timelines, in different MovieClips, it can be tedious to navigate back and forth between frames to make edits to the respective actions. Pinning a script causes it to remain in the Actions panel even when another frame is selected. It becomes associated with a tab at the bottom of the Script pane. Clicking between tabs is a fast way to access scripts on different timelines.

Figure 1.11 *The example code with the hidden characters displayed*

The ActionScript Toolbox and Script Navigator

The Toolbox and Script Navigator panes can be seen in any of the workspace illustrations, like Figure 1.11. The two panes to the left of the Script pane in the Actions panel (from top to bottom) are the ActionScript Toolbox pane and the Script Navigator pane. The Toolbox pane displays a hierarchical directory of functions and classes available for use in code. Sometimes it is hard to remember all the methods of a class. The MovieClip class has dozens of methods and properties. Even experienced Flash programmers rarely memorize them all. When in doubt, browsing through the toolbox can save a lot of time.

The Script Navigator pane is especially useful when there are many scripts distributed throughout an FLA. Finding them all by hunting around can be time consuming. The Script Navigator lists all of the scripts in an FLA and on what frame and layer of what timeline they can be found. Double-clicking on a script icon automatically opens that script in the Actions pane, no matter where it is in the FLA.

The Movie Explorer

The Movie Explorer panel is another way to find elements in an FLA. The best strategy is to be organized from the start, and put everything in a logical place. But even the best plans can go astray. The Movie Explorer can find just about anything.

Figure 1.12 shows the Movie Explorer's interface. It resembles a general find tool. Items are located by name and by type. The text name goes in the Find: field and the type is selected from among the icons at the top. Each icon is effectively a checkbox and clicking it instructs the Movie Explorer to include that type of item. From left to right, the types are: text, MovieClips, scripts, media (images, sounds, and video), and frames and layers. The right-most icon brings up a dialog box in which all of the types can be specified more carefully.

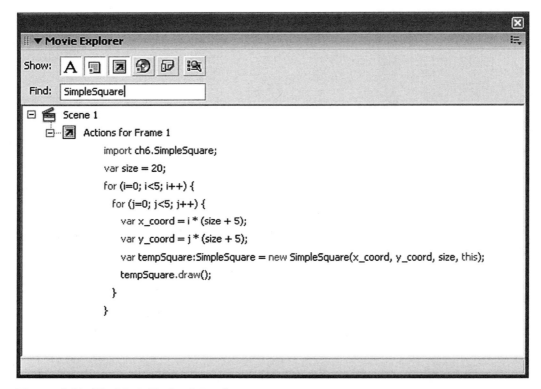

Figure 1.12 *The Movie Explorer's interface*

The Movie Explorer can be especially handy when examining an FLA authored originally by someone else.

The Debugger

Flash provides a special tool that can examine code while it is running. The Debugger makes it possible to stop the execution of a program at a specific point and then examine the state of variables and properties. When a program isn't working properly, this can be very helpful. Getting the Debugger to stop a program at specific points involves setting "breakpoints". A breakpoint is a marker in a program that the Debugger recognizes. Breakpoints are set using the Debugger tool

at the top of the Script pane in the Actions panel (or by right–clicking on a line of code). When a breakpoint is set, a red dot appears in the left margin of the Script pane. Figure 1.13 shows the SimpleSquare.fla example with a breakpoint set on line number 11.

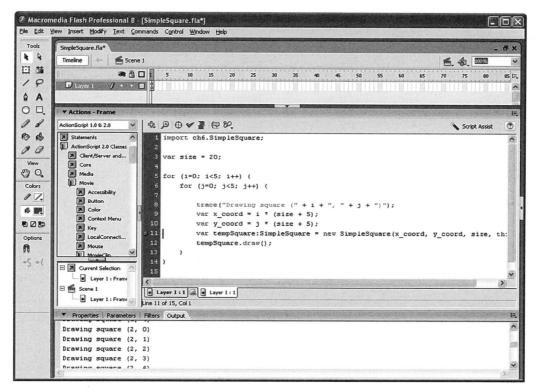

Figure 1.13 *The SimpleSquare.fla example with a breakpoint set on line number 11*

To run the Debugger, the *Control->Debug Movie* command (or <CTRL><SHIFT> <ENTER>) is invoked. This brings up the Debugger window in a paused state. To begin debugging, the play button is pressed (green triangle). The example will execute until line 11 is reached. Then the Debugger will stop. At this point, the top left pane of the Debugger window will show two main options: "_global" and "_level0". These are two properties that refer to the global "container" and the Main Timeline, respectively. (The global container is the one point of reference that is shared by all objects in an FLA. When a property is defined on _global, it is universally accessible.) The Main Timeline is where the example code is defined (on frame 1 of Layer 1) so clicking on this option will display the program's variables: i, j, size, tempSquare, x_coord, and y_coord. Figure 1.14 shows the Debugger window with execution stopped at a point where i = 2, j = 2, x_coord = 50, and y_coord = 50. This corresponds to the point in the program at which the third square in the third column is about to be drawn at (50, 50). This also corresponds to the state of the application as it can be seen in the Player window (behind the Debugger).

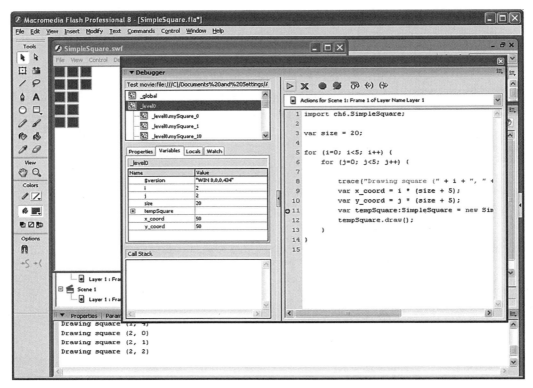

Figure 1.14 *The Debugger window with execution stopped*

Clicking the play button again allows the program to execute until the next breakpoint is encountered. Within the Debugger, breakpoints can be set and cleared. Clearing all breakpoints and then clicking play allows the program to continue unhindered. Breakpoints that are set or cleared in the Debugger are done so only temporarily. They won't be remembered when the Debugger is closed, and they won't affect breakpoints set from with the Script pane. There is much more to know about the Debugger. This has been just a brief introduction.

And More

The Flash environment is rich with features and tools. This chapter has selectively called out a handful that will be important for later chapters. The next chapter explains how FLAs are constructed.

2 Timelines, Layers, The Stage, MovieClips, and the Library

The Main Timeline

One of the most important concepts in Flash development is the timeline. In every new Flash document, the "Main Timeline" is the most prominent feature in the workspace. Figure 2.1 shows a new, empty Flash document with the Main Timeline at the top of the workspace.

Figure 2.1 *The Main Timeline*

The Main Timeline is made up of a sequence of "frames" which are numbered sequentially. There is an unlimited supply of frames. The scroll bar at the bottom of the Timeline pane is used to navigate through all the frames in the timeline. In a new Flash document, all of the frames are completely empty except for one. The first frame on the first layer contains an empty "keyframe". A keyframe is a container that can hold a media element, a label, a script, or all three. In order to

put anything on a timeline frame, it must have a keyframe created on it first. New, empty keyframes are created using *Insert->Timeline->Keyframe* (also <SHIFT><F6>).

Symbol Timelines

Each "Symbol" in a Flash document also has a timeline. New Symbols are created by choosing *Insert->New Symbol. . .* Figure 2.2 shows the "Create New Symbol" dialog.

Figure 2.2 *The "Create New Symbol" dialog*

Every new symbol needs to have a unique name, specified in the "Name:" field. Each symbol also has a type, which can be either: "Movie clip", "Button", or "Graphic". Each of these symbol types has its own timeline. Figure 2.3 shows the timeline for a new MovieClip symbol. The new MovieClip is named "new_movieclip". In the bar just above the new symbol's timeline is a MovieClip icon with the name of the new MovieClip, "new_movieclip". This indicates that the timeline of "new_movieclip" is currently active and being edited in the workspace.

Flash came into existence as a tool for creating animations, so Flash timelines are an abstraction of the "filmstrip". The frames in a Flash timeline are analogous to the frames in a movie filmstrip.

Figure 2.3 *The timeline for a new MovieClip symbol*

A frame in a filmstrip can contain one image. Each frame in Flash timeline that has a keyframe on it can contain an image, a MovieClip, a Graphic, a Button, a Video, a script, or all of these at once.

Layers

Every frame in a timeline exists on a "Layer". Timelines can have many Layers of frames. Layers are a common feature in many graphical design applications including PhotoShop, Illustrator, etc. In Flash, as in many other applications, layers are used to establish which graphical elements are displayed on top of others. Layers also determine the order in which timeline scripts are executed. Visual elements on the first layer are displayed on top of visual elements on the second layer, etc. Scripts on the first layer are executed before scripts on the second layer, etc.

The "Layers.fla" file in the ch2 folder of the Examples shows an example of how layers can be used to determine which symbols are drawn on top of others. The Main Timeline of Layers.fla is shown in Figure 2.4.

The first thing to notice in Layers.fla is that there are four layers named: "ship", "powerups", "space debris", and "space bg". The "space bg" layer contains the bitmap image of the space scene. As it is the bottom-most layer, all of the other elements are drawn on top of it. The next thing to notice is that each layer has one keyframe, and the keyframe is displayed with a black dot in it. This indicates that the keyframe is not empty and that it has a media element on it.

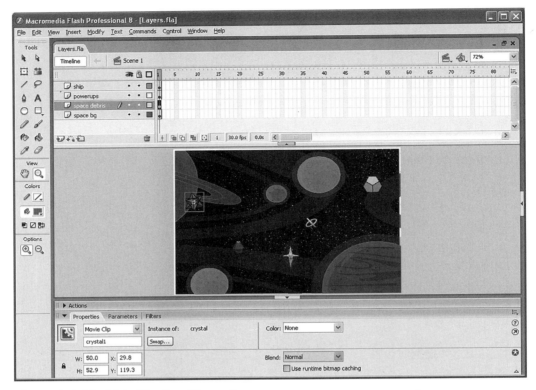

Figure 2.4 *The Main Timeline of Layers.fla*

As seen in this example, layers can be given descriptive names. This is accomplished by double-clicking on the layer label. It is a very good idea to give layers meaningful names, and to keep related symbols on their own layers. Layers are free, so it is good to use as many as necessary to keep an application well organized.

Scenes

Scenes are yet another way to group elements of a Flash application. Every new Flash document includes one Scene, called "Scene 1". Flash applications can have many Scenes, and for some types of projects they are very useful. Dynamic applications, like the game in this book, rarely need more than one Scene, so they are not discussed in detail. In a nutshell, having multiple Scenes is like have multiple Flash documents in one. This was a very valuable feature in the early days before it was possible to dynamically load external SWF files. In recent version of Flash, most of the benefits of Scenes can be achieved using coding techniques.

The Stage

Of course, the most noticeable thing about Layers.fla is the Stage: it contains a space scene. The stage is where everything on the Main Timeline is displayed. In this example, the Stage contains

a background image (on the "space bg" layer), a "crystal" symbol and a generic "debris" symbol (on the "space debris" layer), two "powerup" symbols (on the "powerups" layer), and a "ship" (on the "ship" layer). When a symbol is selected (clicked on), its layer is also selected. In Figure 2.4, the "crystal" symbol is selected. As a result, it has a blue selection box around it and the "space debris" layer is highlighted. Also, the properties of the crystal symbol are displayed in the Properties panel at the bottom of the workspace. The properties listed for the crystal indicate that it is:

1. a MovieClip symbol,
2. an instance of the "crystal" symbol,
3. "Instance Name" is "crystal1",
4. located at coordinates (29.8, 119.3),
5. 50 pixels wide and 52.9 pixels high.

The Movie Explorer Panel

Another way to take an inventory of the current Scene is to use the Movie Explorer panel. (*Window->Movie Explorer*) It displays a hierarchical list of all the currently active MovieClips. Figure 2.5 shows the Movie Explorer view of Layers.fla.

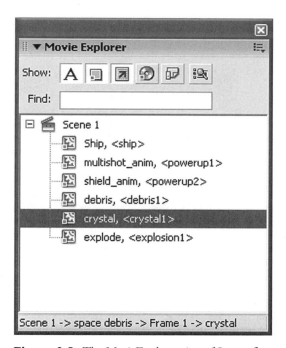

Figure 2.5 *The MovieExplorer view of Layers.fla*

Testing the Movie

Testing the example (<CTRL><ENTER>) will reveal the animation cycles of all the symbols. It will also reveal a sixth symbol on the "space debris" layer: an explosion. Clicking on the "space

debris" layer's label will automatically select all the symbols on that layer – including the explosion symbol, which is otherwise invisible because it doesn't have an image on its own first frame.

Layers in Flash Applications

Layers are used in every Flash project. They are used extensively by designers to create visual effects. When developing an application in Flash, layers can also be used to organize some of the program code. In general, application code is best kept out of the FLA and put into external ActionScript 2 ".as" class files. But some code needs to exist in the FLA and layers can help make this code easily accessible.

For example: the game code that will be analyzed in later chapters is organized on the timeline as shown in Figure 2.6.

Figure 2.6 *The Astro Sweeper game timeline*

All of the Main Timeline scripts in this example live on frames in the top three layers, which are organized as follows:

- Labels – contains the labels which are used by the code to jump to parts of the application.
- Actions – contains the calls to the code which manages the game.

- Stops – contains all of the stop() actions. Keeping stops on one layer makes the application flow more obvious.

There are additional scripts that are attached to certain MovieClips when appropriate and necessary. The rest of the game code exists in external files and will be explained in later chapters.

Keeping Things Organized

It is important to have a consistent organization strategy for symbols and scripts. Flash is very open and unstructured in this regard, which, on one hand, is nice. But on the other hand, this openness makes it possible for FLAs to get disorganized easily. When this happens, an increasing percentage of development time can be spent looking for misplaced symbols and scripts. The problem is compounded when developers collaborate. When one person needs to work with an FLA authored by another person, a consistent organization strategy can mean the difference between productive work and frustration.

MovieClips

Flash development revolves around MovieClips. In fact, a Flash application is a MovieClip that acts as a container for the rest of the application's elements, and its timeline is the Main Timeline. In other words, when an SWF file is generated, the SWF is essentially a MovieClip that contains other MovieClips. Later in this chapter, it will be seen that an SWF can be dynamically loaded into a Flash application as a MovieClip and controlled as such.

In general terms, a MovieClip is a container that has a timeline and layers. MovieClips can contain MovieClips, which can contain MovieClips, ad infinitum. In some ways, MovieClips act like folders (directories) in a file system. The main hard drive is like the Main Timeline, and each MovieClip is like a folder (subdirectory). Just like folders on a hard drive, MovieClips are referenced using path names. On most PCs, the main hard drive is referred to as "C:". On Macintosh computers, it is often called "Macintosh HD". A pathname to a file might look something like:

```
C:\Documents and Settings\arapo\My Documents\book.pdf
```

In this example, the backslash "\" is used as the pathname separator. Based on this pathname, the file "book.pdf" lives in a folder called "My Documents" inside a folder called "Andrew Rapo" inside a folder called "Documents and Settings". The pathname is a concise way to reference the file.

In a Flash application, the Main Timeline has a special name, "_root". A pathname to a MovieClip might look like:

```
_root.ship.ship_anim
```

The pathname separator for object instances in Flash is ".", a dot. The above path implies that the "ship_anim" MovieClip lives inside a MovieClip called "ship" which lives on the Main Timeline (_root). MovieClips that are contained in other MovieClips are said to be "nested". The ship_anim MovieClip is nested inside the ship MovieClip.

Dot Notation

In addition to acting as the pathname separator for Flash objects, the dot (".") has another import-ant function. It is also used to refer to elements within objects, such as the properties of an object and the methods (functions) associated with the object. For example, the _name property if a MovieClip instance is referenced like:

```
_root.ship._name
```

This notation is referred to as "dot notation" and it is used extensively in ActionScript, as well as in most object oriented programming languages.

Instance Names

In order to reference a MovieClip using a pathname, the MovieClip must have an "instance name" and so must every other MovieClip in the path. When a MovieClip is dragged from the Library to the Stage, its instance name is blank. The MovieClip will still appear and play correctly, but without an instance name there is no way to reference it from ActionScript. Referring back to Figure 2.4, the crystal MovieClip that is selected has an instance name of "crystal1". This can be seen in the Properties panel at the bottom of the workspace. As it has an instance name, it can be referenced within a script by using the path:

```
_root.crystal1
```

Referring back to Figure 2.5 (the Movie Explorer panel), every MovieClip in the Scene has an instance name listed after the symbol name (in angle brackets < >). For instance, the Ship symbol has an instance name, "ship". The debris symbol has an instance name, "debris1".

Controlling MovieClips from ActionScript

The simplest way to control a MovieClip from ActionScript is to modify its properties. Every MovieClip instance has properties called _x and _y that determine where it is drawn on the Stage – relative to its containing MovieClip. To move the ship MovieClip, for instance, its coordinates can be changed by adding a script to the Main Timeline. To keep things organized, an actions layer is added. This layer will have keyframes that will only be used to hold actions (scripts). Figure 2.7 shows the timeline from the example, LayersActions.fla, from the ch2 folder of the Examples. The "actions" layer is the topmost layer, and it contains one keyframe. The "a" displayed on the keyframe indicates that it contains actions.

In Figure 2.7, the Actions panel has been freed to float on its own by dragging the top left corner of the panel to an open place in the workspace. It can be activated and hidden using <F9>. Also, the Stage has been scaled down (shrunk) using *View->Magnification->Show Frame* (also <CTRL> <2>). At any time, the workspace can be reset to its default layout using *Window->Workspace Layout->Default*. The code on the action frame can be seen in Listing 2.1:

Listing 2.1

```
_root.ship.gotoAndStop(1);
_root.ship.hit_target._visible = false;
```

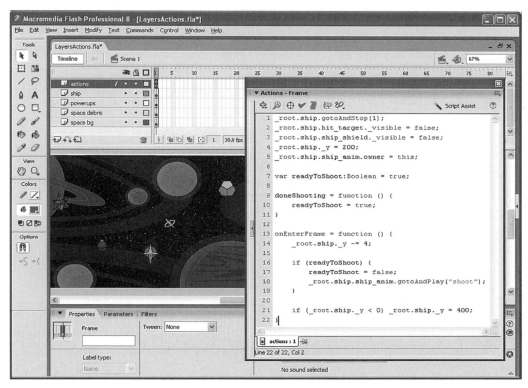

Figure 2.7 *The timeline from the LayersActions.fla example*

```
_root.ship.ship_shield._visible = false;
_root.ship._y = 200;
_root.ship.ship_anim.owner = this;

var readyToShoot:Boolean = true;

doneShooting = function () {
  readyToShoot = true;
}

onEnterFrame = function () {
 _root.ship._y -= 4;

  if (readyToShoot) {
    readyToShoot = false;
    _root.ship.ship_anim.gotoAndPlay("shoot");
  }

  if (_root.ship._y < 0) _root.ship._y = 400;
}
```

The first line uses the pathname of the ship MovieClip instance to invoke its "gotoAndStop()" method. The parameter in parentheses indicates the frame that the MovieClip should stop at. The ship MovieClip contains an animation cycle that rotates the nested Ship_anim MovieClip. The gotoAndStop() method tells the ship to go to its first frame and stop, so the ship stops rotating.

The next few lines hide some of the other nested MovieClips that don't need to be visible and set the initial position of the Ship.

The code inside the "onEnterFrame" function is called repeatedly during playback. The onEnterFrame function is an "event handler" function that is called automatically by the Flash player, once every frame. In this case it controls the Ship MovieClip by modifying the ship's _y property, causing it to move upward. If it moves past the top of the screen, it starts again at the bottom of the screen. The code also triggers an animation in one of the Ship's nested MovieClips, making the Ship play its "shoot" animation. Code like this is explained in detail in later chapters.

Testing the SWF

Control->Test Movie can be used to test the SWF. Figure 2.8 shows the SWF in action. When the SWF plays, the ship moves vertically up the screen and then wraps around to the bottom of the screen, over and over again. At the same time, the other MovieClips cycle through their

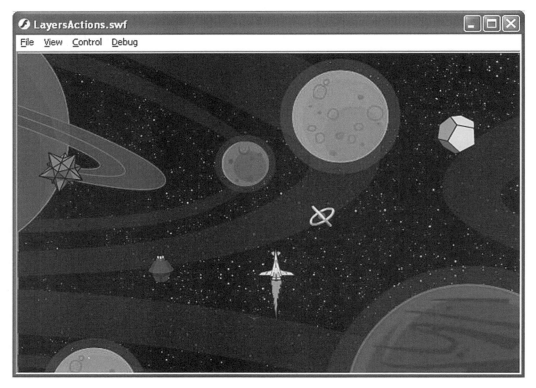

Figure 2.8 *The LayersActions.swf being tested*

animations. This demonstrates multiple timelines doing their own things, while one timeline is controlled by actions on a Main Timeline keyframe. The total behavior of the application is complex, but the organization of the FLA is simple and straightforward. This is the beauty and power of nested timelines.

The Library

The Library is where all the assets in an FLA are organized. Every symbol used in an FLA can be found in the Library. The Library panel is, by default, on the right side of the workspace. Figure 2.9 shows the Library panel in the top right corner of the workspace. Assets in the library can be organized in folders. Again, it is a good idea to keep things organized, especially in the Library panel. Symbols in the library need to have names, and all symbols in a folder need to have unique names. A symbol in one folder can have the same name as a symbol in another folder, but this is generally a bad idea. Giving symbols clear, consistent names will always be worth the effort.

In the Library of the LayersActions.fla (Figure 2.9) the crystal symbol is in a folder called, "debrisStuff". Right-clicking on the symbol name brings up a menu that can be used to set various properties of

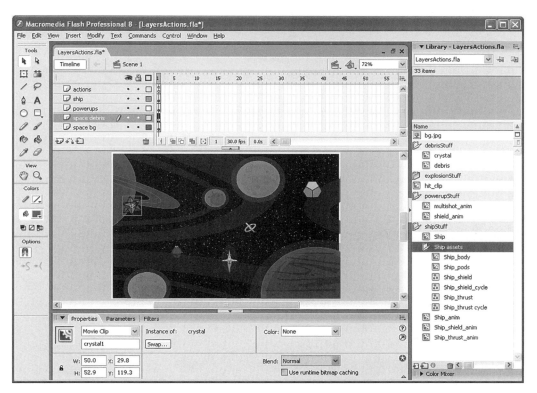

Figure 2.9 *The Library of the LayersActions.fla*

the symbol. Double-clicking on the icon to the left of a symbol name opens the symbol for editing – its timeline becomes the active timeline in the workspace and its contents are displayed on the Stage.

The crystal symbol can be examined and edited by double-clicking on the MovieClip icon to the left of its symbol name in the Library. Figure 2.10 shows the crystal symbol open for editing.

Figure 2.10 *The crystal symbol's timeline*

In Figure 2.10, the crystal symbol's timeline is visible, and on it are nine keyframes. The frame numbers are listed in the bar above the keyframes, and in this bar is the timeline "Playhead". The playhead indicates which frame is currently being displayed on the stage. Dragging the playhead causes the individual keyframes to be displayed as the playhead moves over them. This is an easy way to preview an animation.

Placing Symbols on the Main Stage

In the bar above the timeline is the "Scene 1" icon. Clicking on this icon makes the Main Timeline active again. Adding symbols to the Main Timeline is as easy as dragging them from the

Library to the Stage. Figure 2.11 shows the Main Timeline after several ship symbols have been dragged onto the Stage. Each ship is an instance of the Ship symbol in the Library. By default, new instances do not have instance names. To control them from ActionScript they must be given instance names using the Properties panel.

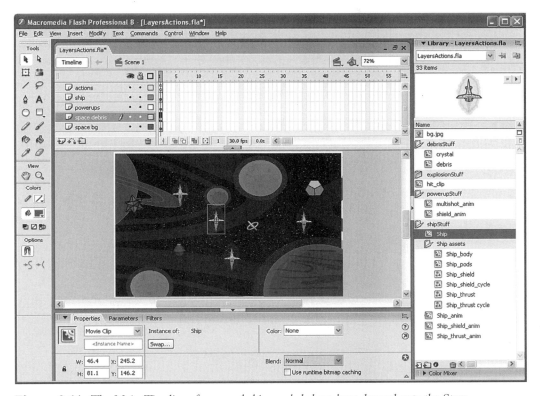

Figure 2.11 *The Main Timeline after several ship symbols have been dragged onto the Stage*

When symbols are dragged onto the Stage from the Library, they become associated with the layer that is currently active. In Figure 2.11, the active layer is "space debris". To move symbols from one layer to another, they can be cut (*Edit->Cut*) from the current layer. A new layer can be selected by clicking its label name. Then they can be pasted in the same place using *Edit->Paste In Place*.

A Timeline Strategy for Game Objects

The essential characteristic of a MovieClip is its timeline. The timeline is a powerful mechanism and it is ideally suited for animation and other sequential, visual elements. In many applications there is a need for objects that animate and move. The simplest of these objects can be implemented as a MovieClip with animation keyframes on its timeline. A good example is the crystal symbol,

above. A more complex example is the ship symbol. Figure 2.12 shows the ship symbol's timeline. The ship symbol has four layers:

- ship – contains a symbol called "Ship_anim". This symbol is "tweened" so that it completes a full rotation in 33 frames.
- shield – contains a symbol called "Ship_shield_anim". This symbol is "tweened" so that it completes a full rotation in 33 frames.
- thrust – contains a symbol called "Ship_thrust_anim". This symbol is "tweened" so that it completes a full rotation in 33 frames.
- hit target – contains a symbol called "hit_clip". This symbol doesn't need to rotate so it is not "tweened".

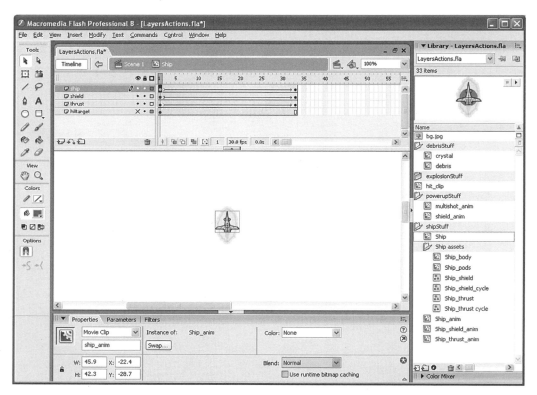

Figure 2.12 *The ship symbol's timeline*

Several things are accomplished by this organization:

- The Ship_anim, Ship_shield_anim, and Ship_thrust_anim elements are separate MovieClips, so they can be controlled independently. The shield and thrust MovieClips can be turned off when they are not in use.

- The hit_clip is a separate clip which is used in the game to determine if the ship has collided with anything. It is a simple geometric representation of the ship. By using the hit_clip instead of the Ship_body for collision detection, collisions don't occur when other objects simply graze the nose and wings of the ship. The hit_clip shouldn't be visible, so it can be hidden by the game program.
- The independent elements of the ship are layered so that the ship is topmost.
- The built-in tweening capability of Flash is used to create smooth, synchronized rotation cycles for the ship elements.

The Ship_anim, Ship_shield_anim, and Ship_thrust_anim MovieClips all have their own timelines. The Ship_shield_anim, and Ship_thrust_anim timelines contain simple cycles. The Ship_anim timeline, however, is more interesting. It contains a sequence of animations that correspond to states that the ship will have in the game. The Ship_anim timeline can be seen by double-clicking on its icon in the Library (to the left of its symbol name). Figure 2.13 shows the elements of the Ship_anim timeline.

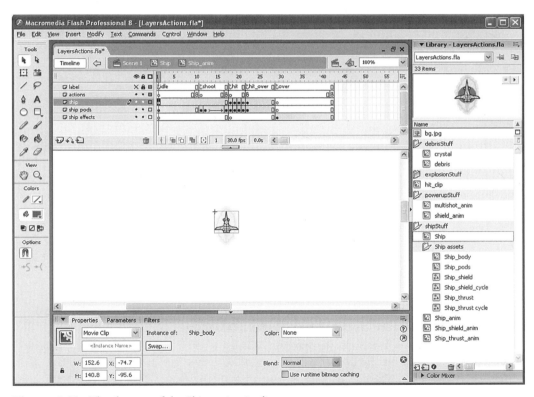

Figure 2.13 *The elements of the Ship_anim timeline*

The Ship_anim timeline has five layers. The first two are for labels and actions. Labels are assigned to keyframes using the Properties panel. When a keyframe is selected, the Properties panel displays

a "Frame" field where a label can be entered. When a frame has a label, the label can be used by ActionScript to tell the MovieClip to jump to that label. For example, the following code tells the Ship's nested Ship_anim clip to go to the "shoot" label and play from that point:

```
_root.ship.ship_anim.gotoAndPlay("shoot");
```

It is important to note that both the Ship symbol and the nested Ship_anim symbol have instance names, "ship" and "ship_anim", respectively. This makes it possible to reference them from ActionScript. This is potentially confusing, because the symbols in the Library also have names, but they don't have instance names. Instance names have to be given to symbols after they are dragged to the Stage of the Main Timeline or into another MovieClip.

The keyframe labels on the "labels" layer are markers for the animations contained in the Ship_anim MovieClip. Using these labels, the application code can easily tell the Ship_anim clip to play any of its animations using the gotoAndPlay() method of the MovieClip. The "actions" layer contains several keyframes that contain actions (Note the "a" on each of these "action frames"). At the end of each animation, an action tells the clip what to do next. In most cases, the action is:

```
gotoAndPlay("idle");
```

This tells the MovieClip to go back to its "idle" label and play its idle animation. In some cases, the action includes a line like:

```
owner.doneShooting();
```

This anticipates the need for the clip to inform the application code that the particular animation is complete. In this way, the application can avoid retriggering the animation until the previous cycle is complete. For this to work, the application has to create and set the "owner" property for the Ship_anim MovieClip. By setting this property to reference an application object, that object can have its "doneShooting()" method invoked when the "shoot" animation cycle is complete. The necessary code to make this work can be seen in Listing 2.1 (on page 26).

The animation cycles included in the Ship_anim MovieClip can be seen by dragging the playhead back and forth in the timeline.

Adding MovieClips Dynamically

So far, the MovieClips in this chapter have been added to their respective timelines manually – having been dragged from the Library to the Stage. The final section of this chapter demonstrates three ways to dynamically add MovieClip instances to the Stage. The first two ways utilize methods (functions) of the MovieClip class. The third way uses a method of the MovieClipLoader class to load an external SWF file into a MovieClip. The two MovieClip methods are:

- createEmptyMovieClip(name:String, depth:Number)
- attachMovie(id:String, name:String, depth:Number)

Names and Depths for Dynamic MovieClips

The createEmptyMovieClip() method, as the name implies, creates an empty MovieClip with a name and a depth. The depth of a dynamic MovieClip determines how it will be layered among other MovieClips on the Stage. Dynamic MovieClips are always drawn on top of MovieClips that are on the layers of a timeline. Dynamically created MovieClips cannot be added to an existing timeline layer. Instead, they are stacked above the topmost timeline layer according to their depth value. There can only be one MovieClip at a given depth, so it is important to choose unique depths for all dynamic MovieClips. The easiest way to do this is to use the getNextHighestDepth() method of the current timeline. Depth values are relative to the given timeline. Every timeline has its own set of depth values. The "this" keyword can be used to specify the current timeline. Invoking this.getNextHighestDepth() returns the next highest unused depth for the current timeline:

```
var depth:Number = this.getNextHighestDepth();
```

The name of a dynamic MovieClip is its instance name and it is used by ActionScript to reference the MovieClip. MovieClips that live on the same timeline need to have unique names. Since depths also have to be unique, a unique name can be generated by concatenating a base name with the depth value. For example:

```
var name:String = "TBD_" + depth;
```

This code generates names like "TBD_10" and "TBD_39".

The AttachMovie() Method

The attachMovie() method is used to make a dynamic instance of a symbol that is in the Library. For this to work, the symbol must have a "Linkage" identifier set. The "explode" symbol in the Library of the LayersActions.fla has its Linkage identifier set to "explosion". This can be seen by right-clicking on the "explode" symbol's name and choosing *Properties...* This will bring up the "Symbol Properties" dialog. Figure 2.14 shows the Symbol Properties dialog for the "explode" symbol.

The "Export for ActionScript" checkbox needs to be checked and the "Identifier" field needs to be filled in. The identifier name can be different than the symbol's name. In this case it is "explosion".

Once the linkage identifier is set, a dynamic instance of the symbol can be created with code like:

```
this.attachMovie("explosion", "TBD_10", 10);
```

This creates an instance of the "explode" symbol which is referenced by its linkage identifier, "explosion", with the instance name, "TBD_10", and a depth of 10. This instance is created on the current timeline and can be referenced using its instance name. The code to do this looks like:

```
var newPowerup:MovieClip = this["TBD_10"];
```

Figure 2.14 *The Symbol Properties dialog for the "explode" symbol*

This assigns a reference to the MovieClip with the instance name, "TBD_10", to a variable called newPowerup. The MovieClip's properties can then be set using code like:

```
newPowerup._x = 10;
newPowerup._y = 10;
```

This code would move the MovieClip referenced by newPowerup to the coordinates, (10, 10).

The MovieClipLoader Class

The MovieClipLoader class is used to dynamically load external SWF files into MovieClips. To use it, an instance of the MovieClipLoader class must be created:

```
var mcl:MovieClipLoader = new MovieClipLoader();
```

Then the loadClip() method can be used. Given a file name (or URL) and a reference to a MovieClip instance, the loadClip() method will replace the contents of the MovieClip instance with the loaded SWF.

```
mcl.loadClip("PowerupTBD.swf", newPowerup);
```

Figure 2.15 shows the timeline of the bg_clip symbol, the symbol that serves as the space background graphic in the LayersActions.fla. The bg_clip symbol has actions on the first frame of its actions layer. This code listens for mouse clicks and then creates a new dynamic MovieClip at the clicked coordinates. When the <SHIFT> key is held down, the MovieClipLoader class is used to dynamically load an SWF called, "PowerupTBD.swf" and position it at the mouse coordinates. When the <SHIFT> key is not held down, attachMovie() is used to dynamically create an instance of the explode symbol and place it at the mouse coordinates.

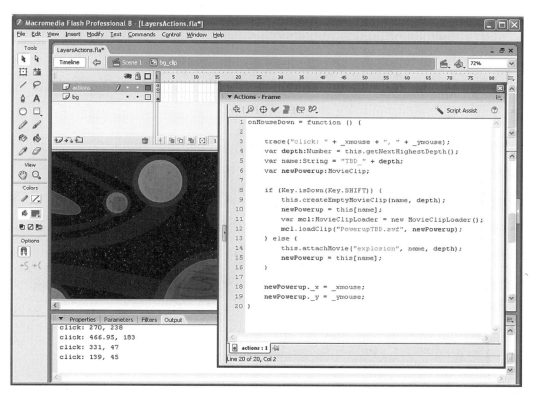

Figure 2.15 *The timeline of the bg_clip symbol*

Listing 2.2 shows the code to add dynamic MovieClips. The code is defined inside the timeline's onMouseDown() function. This function is an event handler function that is called every time the left mouse button is pressed. Event handlers are the subject of Chapter 3.

Listing 2.2 *Code to dynamically add MovieClips to the bg_clip*

```
onMouseDown = function () {
    trace("click: " + _xmouse + ", " + _ymouse);
    var depth:Number = this.getNextHighestDepth();
    var name:String = "TBD_" + depth;
    var newPowerup:MovieClip;
    if (Key.isDown(Key.SHIFT)) {
        this.createEmptyMovieClip(name, depth);
        newPowerup = this[name];
        var mcl:MovieClipLoader = new MovieClipLoader();
        mcl.loadClip("PowerupTBD.swf", newPowerup);
    } else {
        this.attachMovie("explosion", name, depth);
        newPowerup = this[name];
    }
    newPowerup._x = _xmouse;
    newPowerup._y = _ymouse;
}
```

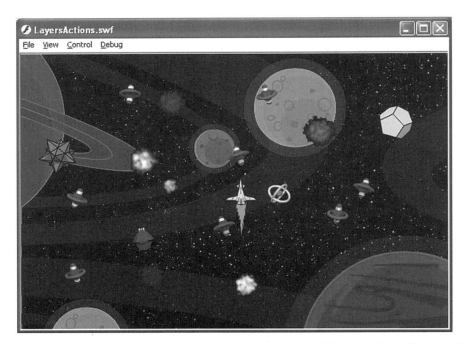

Figure 2.16 *The running LayersActions.swf after a number of dynamic MovieClips have been added by clicking on the screen*

Testing the Dynamic MovieClip Code

When the LayersActions.fla is tested (<CTRL><ENTER>) clicking anywhere on the background will invoke the bg_clip's onMouseDown() function. Figure 2.16 shows the running SWF after a number of dynamic MovieClips have been added to the Stage.

Event Handlers

In this chapter, the code in both listings made use of event handlers. Listing 2.1 uses the onEnterFrame handler. Listing 2.2 uses the onMouseDown handler. Event handlers can be used in many ways, as will be seen in the next chapter.

3 Events and Event Handlers

Events

Programs are like recipes. They are essentially a list of instructions. ActionScript programs tell the Flash Player what to do and when to do it. In a recipe for scrambled eggs, there might be an instruction like:

```
When the eggs start to brown on the bottom, turn them over.
```

This instruction deals with a phase of the recipe that is guaranteed to happen. But unpredictable things can happen when making scrambled eggs. Recipes generally don't address them, but if they did the instructions might look like:

```
If the doorbell rings before the eggs are done, remove them
from the burner while you see who it is.
```

The ringing doorbell is an unpredictable event, and the response is considered common sense. Computers, of course, don't have common sense so everything needs to be communicated explicitly in the code.

Events in ActionScript

In the context of ActionScript, an event is any unpredictable occurrence that needs to be dealt with immediately when it happens. Events are "asynchronous" because they can happen at any time, not necessarily in sync with everything else that is going on. The best example of an asynchronous event is a mouse click. There is no way for a program to predict when a user will click the mouse. The program simply has to be ready for anything.

Polling

One strategy that is often used to detect events is to have the program check repeatedly to see if the mouse button is down, or a key is down, or an e-mail has arrived, etc. This is called "polling". Polling is a fine strategy, and just about every program that needs to detect events does some amount of polling. Because it is so prevalent, programmers at Macromedia have decided that rather than have developers put the same polling code into every application, the mechanism can be included in the Flash Player. As a result, the Player does all the polling necessary to keep track of the basic events that every program need to deal with.

Event Handler Functions

When the Player detects an event, it informs the application code by automatically calling an appropriate event handler function. The onEnterFrame() event handler function used in the previous chapter is a perfect example. The Main Timeline and every MovieClip timeline has an onEnterFrame() event handler function that responds to "enterFrame" events. An enterFrame event is generated every time the playhead moves from one frame to another on a timeline. As a result, the onEnterFrame() function is automatically called once during each frame for each timeline. The onEnterFrame() function is undefined by default, so even though it is always called, unless it is defined, nothing happens. Defining an event handler is very straightforward. For example, an event handler function to output elapsed milliseconds (to the Output window) would look like this:

```
onEnterFrame = function() {
  trace("Current Time: " + getTimer());
}
```

The Output looks like:

```
Current Time: 20
Current Time: 110
Current Time: 200
Current Time: 291
Current Time: 381
```

The above example can be seen in "SimpleEventHandlerExample.fla" in the ch2 folder of the examples.

Event Handler Properties

Technically speaking, "onEnterFrame" is actually a "property" of all timeline "objects", and when this property contains a reference to a function, the function is automatically invoked. The term "object" is explained in Chapter 5, but briefly: an object is any unit in an application that has functions and properties. MovieClip instances are objects, as are Button instances, etc. Objects are always instances of a "class". The term, "class", is also explained in Chapter 5. Examples of ActionScript classes include the MovieClip class, the Button class, etc.

Many ActionScript classes have event handler properties that can refer to useful functions. Table 3.1 is a short list of Classes and their respective event handler properties.

Detecting Mouse Events in Buttons and MovieClips

Most Flash applications use Buttons to get user input and use that input to control MovieClips. Buttons and MovieClips are actually very similar. In fact, as seen in Table 3.1, they have some of the same event handler properties. Both Buttons and MovieClips can have "onRollOver" and "onRollOut" event handler functions. The onRollOver and onRollOut events are generated whenever the mouse rolls into and then out of a Button or MovieClip instance. Figure 3.1 shows the SimpleRolloverExample.fla, available in the ch3 folder of the examples.

Table 3.1 *Classes and their respective event handler properties*

Class	Event handler property	Automatically called when
MovieClip	onEnterFrame	every frame
MovieClip	onData	loading a SWF
MovieClip	onSetFocus	gets key focus
MovieClip	onKillFocus	loses key focus
MovieClip	onKeyDown	has key focus and a key is pressed
MovieClip	onKeyUp	has key focus and a key is released
MovieClip	onMouseDown	the mouse button is pressed
MovieClip	onMouseUp	the mouse button is released
MovieClip	onMouseMove	the mouse is moved
Button	onPress	the Button is pressed
Button	onRelease	the Button is released
Button	onRollOver	the mouse rolls over the Button
Button	onRollOut	the mouse rolls out of the Button area
Button	onSetFocus	gets key focus
Button	onKillFocus	loses key focus
Button	onKeyDown	has key focus and a key is pressed
Button	onKeyUp	has key focus and a key is released
Key	onKeyDown	a key is pressed
Key	onKeyUp	a key is released
LoadVars	onData	data has been downloaded
LoadVars	onLoad	load operation has completed
Mouse	onMouseDown	the mouse button is pressed
Mouse	onMouseUp	the mouse button is released
Mouse	onMouseMove	the mouse is moved
MovieClipLoader	onLoadComplete	a MovieClip is fully loaded
MovieClipLoader	onLoadProgress	MovieClip data is written to disk
Sound	onSoundComplete	a Sound finishes playing
Sound	onID3	ID3 tags are detected during load
Sound	onLoad	a Sound is fully loaded
Stage	onResize	the Stage is resized
TextField	onChanged	the text in a TextField is changed
TextField	onSetFocus	a TextField is selected
XML	onData	document is completely loaded
XML	onLoad	returns success flag when loaded

The SimpleRolloverExample.fla example has four layers on its Main Timeline: one for actions and three more for the crystal, stop button, and background symbols. The stop button is an instance of the "gel Stop" symbol from the Common Libraries that comes with Flash. Both the "gel Stop" and crystal symbols have instance names: "btn" and "crystal1", respectively. Using their instance names, the code on the actions layer assigns functions to their onRollOver and onRollOut properties. The code for the SimpleRolloverExample.fla example can be seen in Listing 3.1.

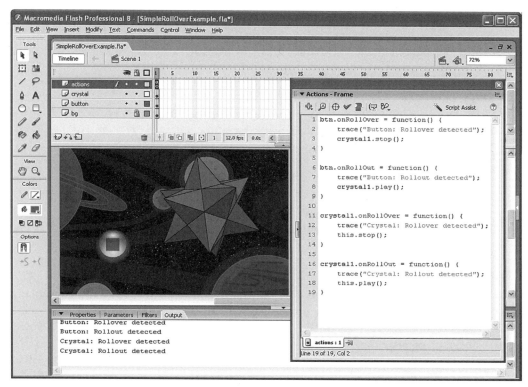

Figure 3.1 *The SimpleRolloverExample.fla*

Listing 3.1 *RollOver Code*

```
btn.onRollOver = function() {
  trace("Button: Rollover detected");
  crystal1.stop();
}

btn.onRollOut = function() {
  trace("Button: Rollout detected");
  crystal1.play();
}

crystal1.onRollOver = function() {
  trace("Crystal: Rollover detected");
  this.stop();
}

crystal1.onRollOut = function() {
  trace("Crystal: Rollout detected");
  this.play();
}
```

For both the "btn" and the "crystal1" instances, the onRollOver() function outputs a "Rollover" message to the Output window and then stops the crystal1 instance from playing. Similarly, the onRollOut() functions output a "Rollout" message and then tell the crystal1 instance to play again.

Trying it Out

The SimpleRolloverExample.fla can be tested by typing <CTRL><ENTER>. The crystal immediately begins animating, and stops whenever the mouse rolls over the button or the crystal, itself. Animation resumes when the mouse rolls back into space. The output looks like:

```
Button: Rollover detected
Button: Rollout detected
Crystal: Rollover detected
Crystal: Rollout detected
```

Listeners

Objects that receive event notifications are referred to as "Listeners". Some classes are automatically designated as listeners for certain types of events, like those in Table 3.1. For classes that don't automatically receive notification about a certain type of event, there is a mechanism for making them listeners. This mechanism puts them on the distribution list, so to speak. For example, the TextField class generates "onChanged" events whenever the contents of a TextField instance changes. Each TextField instance automatically has an onChanged property which can be assigned a function to handle the event. But what if a MovieClip needs to know when the contents of a certain text field changes? The answer: The TextField class has an addListener() method that can add on object, like a MovieClip instance, to its listener list. Once added, the MovieClip instance will receive notification whenever the contents of the TextField instance change. To handle the event, the MovieClip instance needs to have an onChanged property defined, and this property needs to be assigned a handler function.

The following code is from the SimpleListenerExample.fla in the ch3 folder of the examples. It refers to two TextField instances: crystal_x_txt and crystal_y_txt. These TextFields are used to set the x and y coordinates of the crystal MovieClip (from the SimpleRolloverExample.fla).

```
crystal_x_txt.addListener(crystal1);
crystal_y_txt.addListener(crystal1);

crystal1.onChanged = function () {
  trace("Coordinate changed:" + this._name);
  this._x = Number(crystal_x_txt.text);
  this._y = Number(crystal_y_txt.text);
}
```

When the text in either of the TextFields changes, the crystal1 MovieClip instance is notified, and it updates its own coordinates based on the contents of the TextFields. The working example can be seen by testing the FLA, <CTRL><ENTER>. The SWF can be seen in Figure 3.2.

Figure 3.2 *The SimpleListenerExample.swf*

The UpdateAfterEvent() Function

Because events can come at any time, they will rarely occur exactly at the beginning or the end of a frame. The Flash Player typically processes all the code associated with a frame before it redraws the Stage. This is the best behavior most of the time. But with events, it may sometimes be necessary to force the Flash Player to redraw the Stage as soon as an event occurs, without waiting for the rest of the frame's code to execute. To force the Player to redraw the Stage, the updateAfterEvent() function can be called. Flash applications that maintain a high frame rate, rarely need to use updateAfterEvent(). And it doesn't work with every event, only certain Mouse and MovieClip events, including:

Mouse.mouseDown
Mouse.mouseUp
Mouse.mouseMove
Mouse.keyDown
Mouse.keyUp

MovieClip.onMouseMove
MovieClip.onMouseDown
MovieClip.onMouseUp

MovieClip.onKeyDown
MovieClip.onKeyUp

The updateAfterEvent() function does not work with the Key class.

Race Conditions

The term, "race condition", refers to the situation where instructions will produce different results when executed in a different order, and the order of execution is inconsistent. Race conditions can produce intermittent bugs (errors), and these are the hardest to track down and fix. Flash makes it very easy to inadvertently create race conditions. This is primarily because Flash allows multiple timelines to be running simultaneously. The Flash Player always executes code consistently, according to invariable rules. However, the complexity of Flash applications makes it hard for developers to accurately predict how multiple timelines will interact.

When the code on frame 5 of one MovieClip needs to execute before the code on frame 10 of another MovieClip, everything may be fine when the application starts. But, if one MovieClip gets stopped for a few frames and then restarted, things can get out of sync, and unintended behavior can result.

Events only add to the problem, because by definition they are unpredictable, and cause code to execute at (apparently) random, asynchronous times.

Avoiding Race Conditions

The only solution is to centralize the important code and have all of the various MovieClips and event handlers report back to an authoritative "application controller". Developing an effective application controller requires careful analysis and planning. The game, developed in later chapters, includes a GameController class as an example of this technique.

Making Use of Event Handlers

The event handler mechanism provided by ActionScript (and the Flash Player) is really a nice feature of the language. Not all programming languages provide such a mechanism, and it is often left to the programmer to construct something similar – often from scratch. This chapter has explained the basic concept and has provided some useful examples, but there are many ActionScript classes with a wide range of event handler capabilities. All of these are well-documented in the online Flash documentation. Once the technique is mastered for a few simple cases, it is easily extended to all of the others.

4 External ActionScript Class Files

ActionScript Class Files

To make full use of ActionScript 2, code needs to be authored in external ".as" files, called "class files". The ".as" suffix indicates to the flash compiler that the file contains a "class definition". Classes are the subject of Chapters 5, 6, and 7. This chapter explains the mechanics of creating .as files.

Both the Professional and Basic versions of Flash 8 include a full-featured ActionScript text editor that is used to create ActionScript class files. As discussed earlier, only the Professional version of MX 2004 includes the editor. Since .as files are really just text files, they can be created by any text editing program. Of course it is helpful to use one that knows about ActionScript syntax so it can color code the text and help format it. But these features aren't absolutely necessary. This chapter assumes that either Flash 8 or MX2004 Professional is available.

Using the Built-in ActionScript Editor

ActionScript files are created by using the *File->New...* command and then choosing "ActionScript File" from the "New Document" dialog that appears. This can be seen in Figure 4.1.

Figure 4.1 *The "New Document" dialog*

When a new ActionScript class file is created, the Script window appears in the workspace in place of the Timeline and Stage panels. In the title bar of the script Window is a "tab" that contains the title of the current script. There is also a tab for the FLA document. Switching between the FLA and the Script window is accomplished by clicking on the appropriate tab. This can be seen in Figure 4.2.

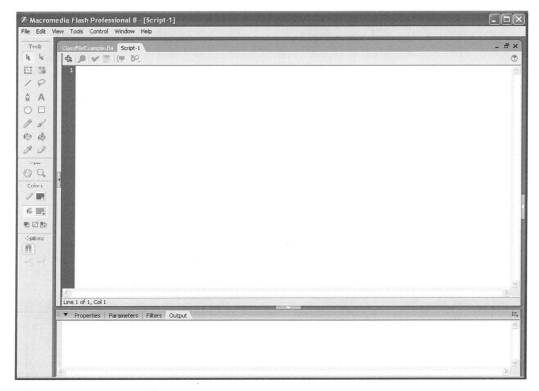

Figure 4.2 *A new script file*

ActionScript class files can be authored simultaneously with FLA files, and they can become associated with an FLA, but they are actually completely separate documents. Even when authored with a particular FLA in mind, ActionScript class files can be used by other FLAs. The FLA just needs to know where to look for the .as files that it needs.

ActionScript Settings: Version and Classpath

The list of file system locations that the FLA will look for a class file is called the "classpath". The classpath is a list of folders (directories) where required .as files can be found. The classpath is set in the "Publish Settings" dialog, which is accessed using *File->Publish Settings...*

The Publish Settings dialog is also where the version of ActionScript is set. Figure 4.3 shows the Flash tab of the Publish Settings dialog, in which the ActionScript version is set to ActionScript 2.0.

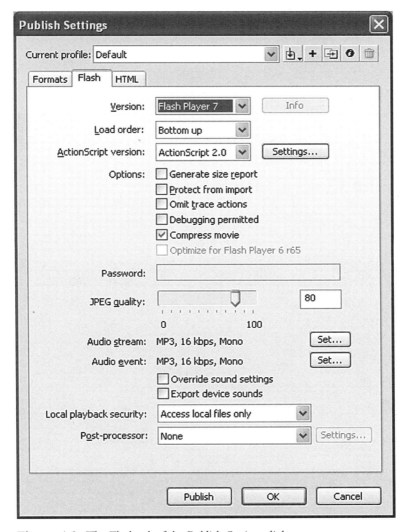

Figure 4.3 *The Flash tab of the Publish Settings dialog*

The classpath for the current FLA is set by clicking the "Settings..." button. This brings up the ActionScript 2.0 dialog. A location can be added to the classpath list by clicking the plus sign icon. This adds a text field to the list in which a path can be entered. To ensure that the examples in this book work properly, the classpath needs to point to the folder that contains all the examples.

Absolute and Relative Paths

If the folder structure of the Examples.zip file is preserved, then every example will live in a chapter-specific folder inside the main "Examples" folder. This main Examples folder may live

anywhere on the user's hard drive, so there is no way to know what the "absolute path" to this folder will be. But its "relative path" is one level up from the current example. To specify this in the classpath, the special ".." path is used. To Flash, ".." means one level up.

The Global Classpath

By default, all Flash documents also have the special path, ".", in their classpaths. The "." path refers to the current folder – the one that the active FLA lives in. It is automatically included because it is in the global classpath. The global classpath is set using *Edit->Preferences...*

Setting the FLA's Classpath

Figure 4.4 shows the appropriate classpath setting for this example, and the rest of the examples in this book. All of the example FLA files already have this classpath setting defined.

Figure 4.4 *The appropriate classpath setting for this example*

Putting code ActionScript Class Files

Getting the settings right is important, but the goal of creating class files is to put code in them. Coding an ActionScript file simply involves typing the appropriate text into the editor. Typing is easy. Knowing what to type is the hard part. That will be covered later. For now, an example class is provided: the SimpleSquare class that is discussed in Chapter 6. Figure 4.5 shows the Script window with the SimpleSquare code in it. The color coding provided by the ActionScript editor is a very helpful feature. Also, all of the standard script-writing tools are available: Syntax Checking, Code Hints, Debugger Breakpoints, etc.

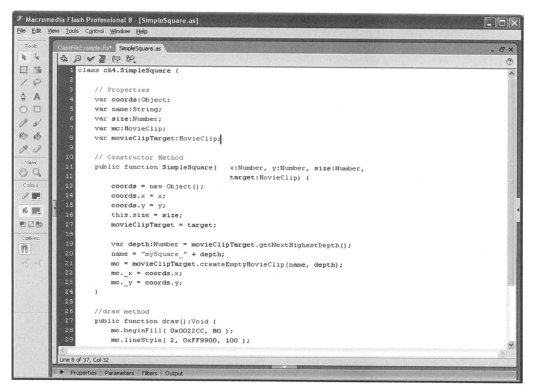

Figure 4.5 *The Script window with the SimpleSquare code in it*

The SimpleSquare code defines a class that can draw a simple, blue square. The full listing is shown in Listing 4.1.

Listing 4.1 *The SimpleSquare class*

```
class ch4.SimpleSquare {

  // Properties
  var coords:Object;
  var name:String;
  var size:Number;
  var mc:MovieClip;
  var movieClipTarget:MovieClip;

  // Constructor Method
  public function SimpleSquare(x:Number, y:Number,
                      size:Number, target:MovieClip) {
    coords = new Object();
    coords.x = x;
    coords.y = y;
```

```
    this.size = size;
    movieClipTarget = target;

    var depth:Number =
        movieClipTarget.getNextHighest Depth();
    name = "mySquare_" + depth;
    mc = movieClipTarget.createEmptyMovieClip name,depth);
    mc._x = coords.x;
    mc._y = coords.y;
}

//draw method
public function draw() :Void {
    mc.beginFill(0x0022CC, 80);
    mc.lineStyle(2, 0xFF9900, 100);
    mc.moveTo(0, 0);
    mc.lineTo(size, 0);
    mc.lineTo(size, size);
    mc.lineTo(0, size);
    mc.lineTo(0, 0);
    mc.endFill();
}
}
```

Importing Class Files using Dot Notation

In order for the class to be used by the FLA, it needs to be imported. Figure 4.6 shows the code in the FLA that imports and then uses the SimpleSquare class. This code lives in the FLA on the first frame of the Main Timeline, on the actions layer. The import statement refers to the SimpleSquare class as "ch4.SimpleSquare" because the class file lives in the "ch4" folder of the Examples. Import statements use "dot notation" to specify paths to class files.

The code from the FLA is shown in Listing 4.2.

Listing 4.2 *FLA code to import and use the SimpleSquare class*

```
import ch4.SimpleSquare;

var size = 20;

for (var i:Number = 0; i < 5; i++) {
    for (var j:Number = 0; j < 5; j++) {

        trace("Drawing square (" + i + ", " + j + ")");
        var x_coord = i * (size + 5);
        var y_coord = j * (size + 5);
```

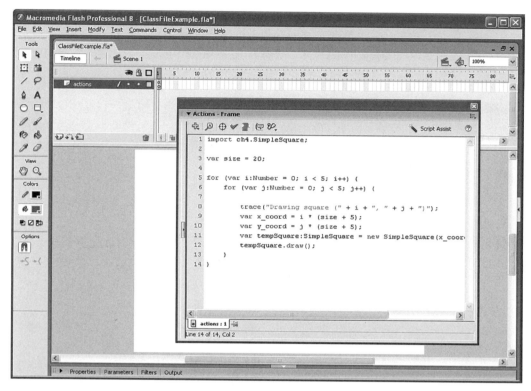

Figure 4.6 *The code in the FLA that imports and then uses the SimpleSquare class*

```
var tempSquare:SimpleSquare =
  new SimpleSquare(x_coord, y_coord, size, this);
tempSquare.draw();
    }
}
```

Analyzing the Code

If the classpath setting is correct, the import statement at the top of the LFA code will work, and Flash will successfully load the SimpleSquare class definition. Once this happens, the FLA can "instantiate" SimpleSquare objects. Each SimpleSquare instance (object) needs to know a few pieces of information that are passed to it as "parameters". These parameters are: *x_coord*, *y_coord*, *size*, and *this*. The "this" parameter is a reference to the Main Timeline so that SimpleSquare can create its MovieClip in the right place. Once it has the necessary information, a SimpleSquare instance can draw itself. In the above example, each new SimpleSquare instance is temporarily stored in a variable called, "tempSquare". Drawing a square is as simple as telling the tempSquare object to invoke its draw() method:

```
tempSquare.draw();
```

Testing the Code

When the FLA is tested (<CTRL><ENTER>) the FLA code creates 25 SimpleSquares with coordinates that arrange them in a 5 by 5 grid. The resulting SWF can be seen in Figure 4.7.

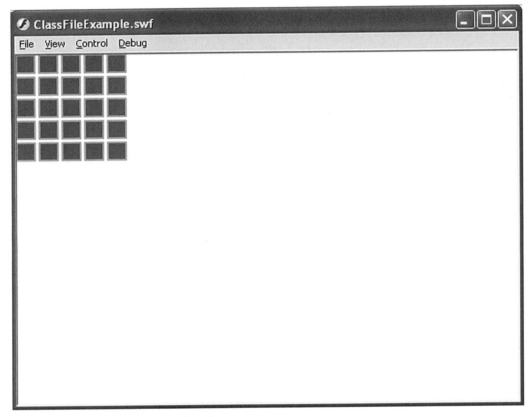

Figure 4.7 *The ClassFileExample.swf*

More to Come

The next few chapters explain how to create classes for a variety of objects. Once the mechanics of creating classes is understood, the real power of ActionScript 2 can be utilized.

ACTIONSCRIPT 2.0
FUNDAMENTALS

02

5 A Brief Overview of ActionScript 2 Programming

Scripting

Scripting is often thought of as a kind of programming where built-in features – such as MovieClips, timelines, and buttons – provide most of the application's functionality. For example, a Web site that uses Flash for navigation may make use of MovieClips, Buttons, Sounds, etc. This kind of functionality is provided by ActionScript and very little additional programming is required. On the other hand, a game created with Flash may require code for handling physics, collisions, special timing control, etc. Usually, some significant programming is required to accomplish this. Writing this code using ActionScript 1.0 is possible, but it can often be cumbersome and the code can easily get confusing and unmanageable. ActionScript 2.0 can help make complex applications much easier to manage. It can also allow code for one application to be easily used in another. This maximizes the value of the code. And it can make sharing code between programmers – a sort of Holy Grail of programming – a real possibility.

ActionScript 2.0, opens up a whole new world for Flash developers by providing some of the organization and structure found in professional programming languages like Java and C++. Many Flash developers will continue to use simple scripting techniques associated with ActionScript 1 (AS1). For those who need more, there is ActionScript 2 (AS2). Flash developers can take either approach, but for complex applications, AS2 can make life a lot easier. The key is to make use of AS2's programmer-friendly features and to think about programming the way a programmer does.

Programming

Creating simple ActionScript code for the Flash Player is similar to what a screenwriter does for an actor. A screenwriter's script does not attempt to teach the actor how to act, it simply calls on the actor to perform. To continue the analogy, a programmer might be thought of as an acting instructor, imparting new, foundational skills.

The Flash Player can do quite a bit with very little programming. For instance, the code in Listing 5.1 will tell the Flash Player to draw a 100 by 100 square at the top left of the screen. The code is from the oneSquare.fla file in the ch5 folder of the examples.

Listing 5.1 *From example oneSquare.fla*

```
var depth = _root.getNextHighestDepth();
var square = _root.createEmptyMovieClip("example", depth);

square.beginFill(0x0022CC,80);
```

```
square.lineStyle(2, 0xFF9900, 100);
square.moveTo(0, 0);
square.lineTo(100, 0);
square.lineTo(100, 100);
square.lineTo(0, 100);
square.lineTo(0, 0);
square.endFill();
```

The output of this code can be seen in Figure 5.1.

Figure 5.1 *oneSquare.swf*

Functions

One universal goal of programming is to avoid writing the same code more than once. If there is a need to use the same code many times, it can be encapsulated in a reusable form – such as a **function**. This is like teaching Flash a new skill. The code in Listing 5.2 (from the mySquare.fla file in the ch5 folder of the examples) defines a function that will tell the Flash Player how to draw a square of arbitrary size at an arbitrary place on the screen. The size and location are determined by **parameters** that are **passed** to the function when it is **executed**. In this case: x, y, and size:

Listing 5.2 *From example mySquare.fla*

```
function mySquare (x:Number, y:Number, size:Number):
  MovieClip {
```

```
var depth:Number = _root.getNextHighestDepth();
var square:MovieClip =
  _root.createEmptyMovieClip("example", depth);
square.beginFill(0x0022CC, 80);
square.lineStyle(2, 0xFF9900, 100);
square.moveTo(0, 0);
square.lineTo(size, 0);
square.lineTo(size, size);
square.lineTo(0, size);
square.lineTo(0, 0);
square.endFill();
square._x = x;
square._y = y;

return square;
}

var tempSquare:MovieClip = mySquare(100, 100, 50);
```

The output of this code can be seen in Figure 5.2.

Figure 5.2 *mySquare.swf*

The code to draw one square, can easily be used to draw many squares – with relatively little additional code. Listing 5.3 (from the mySquare5x5.fla file in the ch5 folder of the examples) demonstrates how to draw 25 squares in a 5 by 5 grid.

Listing 5.3 *From example mySquare5x5.fla*

```
var size = 20;

for (i=0; i<5; i++) {
  for (j=0; j<5; j++) {

    var x_coord = i * (size + 5);
    var y_coord = j * (size + 5);
    var tempSquare:MovieClip =
      mySquare(x_coord, y_coord, size);
  }
}
```

The output of this code can be seen in Figure 5.3

Figure 5.3 *5 × 5 Grid from mySquare5×5.swf*

Limitations of Functions

Functions are in important part of ActionScript 1.0. They are a powerful way to organize code. Generally a function is created to do just one thing. This keeps things simple – at first. But with anything, but the most trivial application, situations quickly arise where it is impossible to keep functions nice and simple. For the sake of discussion, an example might be an application that needs to draw different kinds of squares. To draw some squares with shadows, some with dotted borders, some filled, some empty, an ugly compromise will be necessary. Either one function will be used, with a whole bunch of parameters, or a number of slightly different functions will be defined, each duplicating some code from the others.

A Solution – Classes

There is a solution to this problem. Professional programmers use Classes to simplify their code. Classes are a core part of the Java and C++ programming languages, and they are a new feature of AS2. They are a natural evolution of functions.

Classes are called, "classes," because they define classes of **objects** that can do specific things. Anyone familiar with ActionScript is familiar with classes. Much of the built-in functionality of Flash exists in the form of classes like the MovieClip class or the Sound Class.

A class is a convenient way to encapsulate both the code and data required to perform a specific task. In a sense, it is a way to group-related elements. To see this, consider the built-in MovieClip class. It has a number of **properties** – which hold important data. And it has a number of **methods** – which contain code to do things. These include:

Some properties of the MovieClip object:

_x	the x coordinate of the MovieClip (on the stage)
_y	the y coordinate of the MovieClip (on the stage)
_visibile	whether or not the MovieClip is visible
. . .	

Some methods of the MovieClip object:

play()	tells the MovieClip to start playing
stop()	tells the MovieClip to stop playing
gotoAndPlay()	tells the MovieClip to start playing at a specified frame
. . .	

Methods do the work and properties keep track of the data that the methods need.

Objects

A class, like the MovieClip class, can be instantiated as many times as necessary. Most Flash projects have dozens if not hundreds of MovieClips. Each individual MovieClip is an **instance** of the MovieClip class, and it is referred to in general as an **object**. Any Flash project is – from a programming point of view – a collection of objects. Some of these objects are instances of

the MovieClip class. Some are instances of the Sound class. Many objects are instances of custom, specialized classes that have been created by the programmer to do things that are specific to the project.

In a very high-level, oversimplified sense, the job of the Flash Player is to:

1. Read the definitions of all required classes.
2. Instantiate objects based on these classes.
3. At each frame:

 give every object an opportunity to do what it needs to do.

For any space-debris-shooting game, the process might work something like:

1. Read the definitions of all required classes:
 Debris class
 Spaceship class
 Score class
 . . .
2. Instantiate objects based on these classes:
 Create a number of Debris objects
 Create one Spaceship object
 Create one Score object
 . . .
3. At each frame
 Let the Debris objects do what they need to do:
 Execute methods:
```
            rotate()
            move()
            check_for_collision_with_ship()
            determine_if_hit_by_laser()
            . . .
```
 Let the Spaceship object do what it needs to do:
 Execute methods:
```
            listen_for_keyboard_input()
            rotate()
            move()
            fire()
            . . .
```
 Let the Score object do what it needs to do:
 Execute methods:
```
            update_score()
            display_new_score()
            . . .
```

Object Oriented Programming

In the outline above, the program code is organized and there is a clear strategy for executing the code. This technique of using classes and objects is called **Object Oriented Programming,** or **OOP.** It is not only helpful for organizing code, it also makes it much easier to *think* about how a program is organized. Programming is a mental exercise. To be successful, a programmer needs to be able to imagine and anticipate how a program will run – before it is written. OOP makes it possible for even inexperienced programmers to devise and keep track of complicated programs.

6 Transitioning from AS1 Classes to AS2 Classes

Classes in ActionScript 1

In ActionScript 1, it was possible to define and use classes. The code was awkward but it worked well and allowed for a dramatic improvement in the organization of application code. For anyone who mastered ActionScript 1 classes, the transition to ActionScript 2 will be easy.

The SimpleSquareAS1 Class

Listing 6.1 shows a class definition – in ActionScript 1 style – for a class called SimpleSquareAS1. It is based on the mySquare() function from Chapter 5. The initial function definition – SimpleSquareAS1 – serves as the main class definition and the "constructor". It initializes the variables which will serve as the class's "properties". In Chapter 7, the anatomy of a class is discussed in detail and these terms are explained. For now, the important thing to note is that the constructor function does very little work. The actual drawing of the square happens in a function called:

```
SimpleSquareAS1.prototype.draw
```

This is where AS1 classes get awkward. The "prototype" property of the SimpleSquareAS1 function is a behind-the-scenes mechanism for associating other functions with the main SimpleSquareAS1 function. The "draw" property – attached to the prototype property – is a new function that acts as a "method" of the SimpleSquareAS1 class.

Listing 6.1 *An ActionScript 1 class definition*

```
// Constructor Method
function SimpleSquareAS1 (x:Number, y:Number, size:Number,
                                   target:MovieClip) {

  // Properties
  coords = new Object();
  coords.x = x;
  coords.y = y;
  this.size = size;
  movieClipTarget = target;

  var depth:Number = movieClipTarget.getNextHighestDepth();
  name = "mySquare_" + depth;
  mc = movieClipTarget.createEmptyMovieClip(name, depth);
```

```
    mc._x = coords.x;
    mc._y = coords.y;
}

//draw method
SimpleSquareAS1.prototype.draw = function() {
    trace("draw: " + mc);
    mc.beginFill(0x0022CC, 80);
    mc.lineStyle(2, 0xFF9900, 100);
    mc.moveTo(0, 0);
    mc.lineTo(size, 0);
    mc.lineTo(size, size);
    mc.lineTo(0, size);
    mc.lineTo(0, 0);
    mc.endFill();
}
```

The code for ActionScript 1 classes lives in the FLA, on a timeline frame. Figure 6.1 shows the SimpleSquareAS1 function/class definition on a frame of the Main Timeline.

Figure 6.1 *The SimpleSquareAS1 function/class definition on a frame of the Main Timeline*

The draw() method – attached to the SimpleSquareAS1 class via its prototype property (gasp!) – contains the code for drawing the square. Once the class is defined, its usage is much more similar to AS2 Listing 6.2 shows the code for invoking (using) the SimpleSquareAS1 class.

Listing 6.2 *Code to invoke the SimpleSquareAS1 class*

```
var size = 20;

for (i=0; i<5; i++) {
  for (j=0; j<5; j++) {
    trace("Drawing square (" + i + ", " + j + ")");
    var x_coord = i * (size + 5);
    var y_coord = j * (size + 5);
    var tempSquare =
      new SimpleSquareAS1(x_coord, y_coord, size, this);
    tempSquare.draw();
  }
}
```

The code in Listing 6.2 is the same basic loop as the one from Chapter 5 that creates a grid of squares. The only interesting line is:

```
var tempSquare = new SimpleSquareAS1(x_coord, y_coord, size,
                                     this);
```

In the above line, a new SimpleSquareAS1 "instance" is created and stored in the tempSquare variable. This instance is essentially a copy of the SimpleSquareAS1 function. It has all the variables that are defined in the main function and, more importantly, it has all of the method functions that are attached to the SimpleSquareAS1.prototype property. In this case, that includes the draw() method.

The draw() method of the SimpleSquareAS1 class instance – contained in the tempSquare variable – is invoked by referencing it like:

```
tempSquare.draw();
```

During every iteration of the loop, a new SimpleSquareAS1 is created and its draw() method is invoked. The result is a grid of squares, exactly like the grid created by the mySquare5x5.swf from Chapter 5. The code is really identical, but it is nicely organized. The SimpleSquareAS1.fla in the ch6 folder of the examples contains the full SimpleSquareAS1 example. Figure 6.2 shows the output of SimpleSquareAS1.swf.

ActionScript 2 Classes

As discussed, the code for ActionScript 1 classes lives in the FLA, on a timeline frame. The code for ActionScript 2 classes lives in external .as files. In anticipation of creating classes, it may be

Figure 6.2 *The output of SimpleSquareAS1.swf*

helpful to review the mechanics of how they will be used. Since AS2 classes are defined in external files, they are not automatically part of the FLA file that will use them. The FLA needs to be made aware of the names of the classes that it will use, and it needs to know the locations of the corresponding ".as" files. Finally, the FLA needs to be told to create object instances of the required classes and it needs to "instantiate" these objects.

Example: A Class for Drawing Squares

An ActionScript 2 version of the SimpleSquareAS1 class is available in the SimpleSquare.fla from the ch6 folder of the examples. The code can be seen in Listing 6.3.

Listing 6.3 *An ActionScript 2 version of the SimpleSquare class*

```
class ch6.SimpleSquare {

  // Properties
  var coords:Object;
```

```
var name:String;
var size:Number;
var mc:MovieClip;
var movieClipTarget:MovieClip;

// Constructor Method
public function SimpleSquare(x:Number,  y:Number,  size:
                                  Number, target:MovieClip) {
  coords = new Object();
  coords.x = x;
  coords.y = y;
  this.size = size;
  movieClipTarget = target;

  var depth:Number = movieClipTarget.
    getNextHighestDepth();
  name = "mySquare_" + depth;
  mc = movieClipTarget.createEmptyMovieClip(name, depth);
  mc._x = coords.x;
  mc._y = coords.y;
}

//draw method
public function draw() :Void {
  mc.beginFill(0x0022CC, 80);
  mc.lineStyle(2, 0xFF9900, 100);
  mc.moveTo(0, 0);
  mc.lineTo(size, 0);
  mc.lineTo(size, size);
  mc.lineTo(0, size);
  mc.lineTo(0, 0);
  mc.endFill();
  }
}
```

On one hand, the class looks a lot like the SimpleSquareAS1 class. In fact, the properties and methods are the same. On the other hand, there are number of extra elements which will be explained fully in the next chapter. The most important thing to note is that the properties (variables) and the methods (functions) are encapsulated in one unit, a class definition:

```
class ch6.SimpleSquare {
```

An AS2 class is one unit in one file. This is may take getting used to, but it actually makes it easier to manage and even think about application code.

Referencing Classes From Within an FLA

To use this class, it needs to be loaded and invoked from within an FLA. The timeline code from the SimpleSquare.fla example can be seen in Figure 6.3.

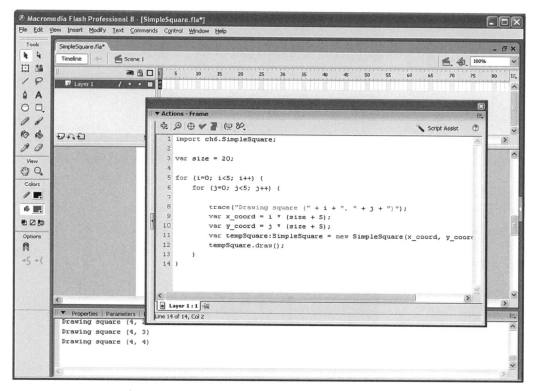

Figure 6.3 *The timeline code from the SimpleSquare.fla example*

Listing 6.4 shows the code from frame 1 of the Main Timeline. It imports the class and uses it to instantiate enough SimpleSquare objects to fill – surprise – a 5 × 5 grid.

Listing 6.4

```
import ch6.SimpleSquare;

var size = 20;

for (i=0; i<5; i++) {
  for (j=0; j<5; j++) {

    trace("Drawing square (" + i + ", " + j + ")");
    var x_coord = i * (size + 5);
    var y_coord = j * (size + 5);
```

```
    var tempSquare:SimpleSquare =
      new SimpleSquare(x_coord, y_coord, size, this);
    tempSquare.draw();
  }
}
```

Trying It Out

The SimpleSquare.fla can be tested using *Control->Test Movie* menu command, or by typing <CTRL>-<ENTER>. The result is shown in Figure 6.4.

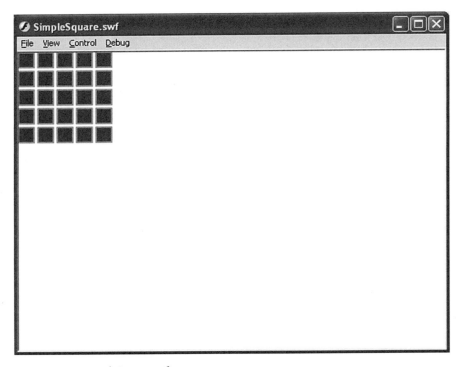

Figure 6.4 *SimpleSquare.swf*

An ActionScript Rosetta Stone

There are plenty of more interesting examples in later chapters, but the goal of Chapters 5 and 6 is to provide a kind of Rosetta Stone for ActionScript developers. Seeing the parallels between AS1 and AS2 should ease the transition to AS2 coding. And if the demand increases for grids of blue squares, readers of this book will be uniquely prepared.

In the next chapter, the anatomy of a class is examined in detail.

7 The Anatomy of a Class

The SimpleSquare class from Chapter 6 is a very simple example of a class, but it has all of the most important elements. Like all classes it exists in an external file, which in this case is called, "SimpleSquare.as". More importantly, it has the necessary structure that allows Flash to know what to do with it. Every class has at least the following elements:

- A class declaration.
- A number of property declarations.
- A constructor method declaration.
- A number of method declarations.

These elements can be seen in Listing 7.1.

Listing 7.1

```
class ch6.SimpleSquare {
  // Properties
  public var coords:Object;
  public var name:String;
  public var size:Number;
  public var mc:MovieClip;
  public var movieClipTarget:MovieClip;

  // Constructor Method
  public function SimpleSquare(x:Number,  y:Number,  size:
                              Number, target:MovieClip) {
    coords = new Object();
    coords.x = x;
    coords.y = y;
    this.size = size;
    movieClipTarget = target;

    var depth:Number =
      movieClipTarget.getNextHighestDepth();
    name = "mySquare_" + depth;
    mc = movieClipTarget.createEmptyMovieClip(name, depth);
    mc._x = coords.x;
    mc._y = coords.y;
  }
```

```
//draw method
public function draw():Void {
  mc.beginFill(0x0022CC, 80);
  mc.lineStyle(2, 0xFF9900, 100);
  mc.moveTo(0, 0);
  mc.lineTo(size, 0);
  mc.lineTo(size, size);
  mc.lineTo(0, size);
  mc.lineTo(0, 0);
  mc.endFill();
  }
}
```

Declarations

The first thing you will notice is the **class declaration**:

```
class ch6.SimpleSquare {
```

This line starts with the "class" keyword which is followed by the name of the class, "ch6.SimpleSquare". Notice that in this case the name includes the full path to this class. The "ch6." prefix reflects the fact that the class file lives in the "ch6" folder in the classpath. It is possible to have more than one "SimpleSquare" class in an application as long as the files live in different folders within the classpath. Specifying the full path in the class declaration eliminates any ambiguity.

Finally, the declaration has an open brace, "{", that is matched by a closed brace, "}", at the end of the class definition. The rest of the class is defined between this outer pair of braces.

Property Declarations

Following the class declaration is the list of declarations for properties used by the class. Properties hold the class's data:

```
// Properties
public var coords:Object;
public var name:String;
public var size:Number;
public var mc:MovieClip;
public var movieClipTarget:MovieClip;
```

These declarations describe properties that each instance of this class will need. The first line defines a property called, "coords", and it contains the following elements:

- `public`
- `var`
- `coords`
- `:`
- `Object`

The "public" keyword indicates that this property can be accessed by other classes. The alternative to public is private. The "private" keyword indicates that a property will be accessible only by methods defined in this class. A public property can be accessed from outside the class like:

squareInstance.coords.x = 100;

Outside of its own class, a private property cannot be accessed this way. In our example, the size property is private, so it would have to be accessed through one of its class's methods, like:

squareInstance.getSize()

OR

squareInstance.setSize(value)

Of course, for this to work, the getSize() and setSize() methods need to be defined. In our example they are not, so the size property is simply inaccessible outside of its own class. Methods to get and set private properties are generally referred to as "getters" and "setters".

If neither public nor private is specified, the property will be public by default.

The "var" keyword indicates that this is a property, rather than a method. The term, var, is short for variable, and it refers to the fact that the contents of this property can be changed by the class's methods.

The "coords" identifier is the name of the property being declared. An "identifier" is a name used to identify a user-defined element of a program, like a variable or a function.

The ":" following the identifier is used to assign this property, a data type. In AS1, data types are rarely used. When no type is specified, the Flash Player treats all properties as generic, all-purpose containers. This can be convenient for programmers – in the short term – but it creates problems down the line. In AS2, programmers are encouraged to explicitly declare the type of all class properties.

The "Object" keyword indicates that the data type of the coords property is: Object. The Object class defines a generic object type that has a wide range of uses. In this case, it is used to store the x and y coordinates of the SimpleSquare instances.

Property Types

Like JavaScript, AS1 makes use of general-purpose variables to store an application's data. In AS1 and JavaScript, it is not necessary to declare the type of a variable. The type is determined implicitly by how the variable is used. The advantage is that the programmer can be a little more casual when writing code. If a function which is expecting a Number is passed a String, it will first try to convert the string into a number, and if it cannot, it will use the value, 0. In this way, the function won't fail and generate an error, but it won't necessarily do the right thing. Of course, there is no way for Flash to know if the function got the wrong data, because AS1 functions can accept any data.

With AS2, types should (and often must) be declared explicitly and this has two important consequences:

1. Programmers must determine appropriate data types ahead of time.
2. Based on the type declarations, the Flash compiler can check whether the parameters that are passed to class methods are the appropriate type. If not, the compiler can generate errors and programmer can fix them before the code is deployed.

The first consequence means that programmers have to do a little more up-front planning, and this means more work. The second consequence means that the compiler can detect many more bugs, and this means significantly less work in the long run.

Within class definitions (.as files) all variables (properties) should have their types specified explicitly. When code is attached to frames on a timeline (within an .fla file), AS1 conventions are allowed and variables can be untyped. But this should be avoided.

Method Declarations

The next section in the class file is the method declarations, and the most important method is the "constructor". The constructor is the method that has the same name as the class. It is referred to as the constructor because it is automatically called whenever the class is instantiated, and it is used to initialize the class instances.

```
// Constructor Method
public function SimpleSquare(x:Number, y:Number, size:Number,
                            target:MovieClip) {
  coords = new Object();
  coords.x = x;
  coords.y = y;
  this.size = size;
  movieClipTarget = target;

  var depth:Number = movieClipTarget.getNextHighestDepth();
  name = "mySquare_" + depth;
  mc = movieClipTarget.createEmptyMovieClip(name, depth);
  mc._x = coords.x;
  mc._y = coords.y;
}
```

The first line of the constructor method contains the following elements:

```
public
function
SimpleSquare
(x:Number, y:Number, size:Number, target:MovieClip)
{
```

The public keyword indicates that this method can be referenced and called by other classes. As with properties, a method can also be declared *private* in which case it can only be called by other

methods in the class. A constructor method is, by definition, public, so the public identifier is not necessary in this case. But it won't hurt and may be a helpful reminder. If neither public nor private is specified, the method will be public by default.

The function keyword indicates that this is a block of code that can be called and that it will accept parameters as specified in the parameter list. In general, a function will also return a value of a specific type, but constructor methods cannot return values. The *function* identifier is a little bit redundant. It is not required by Java or C++. It is a holdover from AS1 and may eventually go away.

The SimpleSquare identifier is the name of the method. As this is the constructor method, its name is the same as the class's name.

Following the identifier is the parameter list: (x:Number, y:Number, size:Number) This list indicates that this method can accept three parameters, all of which must be of the data type, Number.

The open brace – after the parameter list – is matched by a closed brace at the end of the function, and between them is the "definition" of the method.

The draw() method has the same structure:

```
//draw method
public function draw():Void {
  mc.beginFill(0x0022CC, 80);
  mc.lineStyle(2, 0xFF9900, 100);
  mc.moveTo(0, 0);
  mc.lineTo(size, 0);
  mc.lineTo(size, size);
  mc.lineTo(0, size);
  mc.lineTo(0, 0);
  mc.endFill();
}
```

The function declaration looks about the same, with two exceptions:

```
public function draw():Void {
```

1. The parameter list is empty, meaning that this method does not expect to have any parameters passed to it.
2. The method, itself, has a data type declaration, *Void*. Void is a special type that means the method will return no value. Functions that return values need to declare the type of the returned value, which can be any supported type: Number, String, Array, etc.

Classes as Types

When a class is defined, it becomes a valid type for properties and variables. A class defines a type of object, and instances of the class can be assigned to properties and variables that have the appropriate type. Having defined the SimpleSquare class, it can be used as a type:

```
var tempSquare:SimpleSquare;
```

75

Static Properties and Methods

Sometimes it makes sense to declare a class member (a property or a method) "static". The static keyword indicates that the property or method is owned by the class and not the instances of the class. For this reason static members are also referred to as "class members". A "class property" is a static property. A "class method" is a static method. Static members are shared by all instances of a class. If a class has no instances, the static members of the class can still be accessed and used. Defining a class with only static properties and methods is one way to provide functionality that can be accessed globally. It is also a handy way to group related functions together. ActionScript's built-in Math class works like this. It cannot have instances. Instead, its properties and methods are accessed statically, like:

```
var randomNumber:Number = Math.random() * 10;
var twoPI:Number = Math.PI * 2;
```

The GameDepthManager Class

Listing 7.2 shows a class called, GameDepthManager, which makes use of both static properties and static methods. In fact, all of its members are static. The GameDepthManager class generates depths for the dynamically created MovieClips in an application. In the SimpleSquare.fla from Chapter 6, the SimpleSquare class is used to dynamically create MovieClips that look like squares. Each one needs a unique depth, which is currently supplied to the SimpleSquare class by a call to getNextHighestDepth():

```
var depth:Number = movieClipTarget.getNextHighestDepth();
```

This is fine for a simple example. But in a complex application, many MovieClips will be generated and some may need specific depth values in order to be layered correctly. The GameDepthManager class addresses this by providing appropriate depth values depending on the type of MovieClip being created.

Listing 7.2

```
class ch7.GameDepthManager{

  static var MIN_OBJECT_DEPTH:Number = 10;
  static var MAX_OBJECT_DEPTH:Number = 399;
  static var SHIP_DEPTH:Number = 450;
  static var HUD_DEPTH:Number = 500;
  static var MIN_AUDIO_CLIP_DEPTH:Number = 1000;
  static var MAX_AUDIO_CLIP_DEPTH:Number = 1200;

  static var nextObjectDepth:Number = MIN_OBJECT_DEPTH;
  static var nextAudioClipDepth:Number =
    MIN_AUDIO_CLIP_DEPTH;
```

```
  public static function getNextAudioClipDepth():Number {
    // recycle depths
    if (nextAudioClipDepth >= MAX_AUDIO_CLIP_DEPTH)
      nextAudioClipDepth = MIN_AUDIO_CLIP_DEPTH;
    return nextAudioClipDepth++;
  }

  public static function getNextObjectDepth():Number {
    // recycle depths
    if (nextObjectDepth >= MAX_OBJECT_DEPTH)
      nextObjectDepth = MIN_OBJECT_DEPTH;
    return nextObjectDepth++;
  }
}
```

This GameDepthManager class is designed to work with a game application, so it knows about game objects, ships, huds (heads–up displays), etc. When a depth is needed for a general game object, the getNextObjectDepth() method is used. When the appropriate depth for the game's space ship is needed, the SHIP_DEPTH property is used. Note that the properties and methods are all public (not private) so they can be accessed directly from other classes.

Static Members and Memory

The Flash Player will allocate memory for each non-static member each time the class is instantiated. Each instance of the class will have its own copy of the member. However, when the static keyword is used, the Flash Player allocates memory for this member only once and each instance of the class contains a reference to this one member. One important result is that if one instance of the class changes a static property, it will be changed for all instances. Static properties are useful when all class instances need to share some common data, and using static properties is one way to provide for some communication between class instances. It can also be a good way to reduce the amount of memory that is used by instances of a class.

Using Static Members

To access a static class member, the member is referenced through the class name itself instead of a through class instance. For example, to access the SHIP_DEPTH property of the GameDepth-Manager class, the following syntax is used:

```
var shipDepth:Number = GameDepthManager.SHIP_DEPTH;
```

Static methods are also referenced through the class name:

```
var objectDepth:Number =
  GameDepthManager.getNextObjectDepth();
```

An example of the SimpleSquare class, modified to use the GameDepthManager class, can be seen in the SimpleSquare2.fla in the ch7 folder of the examples.

The full SimpleSquare2 class is shown in Listing 7.3.

Listing 7.3

```
import ch7.GameDepthManager;

class ch7.SimpleSquare2 {
  // Properties
  public var coords:Object;
  public var name:String;
  public var size:Number;
  public var mc:MovieClip;
  public var movieClipTarget:MovieClip;

  // Constructor Method
  public function SimpleSquare2(x:Number, y:Number,size:
                               Number, target:MovieClip) {

    coords = new Object();
    coords.x = x;
    coords.y = y;
    this.size = size;
    movieClipTarget = target;

    var depth:Number =
      GameDepthManager.getNextObjectDepth();
    name = "mySquare_" + depth;
    mc = movieClipTarget.createEmptyMovieClip(name, depth);
    mc._x = coords.x;
    mc._y = coords.y;
  }
  // draw method
  public function draw():Void {
    mc.beginFill(0x0022CC, 80);
    mc.lineStyle(2, 0xFF9900, 100);
    mc.moveTo(0, 0);
    mc.lineTo(size, 0);
    mc.lineTo(size, size);
    mc.lineTo(0, size);
    mc.lineTo(0, 0);
    mc.endFill();
  }
}
```

8 The Building Blocks of Code

Variables, Operators, Statements, and Functions

Classes and Object Oriented Programming techniques are important, powerful, helpful, modern, etc. But the essential building blocks of code haven't changed since the dawn of computing – when vacuum tubes were new.

To make any kind of program work, several things are required:

- Memory to store data: Variables.
- The ability to manipulate data: Operators.
- Control over the order of operation: Statements.
- A way to make code modular: Functions.

It may be helpful to know that all computer languages are the same – essentially. The most powerful chips (CPUs) in use today all do pretty much the same things. And today's chips are pretty much the same as yesterdays. They are just faster and have fewer resource limitations. Likewise, programs are bigger and more "feature-rich" but they operate in the same way as the first Eniac programs:

- Get some data
- Manipulate the data
- Make some decisions about the data
- Store the data
- Get some more data
- …

It should come as no surprise, then, that the essential building blocks of AS2 code are the same as they were for AS1.

Variables

Programs retrieve, manipulate, and store data in memory. At the hardware level, this memory exists as microscopic transistor networks. In ActionScript, memory exists in the form of variables. A variable is a container that stores a piece of data. The location of the container doesn't change, but the contents can. To access memory on a memory chip, the memory address must be known. Early programmers had to work with these memory addresses directly. Modern languages like ActionScript takes care of this behind the scenes and allow programmers to use easy-to-remember "identifiers" to reference memory. The term "variable" refers to the identifier that ActionScript

uses to reference a chunk of memory. Take for example:

```
var myVariable:Number = 10;
```

This line communicates the following to the ActionScript compiler:

- The "var" keyword tells the compiler to set aside some memory.
- The memory will be referenced by the identifier, "myVariable".
- The type of data referenced by myVariable will be a Number.
- The initial value of this Number will be 10.

Types

There are many valid data types for ActionScript variables. These include:

- Number
- String (text)
- Boolean (true or false)
- Object
- MovieClip
- etc.

Some data types use very little memory, like Booleans. Technically a Boolean can be represented with one bit of memory. MovieClips, on the other hand, can use many thousands of bytes. Today's computers tend to have a lot of memory, so programmers can often ignore the amount of actual storage required by different data types. But if an application is intended to run on an older machine or a handheld device, it may be necessary to pay closer attention.

Identifiers

Choosing good names – identifiers – for variables is important. Good names can make code easy to read and maintain. Cryptic, inconsistent names can cause confusion when someone other than the author tries to read the code. It can even be confusing for the original author. In the early days of programming, memory was so limited that programmers tried to use the shortest names possible to save space. There were lots of programs full of variables named "a", "b", "c", "x", "y", "i", "j", "k", "m1", "z4", etc. But ActionScript identifiers can be as long as necessary to make things readable. Making variable names too long can defeat the purpose, but in general it is better to err on the side of longer, more descriptive names.

There are some rules about ActionScript identifiers that apply to variable names as well as to function names, class names, etc.

- Identifiers must start with a letter, underscore, or dollar sign.
- Identifiers cannot start with a number.
- Identifiers cannot be identical to reserved words.
- Identifiers should only be letters A–Z, a–z, numbers, spaces, underscores and dollar signs.
- When exported for the Flash Players 7 and 8, Identifiers are case sensitive. Flash Players 6 and earlier are not case sensitive.

By convention, variable names start with a lowercase letter and class names start with an upper-case letter. Also by convention, variables that are intended to remain constant (the value won't change) use all uppercase letters with underscores between words. A "constant variable" sounds like an oxymoron, but unlike other languages, ActionScript doesn't have a mechanism for ensuring that the value referenced by an identifier doesn't change once it is set. Instead, programmers agree that when an identifier uses all caps and underscores, the value should be constant.

Some legal variable names and declarations include:

```
var mystring:String = "http://www.sprite.net";
var mynumber:Number = 123;
var q1_question:String = "What is a variable?";
var q1_answer:String = "A contains that stores information";
var result:Number = mynumber + 123;
var done:Boolean = false;
```

And even:

```
var SuperCaliFragilisticExpialiDocious:String = "Precocious";
```

Assignment vs. Comparison

The single equals (=) operator is used to assign a value to a variable, while the double equals (==) is used to compare two values to determine whether they are equal. These two operators can be easily confused so be careful.

Reserved Words

Reserved words are words that are set aside for use by ActionScript, itself. These words cannot be used as user-defined identifiers because they already mean something to the compiler. Table 8.1

Table 8.1 *Reserved words in ActionScript*

add	ge	onClipEvent
and	get	or
break	gt	private
case	if	public
catch	ifFrameLoaded	return
class	implements	set
continue	import	static
default	in	switch
delete	instanceof	tellTarget
do	interface	this
dynamic	intrinsic	throw
else	le	try
eq	lt	typeof
extends	ne	var
finally	new	void
for	not	while
function	on	with

Table 8.2 *Reserved for future use by ActionScript*

abstract	export	synchronized
byte	float	throws
char	goto	transient
debugger	long	volatile
double	protected	
enum	short	

shows the reserved words in ActionScript. Table 8.2 contains a list of words that are reserved for future use by ActionScript.

Built-in Class Names

In addition to reserved words, ActionScript provides built-in, pre-defined classes that have the names listed in Table 8.3. In many cases it is legal to define a new class with the same name as a built-in class, but this could make it impossible to reference the built-in class. It can also be very confusing. It is best to avoid using the names in Table 8.3 for user-defined classes, variables, functions, etc.

Code Hints

In AS1, the "var" keyword and the data type were unnecessary. In most cases, AS2 requires them so it is best to always use them. Because the type of an AS2 variable is usually known, the authoring tool can often provide helpful "hints" about how a variable can be used. For instance, the String data type has a number of properties and methods. It may take a while to memorize all of these, especially at first. As explained in Chapter 1, the authoring tool can provide real-time hints. For example, given a variable declared as a String:

```
var text:String = "Helpful";
```

Typing "text." (the word "text" followed immediately by the period) will invoke the hint popup which will display all the properties and methods available for that data type.

Declarations

The code to create a variable or a function is called a declaration. When a variable is first declared, it is empty and is said to be undefined.

```
var name;
var age;
var y;
```

When they are first declared, variables have the special value "undefined", which is effectively no value at all.

Table 8.3 *Reserved words in ActionScript*

Accessibility	EndPoint	RDBMSResolver
Accordion	Error	Screen
Alert	FocusManager	ScrollPane
Array	Form	Selection
Binding	Function	SharedObject
Boolean	Iterator	Slide
Button	Key	SOAPCall
Camera	Label	Sound
CellRenderer	List	Stage
CheckBox	Loader	String
Collection	LoadVars	StyleManager
Color	LocalConnection	System
ComboBox	Log	TextArea
ComponentMixins	Math	TextField
ContextMenu	Media	TextFormat
ContextMenuItem	Menu	TextInput
CustomActions	MenuBar	TextSnapshot
CustomFormatter	Microphone	TransferObject
CustomValidator	Mouse	Tree
DataGrid	MovieClip	TreeDataProvider
DataHolder	MovieClipLoader	TypedValue
DataProvider	NetConnection	UIComponent
DataSet	NetStream	UIEventDispatcher
DataType	Number	UIObject
Date	NumericStepper	Video
DateChooser	Object	WebService
DateField	PendingCall	WebServiceConnector
Delta	PopUpManager	Window
DeltaItem	PrintJob	XML
DeltaPacket	ProgressBar	XMLConnector
DepthManager	RadioButton	XUpdateResolver

Assigning Values

As noted above, assigning values to variables is accomplished using the assignment operator "=". Not "==", which is a comparison operator. Values can be assigned to variables over and over again without any ill effects. Variables won't wear out.

Scope

The "scope" of a variable is the extent to which it can be referenced or "seen" by code.

When a variable is declared in a script attached to the Main Timeline of a Flash movie, it can be referenced by any other scripts on the Main Timeline. However, if a variable is declared in a script on the timeline of a MovieClip, that variable can only be referenced by other scripts on the time-line of that MovieClip. When declared on a timeline, the scope of a variable is that timeline only.

In the case of timelines, if the timeline, itself, can be referenced, then any variables declared on it can be indirectly referenced through that timeline. For example, consider a MovieClip with the following code on its first frame:

```
var greeting:String = "Hello!";
```

If this MovieClip is dragged to the stage on the Main Timeline and given the instance name, "greeting_clip", then its variables can be accessed from the Main Timeline like:

```
trace("Greeting = " + greeting_clip.greeting);
```

The result will be:

```
Greeting: Hello!
```

In the reference, "greeting_clip.greeting" the period (dot) indicates to the compiler that the greeting variable should be referenced through greeting_clip. "Dot Notation" is used to reference the properties of objects.

Variables that are defined inside functions have limited scope. Consider the following function, also defined on the first frame of the greeting_clip MovieClip:

```
var greeting:String = "Hello!";

testFunction = function () {

  var salutation:String = "goodbye";
}
```

The "salutation" variable is defined inside the function, so it cannot be referenced from the Main Timeline:

```
trace("Greeting = " + greeting_clip.salutation);
```

Will produce this output:

```
Greeting: undefined
```

The scope of the salutation variable is limited to the code inside the testFunction definition.

Referencing the Main Timeline Using _root

ActionScript provides a handy reference to the Main Timeline that can be used from any other timeline. Using "_root", any variable or object defined on the Main Timeline can be referenced. To demonstrate this, the code on the greeting_clip example MovieClip's timeline can be modified to look like:

```
this.greeting = "Hello!";

testFunction = function () {
```

```
    var salutation:String = "goodbye";
    trace("Subject: " + _root.subject);
}
```

And the code on the Main Timeline can be modified to look like:

```
var subject:String = "Brick Oven";

trace("Greeting = " + greeting_clip.greeting);
trace("Salutation = " + greeting_clip.salutation);

greeting_clip.testFunction();
```

Running this clip produces the following output:

```
Greeting = Hello!
Salutation = undefined
Subject: Brick Oven
```

The "subject" variable on the Main Timeline is successfully accessed from within testFunction() by using the _root reference.

The above examples can be seen in Scope.fla in the ch08 folder of the examples.

The Scope Chain

In general, a variable cannot have the same name as another variable. More specifically, a variable cannot have the same name as another variable that has the same scope. Actually, AS1 will allow multiple variable declarations for the same identifier, but the later declaration will "mask" or hide the earlier. Within an action frame (on a timeline) code like this is allowed:

```
var myVariable:String = "Apple";
var myVariable:String = "Orange";
```

But the first declaration will be overridden by the next, so any reference to myVariable will return, "Orange".

Within a class file, multiple declarations are not even allowed. The above example will generate the error: "The same member name may not be repeated more than once."

Variables can have the same name if they have different scope, as in this example:

```
var greeting:String = "Hello!";
testFunction2 = function () {

  var salutation:String = "goodbye";
  var greeting:String = "Good Day!";

  trace("Subject: " + _root.subject);
  trace("Greeting: " + greeting + "\n");
}
```

The variable, "greeting", is declared outside testFunction2 and also inside testFunction2. This is legal, but it makes it impossible for the code inside testFunction2 to see the greeting variable that is declared on the timeline. As far as testFunction2 is concerned, the value of the greeting variable is: "Good Day!". Outside the function the value is "Hello!". To minimize confusion, it is probably best to avoid using duplicate variable names. Since the greeting variable inside testFunction2 only exists while the function is being executed, it might make sense to name it "tempGreeting", or something similar that indicates its temporary nature.

A full discussion of scope is … beyond the scope of this book. But it is well documented in the online documentation that comes with Flash.

Operators

An operator is a symbol or keyword that is used for manipulating data. Familiar operators include "+", "−", "*", and "/" for addition, subtraction, multiplication, and division, respectively. To add two values, the + operator is used;

```
var sum:Number;
sum = 2 + 4;
```

Or:

```
var name:String;
name = "Charles" + " " + "Babbage";
```

Or even:

```
var name:String;
name = "Mach" + " " + 5;
```

The values upon which an operator operates are called "operands".

ActionScript knows how to apply its operators to operands of various data types, so it is possible to add two Strings. The result is a concatenation of the String operands. In the last example, the + operator is used to add a String to a Number. To do this, the Number is first converted to a String and then the Strings are concatenated.

Operators can be used with literal data (as above) or with variables:

```
var:total:Number;
var:price:Number = 15;
var:quantity:Number = 10;

total = price * quantity;
trace(total);
```

The output, showing the value of "total" is:

```
150
```

Operands can be literal values, variables, or even expressions. For example:

```
averageHighScore = (playerOneScore + playerTwoScore) /
                    numberOfPlayers;
```

The expression in parentheses (playerOneScore + playerTwoScore), is evaluated first and then it is divided by numberOfPlayers. The order in which operands are operated upon is determined by the operators' precedence.

Operator Precedence

Some operators take precedence over others. ActionScript uses a strict set of rules to decide which operations to perform first. For example, multiplication is always performed before addition; however, expressions in parentheses take precedence over simple multiplication. So, without parentheses, ActionScript performs the multiplication in the following example first:

```
total = 4 + 5 * 3; // total = 19 = 4 + 15
```

This expression is evaluated as 4 + (5 * 3) because the multiplication (*) has higher precedence than the addition (+). But if parentheses are used, the addition can be made to happen first:

```
total = (4 + 5) * 3; // total = 27 = (9) * 3;
```

The result is 27.

Parentheses are a special kind of operator called the "grouping operator". Elements inside parentheses are evaluated together as one operand, using the rules of precedence.

Operator Associativity

The order in which an operator evaluates its operands is called its "Associativity". Associativity is either "left to right" or "right to left". The + (addition) operator has left to right associativity. Its operands are evaluated left to right. In the expression:

```
a = (b * c) + (c * d)
```

First (b * c) is evaluated, then (c * d) evaluated, and then the addition is performed. The = (assignment) operator, has right to left associativity. In the same expression:

```
a = (b * c) + (c * d)
```

First, the right-hand side of the expression is evaluated, (b * c) + (c * d), and then it is assigned to the left-hand side, a.

There are many operators, so keeping track of precedence and associativity requires a reference table.

Operator List

Table 8.4 lists all of the ActionScript operators and their associativity, from highest to lowest precedence.

Table 8.4 *ActionScript operators and their associativity*

Operator	Description	Associativity
(*Highest precedence*)		
x++	Post-increment	Left to right
x−−	Post-decrement	Left to right
.	Object property access	Left to right
[]	Array element	Left to right
()	Parentheses	Left to right
function()	Function call	Left to right
++x	Pre-increment	Right to left
−−x	Pre-decrement	Right to left
−	Unary negation, such as x = −1	Left to right
~	Bitwise NOT	Right to left
!	Logical NOT	Right to left
new	Allocate object	Right to left
delete	Deallocate object	Right to left
typeof	Type of object	Right to left
void	Returns undefined value	Right to left
★	Multiply	Left to right
/	Divide	Left to right
%	Modulo	Left to right
+	Unary plus	Right to left
−	Unary minus	Right to left
<<	Bitwise left shift	Left to right
>>	Bitwise right shift	Left to right
>>>	Bitwise right shift (unsigned)	Left to right
instanceof	Instance of	Left to right
<	Less than	Left to right
<=	Less than or equal to	Left to right
>	Greater than	Left to right
>=	Greater than or equal to	Left to right
==	Equal	Left to right
!=	Not equal	Left to right
&	Bitwise AND	Left to right
^	Bitwise XOR	Left to right
\|	Bitwise OR	Left to right
&&	Logical AND	Left to right
\|\|	Logical OR	Left to right
?:	Conditional	Right to left
=	Assignment	Right to left
★=, /=, %=, +=, −=, &=, \|=	Compound assignment	Right to left
^=, <<=, >>=, >>>=	Compound assignment	Right to left
,	Comma (Multiple evaluation)	Left to right
(*Lowest precedence*)		

Incremental Operators

Programmers are always on the lookout for shortcuts, especially when it comes to writing code. There are several handy shorthand notations for operators that are used often. For instance, it is very common for a variable to be incremented by one unit. This happens when counting loops, events, scores, etc. Incrementing a value by one unit can be written:

```
counter = counter + 1;
```

But there is a shorthand way which can save time, increase readability, and minimize typos. The equivalent expression, written using the "postfix increment" operator is:

```
counter++;
```

This is the postfix operator because it follows the variable being incremented. The prefix increment operator looks like:

```
++counter;
```

Both operators increment the counter variable, but the postfix operator does it after the variable is evaluated, and the prefix operator does it before the variable is evaluated. Consider this code using the postfix increment operator:

```
var:visitorCount = 0;

trace("You are visitor number: " + visitorCount++);
```

The above code will output:

```
You are visitor number: 0
```

And then the counter variable will be incremented to 1. But if the prefix increment operator is used:

```
trace("You are visitor number: " + ++visitorCount);
```

The output will be:

```
You are visitor number: 1
```

The end result is the same. The counter variable is set to 1. But in the postfix example, the variable isn't set until after it is used. Which to use – prefix or postfix – depends on the requirements of the code. In this case, the prefix version probably makes more sense: "For each new visitor, increment the counter and then display the value."

The pre-decrement and post-decrement operators work the same way:

```
var remainingLives:Number = 10;

trace(msg = "You have " + --remainingLives + " lives left.");
```

The output generated by the above lines looks like:

```
You have 9 lives left.
```

Comparison Operators

Comparison operators compare the values of expressions and return a Boolean value (true or false). Testing for equality is accomplished using the "==" equality operator. (Again: This should not be confused with the "=" assignment operator. Confusing the two will cause problems.) The following expression tests the equality of two Strings:

```
var areEqual:Boolean;

areEqual = "Planet Mars" == "planet mars"; // false

areEqual = "Planet Mars" == "Planet Mars"; // true
```

The != (not equal) operator can determine if two values are not equal:

```
var areNotEqual:Boolean;

areNotEqual = "Planet Mars" != "planet mars"; // true
```

Comparisons can also be made regarding the relative value of operands. The following expression determines if one number is bigger than another:

```
var isBigger:Boolean;

isBigger = 10 > 100; // evaluates to false;

isBigger = 100 > 10; // evaluates to true;
```

Table 8.5 lists the ActionScript comparison operators.

Table 8.5 *ActionScript comparison operators*

Operator	Operation performed
<	Less than
>	Greater than
<=	Less than or equal
>=	Greater than or equal
==	Equal
!=	Not Equal
===	Strict Equality

Comparing Strings

The comparison operators >, >=, <, and <= also have a special effect when operating on Strings. These operators compare two Strings to determine which is first in alphabetical order. If both operands are Strings, they are compared based on their order in the Unicode character set.

In this comparison, "a" comes before, "b", which comes before "c", etc. If only one of the operands is a String, ActionScript converts both operands to numbers and performs a numeric comparison. For example:

```
var stringIsGreater:Boolean;

stringIsGreater = "a" > "z"; // evaluates to false

stringIsGreater = "z" > "a"; // evaluates to true
```

The Strict Equality Operator

The strict equality operator (===) is similar to the equality operator, except that it does not perform type conversion. If two operands are different types, the strict equality operator returns false. For example:

```
trace(10 == "10");
trace(10 === "10");
```

The output of these two lines is:

```
true
false
```

The regular equality operator converts the String "10" to the Number 10 and then compares it to the Number 10, returning true. The strict equality operator will not convert the String "10" to a Number, so it returns false.

Logical Operators

Logical operators compare Boolean (true and false) values and return a Boolean value. Logic is what computers do best. In fact, just about everything that a computer can do is the result of logical comparisons. Even adding two numbers is accomplished by comparing each binary bit of the two numbers. Amazingly, computer logic can be reduced to three operators: (&&) AND, (||) OR, and (!) NOT. AND and OR each take two operands and return a Boolean value. AND returns true if both operands are true. OR returns true if at least one of the operands is true. Here are some examples:

```
var result:Boolean;

result = true && true; // true AND true evaluates to true

result = true && false; // true AND false evaluates to false

result = true || true; // true OR true evaluates to true

result = true || false; // true OR false evaluates to true

result = (9 > 3) && ("Bert" == "Ernie"); // evaluates to false

result = (9 > 3) || ("Bert" == "Ernie"); // evaluates to true
```

The NOT (!) operator takes one operand and returns a Boolean value:

```
result = !(true); // evaluates to false

result = !(9 > 3); // evaluates to false

result = !("Bert" == "Ernie"); // evaluates to true
```

Note: Because it takes only one operator, the ! operator is referred to as a "unary" operator. Table 8.6 lists the ActionScript logical operators.

Table 8.6 *ActionScript logical operators*

Operator	Operation performed
&&	Logical AND
\|\|	Logical OR
!	Logical NOT

Binary Numbers and Bitwise Operators

Bitwise operators test and manipulate the actual bits that make up the Numbers. They are not especially useful for most applications. Manipulating bits was important in the days when memory was scarce. ActionScript stores numbers in memory as 32-bit, binary numbers. Binary numbers are sequences of zeros and ones. As a brief refresher, the numbers 1 to 10, represented in binary notation, look like:

```
 1  =      1
 2  =     10
 3  =     11
 4  =    100
 5  =    101
 6  =    110
 7  =    111
 8  =   1000
 9  =   1001
10  =   1010
```

If this is unfamiliar, it can be ignored. Binary numbers can, for the most part, be ignored. But just in case this is interesting… Each digit in a binary number is called a bit. It can be either a 0 or a 1. There are only two symbols in the binary number system, and consequently it is referred to as a base-2 number system. In the binary number system, the number 1 can be represented by 1 binary bit: "1". The numbers 2 and 3 require two binary bits each: 10 and 11. The numbers 8, 9, and 10 require four binary bits each. Binary numbers are used by computers because keeping track of two symbols – 0 and 1 – is much less complicated that keeping track of 10 symbols – 0, 1, 2, 3, 4, 5, 6, 7, 8, 9.

Actually, the first computers did use a base-10 numbers system, but the logic circuitry was so complicated that it became impractical. Binary logic circuitry is as simple as it gets. The only drawback

is that people don't regularly use binary numbers, so they can take some getting used to. The other tradeoff is that binary numbers use more digits than base-10 numbers. But the added circuitry for a few more digits is still easier to manage than base-10 circuitry for fewer digits.

Modern (current) computers typically store each individual number as 32 binary bits. So, the number 1 looks to the computer like:

00000000 00000000 00000000 00000001

The number 2 looks like:

00000000 00000000 00000000 00000010

Note: The spaces in the above binary number are analogous to commas in decimal numbers (i.e. 1,000,000). By convention, binary digits are grouped into blocks of 8 bits. This is probably because the first widely used computers used 8-bit numbers. The spaces are a notation convention and are only used when writing out binary numbers. Without them it is impossible for the average reader to recognize the number of digits.

The "1" in the above numbers looks pretty lonely with all those 0s. In fact, the zeros are just taking up space. Most numbers in a typical flash application will only use a small number of bits in a 32-bit number. For some programmers this causes anxiety about wasted space. That is why the bitwise operators are provided. People who really want to use memory frugally can – potentially – use the bitwise operators to employ the extra bits for something useful.

The Left Shift (<<) operator can be used to illustrate the potential – though unlikely – use of bitwise operators. What it does is shift all the bits in a binary number one position to the left. Take, for instance, the number 1, stored internally as:

00000000 00000000 00000000 00000001

Shifting all the bits one position to the left results in:

00000000 00000000 00000000 00000010

This is the number 2. Shifting left one more time produces:

00000000 00000000 00000000 00000100

This is the number 4.

The code to shift a number to the left using the << operator looks like this:

```
result = 1 << shiftCount;
```

This will shift the number shiftCount times to the left. To see this in action, the following code will shift a "1" 32 times, showing the resulting value after each shift:

```
var result:Number;
for (var shiftCount=0; shiftCount<=32; shiftCount++) {
```

```
    result = 1 << shiftCount;
    trace("result: " + result + ", shiftCount: " + shiftCount);
}
```

The output looks like:

```
result: 1, shiftCount: 0
result: 2, shiftCount: 1
result: 4, shiftCount: 2
result: 8, shiftCount: 3
result: 16, shiftCount: 4
result: 32, shiftCount: 5
result: 64, shiftCount: 6
result: 128, shiftCount: 7
result: 256, shiftCount: 8
result: 512, shiftCount: 9
result: 1024, shiftCount: 10
result: 2048, shiftCount: 11
result: 4096, shiftCount: 12
result: 8192, shiftCount: 13
result: 16384, shiftCount: 14
result: 32768, shiftCount: 15
result: 65536, shiftCount: 16
result: 131072, shiftCount: 17
result: 262144, shiftCount: 18
result: 524288, shiftCount: 19
result: 1048576, shiftCount: 20
result: 2097152, shiftCount: 21
result: 4194304, shiftCount: 22
result: 8388608, shiftCount: 23
result: 16777216, shiftCount: 24
result: 33554432, shiftCount: 25
result: 67108864, shiftCount: 26
result: 134217728, shiftCount: 27
result: 268435456, shiftCount: 28
result: 536870912, shiftCount: 29
result: 1073741824, shiftCount: 30
result: 22147483648, shiftCount: 31
result: 1, shiftCount: 32
```

The last two lines of the output may be unexpected. The negative result for shifting 31 times results from the fact that the last (32nd) bit is used by ActionScript to determine whether a number is positive or negative. A 1 in the 32nd bit represents a very negative number. The last line of the output is the result of shifting a 1 32 times to the left. This pushes the 1 past the final 32nd position and back to the first position. It rolls around.

Again, bitwise operators are rarely used in simple applications, but they are available when the need arises. Table 8.7 shows the ActionScript bitwise operators.

Table 8.7 *ActionScript bitwise operators*

Operator	Operation performed
&	Bitwise AND
\|	Bitwise OR
^	Bitwise XOR
~	Bitwise NOT
<<	Shift left
>>	Shift right
>>>	Shift right zero fill

Compound Assignment Operators

The basic assignment operator (=) assigns a value to a variable, as in the following:

```
name = "Fred";
```

The compound assignment operators are another example of shorthand to make typing (and reading) code easier. The compound "add and reassign" operator (+=) does the work of adding a value to the left-hand operand and then assigning the result to the left-hand operand. For example:

```
count += 5;
```

This is the same as:

```
count = count + 5;
```

The other compound assignment operators are used in the same way. The "multiply and reassign" operator is used like:

```
count *= 10;
```

This is the same as:

```
count = count * 10;
```

Table 8.8 lists the ActionScript compound assignment operators.

Table 8.8 *ActionScript compound assignment operators*

Operator	Operation performed
=	Assignment
+=	Addition and assignment
−=	Subtraction and assignment
*=	Multiplication and assignment
%=	Modulo and assignment
/=	Division and assignment
<<=	Bitwise shift left and assignment
>>=	Bitwise shift right and assignment
>>>=	Shift right zero fill and assignment
^=	Bitwise XOR and assignment
\|=	Bitwise OR and assignment
&=	Bitwise AND and assignment

Dot and Array Access Operators

The dot (.) operator is used to reference properties and methods of objects. For example, the location properties of a MovieClip object can be accessed like:

```
var mc:MovieClip = createEmptyMovieClip("temp", 1);

x_location = mc._x;
y_location = mc._y;
```

Properties can also be accessed using the Array Element/Object-Property operator []. It is primarily used to access elements of an Array object:

```
var guestList:Array = new Array("Joe", "Mary", "Steve");

trace(guestList[0]);
```

The resulting output is:

```
Joe
```

"Joe" is the 0th element in the Array. (Arrays will be covered in Chapter 10.) Alternatively, the [] operator can be used to access object properties as follows:

```
var mc:MovieClip = createEmptyMovieClip("temp", 1);

x_location = mc["_x"];
y_location = mc["_y"];
```

When using the [] operator to access object properties, the property's name is supplied as a String. It can be either a literal String, "_x", or a variable that contains a String. In the early days of Flash, there was no Array object and arrays were simulated by attaching properties to objects and accessing them with []. Today it is generally preferred to use the Array object for arrays, and use the [] operator to access object properties by name.

The [] operator can be used to set as well as get property values. Also, the [] operator will evaluate its operand before using it, so the name of the property being accessed can be constructed programmatically, as in:

```
var mc:MovieClip = createEmptyMovieClip("temp", 1);
var i:Number = 7;
mc["value_" + i] = "new property value";
```

This will set (and if necessary create) a property on the MovieClip instance, mc, called, "value_7" and assign it the value, "new property value".

Eval

The built-in eval() function can also be used to access properties of objects. It is used infrequently in new Flash applications, but it can be useful. Occasionally it may be necessary to reference a MovieClip by its "path name," a String that describes where the MovieClip lives. Consider a MovieClip on the Main Timeline with an Instance Name of "my_clip". The path name of this clip will be: "/my_clip". The eval() function can take this path name and turn it into an actual Object reference:

```
var myClip:MovieClip = eval("/my_clip");
```

When this line is executed, myClip will contain an Object reference to the MovieClip on the Main Timeline with the Instance Name, "my_clip". If this MovieClip doesn't exist, myClip will be null.

The eval() function was used extensively in early ActionScript code. Today it is used primarily to turn MovieClip path names into object reference. It can do quite a bit more, but now there are better ways to most of these things.

Statements

All programs are collections of statements. Statements tell the computer to do something. Any assignment or operation is a statement. Some statements are used to make decisions about the results of operations and to control the order of operations. There are several kids of statements in ActionScript:

Control Statements
- loops
- conditionals

Variable Declaration Statements
- var
- set

Function Statements
- function
- return

Object Statements
- with
- for...in

Expression Statements
- any expression, i.e.
 - count = 10;
 - visitors += 1;
 - createEmptyMovieClip("temp", 1);

Control Statements

Control statements are used to control flow of execution in a program. They are used to make decisions and then execute certain code based on those decisions. The two main types of control statements are conditionals and loops.

Conditionals

Conditionals make decisions. A Boolean expression is evaluated and the result is then used to choose which code to execute next. An expression is Boolean if it evaluates to true or false. The conditionals that are used in ActionScript include:

- If–Then
- Else
- Else–if
- The Conditional Operator, ?:
- Switch

The most basic conditional is the "If" statement. The If statement considers an expression and then executes code if the expression evaluates to true. For example:

```
if (100 > 10) trace("The expression is true.");
```

When this line is executed, the trace() function is called if 100 > 10, which it is. The output is:

```
The expression is true.
```

The previous example executes one statement if the condition is true. To execute multiple statements, the statements are enclosed in braces, { };

```
if (100 > 10) {
   trace("The results are in:");
   trace("The expression is true.");
}
```

The output is:

```
The results are in:
The expression is true.
```

Statements enclosed in braces are referred to as a statement block. To execute alternate code when the condition is false, the Else conditional is used:

```
if (10 > 100) {
   trace("The results are in:");
   trace("The expression is true.");
} else {
   trace("The results are in:");
   trace("The expression is false.");
}
```

The output is:

```
The results are in:
The expression is false.
```

Else-if is used to try a subsequent conditional if the previous ones evaluate to false:

```
var testNumber:Number = 10;

if (testNumber > 100) {
   trace("The results are in:");
   trace("The first expression is true.");
} else if (testNumber > 5) {
   trace("The results are in:");
   trace("The second expression is true.");
} else {
   trace("Neither expression is true.");
}
```

Now, the output is:

```
The results are in:
The second expression is true.
```

The Conditional Operator

One way to make code "tighter" (and nearly impossible to read) is to use the conditional operator (?:). This operator has three operands, so it is referred to as a tertiary operator. The operands are: a Boolean expression, a true expression, and a false expression – Boolean-expression? true-expression : false-expression. For example:

```
(10 > 100) ? "The expression is true." : "The expression
   is false.";
```

This is shorthand for:

```
if (10 > 100) {
   trace("The expression is true.");
```

```
    } else {
      trace("The expression is false.");
    }
```

The Switch Statement

If an application needs to test a condition and then execute different code for each case, If-Else-If can be used. But a cleaner, more readable alternative is the Switch statement. Switch takes one parameter and applies it to a number of test cases. When a test case evaluates to true, its associated code is executed:

```
    var name:String = "Larry";

    switch (name) {
      case "Moe":
        trace("Hey, Moe.");
        break;
      case "Larry":
        trace("Hey, Larry.");
        break;
      case "Curly":
        trace("Hey, Curly.");
        break;
      default:
        trace("Shemp?");
    }
```

The above code checks the name variable against all of the supplied test cases. Since the name variable contains "Larry", the output is:

```
    Hey, Larry.
```

The "break" statement tells Switch to stop testing after it finds a match. Otherwise, every case that evaluates to true will be executed. The "default" case executes no matter what, unless a break is encountered. In this example, if no other case evaluates to true, then the default case will execute.

Loops

Loops are used to make code execute repeatedly. The two main kinds of loops are:

- while loops
- for loops

While Loops

While loops execute "while" a specified condition is true. For example:

```
    var nameList:Array =
      new Array("Amy", "Anne", "Archie", "Jennifer", "Kyle");
```

```
var nameListIndex:Number = 0;

while (nameList[nameListIndex].charAt(0) == "A") {
  trace(nameList[nameListIndex++]);
}
```

The above while loop checks to see if the first name in the Array starts with "A". If it does, it writes it to the Output Window. Using the postfix increment operator, the nameListIndex is incremented. The While loop then checks the next array element. When a name is found that does not start with "A", the while condition fails and the loop terminates. The output is:

```
Amy
Anne
Archie
```

While loops can also be constructed so the test comes at the end of the loop. This ensures that the loop will execute at least once. For example:

```
nameListIndex = 0;
do {
  trace(nameList[nameListIndex++]);
} while (nameList[nameListIndex].charAt(0) == "A");
```

This example will always output the first name in the Array, even if it doesn't start with "A". As a result, this form of while isn't really appropriate for this example, but it is often the best choice.

A while loop is appropriate when the required number of loops is unknown when looping begins.

For Loops

When a specific number of loops is needed, the "For" statement is used. For example:

```
var arrayLength = nameList.length;

for (nameListIndex = 0; nameListIndex < arrayLength;
     nameListIndex++) {
    trace(nameList[nameListIndex] + " is cool.");
}
```

The above code uses the length property of the Array object to access every element of the nameList array. The output looks like:

```
Amy is cool.
Anne is cool.
Archie is cool.
Jennifer is cool.
Kyle is cool.
```

Since the length of the Array can be determined before looping begins, the For loop uses this information to loop a specified number of times. The syntax of the For loop is:

for(*initialization; condition; update*) {

 statements
}

The initialization section contains an expression that sets the initial value of the loop counter, the variable that is used to count the number of loop iterations. The condition section contains an expression that is checked at the beginning of each loop to determine when the loop will end. The update section is where the loop counter is modified. It can be incremented, decremented, multiplied, divided, etc. For example, to access every other element of an array, the loop counter can be incremented by 2, instead of by one.

```
for (counter = 0; counter < 100; counter += 2) {
   trace("Counter = " + counter);
}
```

The output looks like:

```
Counter = 0
Counter = 2
Counter = 4
Counter = 6
Counter = 8
Counter = 10
Counter = 12
```

Next: Functions

Variables, Operators and Statements can be organized into groups called Functions. Whether they are implemented as the methods of a class, or simply defined on a timeline, Functions can make code modular and reusable. Functions are the subject of the next chapter.

9 Organizing Code with Functions

Functions

Functions are used to assemble statements into meaningful, logical functional units – hence the name, Function. Even simple applications can have a large number of individual statements. Without functions, code would be unruly and unreadable.

ActionScript 2 code exists primarily in the form of classes. The methods of classes are functions. As explained in Chapters 5–7, classes take the idea of modular, reusable code to the next level and provide a way to group functions and variables together into logical units.

Defining Functions

Whether they are part of a class or simply defined on a timeline, functions are constructed in the same way. A function definition has three main elements:

- The function Declaration
- *Parameters* – specified in the declaration
- A *Body* – containing statements
- An *optional Return Value* – the type of which is specified in the declaration

Take, for example, the mySquare() function definition from Chapter 5:

```
function  mySquare  (x:Number,  y:Number,  size:Number):
  MovieClip {

var depth:Number = _root.getNextHighestDepth();
var square:MovieClip =
  _root.createEmptyMovieClip ("example", depth);
square.beginFill(0x0022CC, 80);
square.lineStyle(2, 0xFF9900, 100);
square.moveTo(0, 0);
square.lineTo(size, 0);
square.lineTo(size, size);
square.lineTo(0, size);
square.lineTo(0, 0);
square.endFill();
square._x = x;
```

```
    square._y = y;

    return square;
}

var tempSquare:MovieClip = mySquare(100, 100, 50);
```

The Declaration says that the mySquare() function expects 3 parameters, which are all Numbers, and that it will return a MovieClip object:

```
function   mySquare   (x:Number,   y:Number,   size:Number):
    MovieClip {
```

The Body contains the code to create a MovieClip, draw a square in it, and position it at the given x and y coordinates:

```
var depth:Number = _root.getNextHighestDepth();
var square:MovieClip =
    _root.createEmptyMovieClip ("example", depth);
square.beginFill(0x0022CC, 80);
square.lineStyle(2, 0xFF9900, 100);
square.moveTo(0, 0);
square.lineTo(size, 0);
square.lineTo(size, size);
square.lineTo(0, size);
square.lineTo(0, 0);
square.endFill();
square._x = x;
square._y = y;
```

Finally, the return statement takes the newly created MovieClip object and hands it back to the code that called the function.

```
    return square;
```

In this case, the function was called from the Main Timeline and the resulting MovieClip is stored in the tempSquare variable on the Main Timeline.

The type of the value returned by the function needs to be the same as the return type specified in the function's declaration. When a function is not intended to return a value, its return type is set to "Void". Void is a special type that is used by the AS2 compiler to make sure the programmer didn't simply forget to assign a return type. In a class definition, if no return type is specified, the compiler will complain. Setting the return type to Void tells the compiler that function shouldn't return a value.

Calling a Function

In the above example, the mySquare() function is invoked (called) from the Main Timeline by the line:

```
var tempSquare:MovieClip = mySquare(100, 100, 50);
```

The assignment operator (=) is used to assign the return value of the function to the tempSquare variable – the left-hand operand of (=). The tempSquare variable is declared to be a MovieClip container and the mySquare function is declared to return a MovieClip object. The container's type and the function's return type are in "agreement", so the compiler is happy.

Passing Parameters by Value vs. by Reference

When a variable containing a primitive (simple) data type is passed to a function, the data is passed "by value". This means that a copy of the data is made, and that copy is passed to the function. If the function changes the value of the parameter, the original variable is unchanged. This is how Numbers, Strings, and Booleans are passed to functions. The special values "undefined" and "null" are also passed by value. Copies are made of primitive types because it is practical – they don't use much memory and so copying them doesn't waste much memory.

However, when a variable containing a composite (complex) data type is passed to a function, the data is passed "by reference". Composite data types include everything else: MovieClips, Buttons, class instances, etc. Composite data types can use a lot of memory, and it wouldn't be practical to make copies of them when passing them to functions. But even more importantly, programmers often want a function to modify a composite object. By passing a reference to the original object, the function can modify it. For example, an application may define a function to move MovieClips off the stage. It might look like this:

```
moveClipOffstage = function (mc:MovieClip):Void {

  mc._x = -1000;
  mc._y = -1000;
}
```

When a MovieClip instance is passed to this function, it modifies that very instance and sets its _x and _y properties to values that put it way off stage.

Expressions as Parameters

It is legal to pass an expression to a function as long as that expression evaluates to the data type that the function is expecting. For example:

```
function displayDailyMessage(todays_message:String):Void {
  trace("The message of the day is: " + todays_message);
}
```

This function can be invoked with an expression:

```
var user:String = "Benjamin";
var message:String = "A stitch in time saves nine.";

displayDailyMessage("Good  morning,  " + user + ": " +
                    message);
```

The expression evaluates to: "Good morning, Benjamin: A stitch in time saves nine." The output looks like:

```
The message of the day is: Good morning, Benjamin:
A stitch in time saves nine.
```

Built-in Functions

Flash provides a wide range of useful and powerful built-in functions. Many are provided as methods of built-in classes. One good example is the getTimer() function. This is a built-in global function. It can be called from within any block of code and it will return the number of milliseconds that have elapsed since the Flash application started. Calling getTimer() and storing the value in a variable establishes a starting time for an event. Subsequent calls to getTimer() can be compared to this value to get elapsed time.

Measuring Time

In order to use getTimer(), code is typically written to store its value and compare it to later times. Listing 9.1 shows the code for a general Timer class that can be useful in many applications. It will be used in the game in later chapters.

Listing 9.1 *A general-purpose Timer class*

```
class ch09.Timer {

  var startTime:Number = 0;

  public function Timer () {
    startTime = getTimer();
  }

  public function restartTimer():Void {
    startTime = getTimer();
  }

  public function milliseconds():Number {
    return (getTimer() - startTime);
  }

  public function seconds():Number {
    return getSeconds();
  }

  private function getSeconds():Number {
    return (Math.floor((getTimer() - startTime)/1000));
  }

  public function minutes():Number {
    return Math.floor(getSeconds() / 60);
  }
```

```
public function remaining(time_allowed:Number):Number {
  return time_allowed - milliseconds();
}

public function expire():Void {
  startTime = -100000;
}

public function display():String {

  var mins, secs;

  mins = "00" + minutes();
  mins = mins.substr(mins.length - 2, 2);

  secs = "00" + seconds();
  secs = secs.substr(secs.length - 2, 2);

  return mins + ":" + secs;
}

public    function    displayRemaining(time_allowed:Number)
  :String {

  var mins, secs;
  var millisRemaining = time_allowed - milliseconds();
  var secsRemaining = Math.floor(millisRemaining/1000);
  var minsRemaining = Math.floor(secsRemaining/60);

  if (millisRemaining >=0) {
    mins = "00" + minsRemaining;
    mins = mins.substr(mins.length - 2, 2);

    secs = "00" + secsRemaining;
    secs = secs.substr(secs.length - 2, 2);
  } else {
    mins = "00";
    secs = "00";
  }
  return mins + ":" + secs;
  }
}
```

The sole property of the Timer class is a variable called "startTime". This keeps track of a reference time from which time calculations are made. The class constructor initializes the startTime property:

```
public function Timer () {
  startTime = getTimer();
}
```

107

The restartTimer() method re-initializes the startTime property, effectively restarting the timer.

```
public function restartTimer():Void {
   startTime = getTimer();
}
```

The functions milliseconds(), seconds(), and minutes() return the elapsed time in milliseconds, seconds, and minutes, respectively. The private function, getSeconds(), is used internally by seconds() and minutes():

```
private function getSeconds():Number {
   return (Math.floor((getTimer() - startTime)/1000));
}
```

As it is declared private, getSeconds() cannot be invoked directly to get the elapsed time in seconds. The method, seconds(), is the public interface for this functionality. The remaining() method takes one Number parameter, the allowed amount of time, and returns the difference between this number and the elapsed time. The result is the amount of time remaining. This method allows the Timer class to be used as a countdown timer. The expire() method forces the startTime to be far in the past. This makes the elapsed time large and effectively expires a countdown timer.

The display() and displayRemaining() methods turn the numerical time results into Strings appropriate for display in a text field. The Timer class can be seen in action in the Timer.fla in the ch09 folder of the examples. The timeline code for the example is:

```
import ch09.Timer;

var testTimer:Timer = new Timer();
var timerTextField:TextField;
var timeRemainingTextField:TextField;

this.createTextField("timer_textfield", 10, 0, 0, 550, 100);
timerTextField = this["timer_textfield"];

this.createTextField("timer_remaining_textfield", 20, 0, 150,
                     550, 100);
timeRemainingTextField = this["timer_remaining_textfield"];

var timerTextFormat:TextFormat = new TextFormat();
timerTextFormat.color = 0xFF0000;
timerTextFormat.bold = true;
timerTextFormat.size = 72;
timerTextFormat.align = "center";

onEnterFrame = function () {
   timerTextField.text = testTimer.display();
   timer_remaining_textfield.text =
      testTimer.displayRemaining (30000);
```

```
timerTextField.setTextFormat(timerTextFormat);
timer_remaining_textfield.setTextFormat(timerTextFormat);
}
```

If the examples are unavailable, the Timer.fla can be created by putting the above code on the first frame of a blank FLA. The Timer.fla and the Timer.as file (from Listing 9.1) need to be in a folder named "ch09", and the classpath for the FLA needs to point up one folder level: ".." Figure 9.1 shows the Timer.swf. One TextField shows the elapsed time, the other shows the time remaining.

Figure 9.1 *The Timer.swf*

A Simple Frame Time Manager Class

In game applications, time is measured in frames. A frame is the amount of time between updates to the screen. In traditional animation and in feature films, a new image is displayed 24 times each second. Each image – or frame – is displayed for 1/24 of a second. This frame rate allows typical subject movement to appear smooth and natural. The frame rate of video – shot with a typical video camera – is 30 frames per second (fps). As a result, motion in videos looks even smoother. In order for the animation and object motion in a game to appear smooth, the frame rate must be sufficiently high, and it must be consistent from frame to frame; 30 fps is a typical target frame rate.

When a film or a video is displayed, the projector or video player guarantees that the frame rate will be correct and consistent. With Flash applications, however, there is no way for the Flash player to guarantee a specific and consistent frame rate. The target frame rate can be set in the Document Properties dialog (Modify->Document...). But that is just a target, maximum frame rate. On a slower machine, the application may have a slower frame rate. And even on a fast machine, the frame rate may be inconsistent. If an e-mail arrives during game play, the game may momentarily slow down. Some inconsistencies are unavoidable, but many can be compensated for making game calculations time-dependent rather than frame-dependent.

Instead of moving a game object 5 pixels per frame, it can be moved 5 pixels per second. By keeping track of how much time elapses each frame, time-based calculations can move objects the correct amount each frame: more during long frames, less during short frames. Calculating the specific duration of each frame can be accomplished with a simple FrameTimeManager class. Listing 9.2 shows an example of such a class. It make use of the general purpose Timer class described above.

Listing 9.2 *A Simple Frame Time Manager class*

```
import ch09.Timer;

class ch09.FrameTimeManager {
  static var frameTimeMilliseconds:Number;
  static var frameTimeTimer:Timer = new Timer();

  public static function calculateFrameTime():Void {

    frameTimeMilliseconds = frameTimeTimer.milliseconds();
    frameTimeTimer.restartTimer();
  }

  public static function getFrameSeconds():Number {

    return frameTimeMilliseconds/1000;
  }

}
```

The calculateFrameTime() method needs to be called each frame, typical from the main loop of the application. It calls the milliseconds() method of the frameTimeTimer object to get the milliseconds elapsed since the last frame. It then restarts the frameTimeTimer.

The getFrameSeconds() method is called by the application to get the actual amount of time elapsed since the last frame. Typically this value will be a fraction between 1/15th and 1/30th of a second. The FrameTimeManager class can be seen in action in the FrameTimeManager.fla in the examples. The timeline code is:

```
import ch09.FrameTimeManager;

var frameTimeTextField:TextField;

this.createTextField("frame_time_textfield", 10, 0, 0, 550,
                     100);
```

```
frameTimeTextField = this["frame_time_textfield"];

var frameTimeTextFormat:TextFormat = new TextFormat();
frameTimeTextFormat.color = 0xFF0000;
frameTimeTextFormat.bold = true;
frameTimeTextFormat.size = 72;
frameTimeTextFormat.align = "center";

onEnterFrame = function () {
  FrameTimeManager.calculateFrameTime();
  frameTimeTextField.text =
    String(FrameTimeManager.getFrameSeconds());
  frameTimeTextField.setTextFormat(frameTimeTextFormat);
}
```

The target frame rate for this FLA is set to 30 fps in the Document Settings dialog (Modify->
Document...). On a reasonably fast computer, the value displayed (the frame time in seconds)
should be about 0.33 or 1/30th of a second. Moving the mouse around can cause this to fluctu-
ate a little. Resizing the Flash player window can make it fluctuate a little more. Figure 9.2 shows
the FrameTimeManager.swf.

Figure 9.2 *The FrameTimeManager.swf displaying a frame time of approximately 1/30th
of a second = 30 fps*

The Built-in Functions of the Math Class

Another good example is the Math class. The Math class is utilized by accessing its methods as functions. The Math class cannot have instances. Instead, it serves as a container for the standard library of arithmetic, trigonometric, and other math-related functions, as well as for useful values. The full list of methods and properties of the Math class is shown in Table 9.1.

Table 9.1 *The methods and properties of the Math class*

Method	Description
abs()	Computes an absolute value
acos()	Computes an arc cosine
asin()	Computes an arc sine
atan()	Computes an arc tangent
atan2()	Computes an angle from the x-axis to the point
ceil()	Rounds a number up to the nearest integer
cos()	Computes a cosine
exp()	Computes an exponential value
floor()	Rounds a number down to the nearest integer
log()	Computes a natural logarithm
max()	Returns the larger of the two integers
min()	Returns the smaller of the two integers
pow()	Computes x raised to the power of the y
random()	Returns a pseudo-random number between 0.0 and 1.0
round()	Rounds to the nearest integer
sin()	Computes a sine
sqrt()	Computes a square root
tan()	Computes a tangent

Property	Description
E	Euler's constant and the base of natural logarithms (approximately 2.718)
LN2	The natural logarithm of 2 (approximately 0.693)
LOG2E	The base 2 logarithm of e (approximately 1.442)
LN2	The natural logarithm of 10 (approximately 2.302)
LOG10E	The base 10 logarithm of e (approximately 0.434)
PI	The ratio of the circumference of a circle to its diameter (approximately 3.14159)
SQRT1_2	The reciprocal of the square root of 1/2 (approximately 0.707)
SQRT2	The square root of 2 (approximately 1.414)

A General Purpose MathTables Class

Game applications tend to push the limits of the machines they run on. They tend to use a lot of resources: memory, CPU time, disk space, etc. At one point or another, the performance of a game may need to be improved by making some optimizations. One optimization that can be helpful in games that use trigonometric Math functions is to pre-calculate the values of function calls that are likely to be made repeatedly. Trigonometric calculations like Sine, Cosine, Tangent, etc. are relatively expensive. In a simple space-shooter-arcade-style game, certain angles need to

be calculated over and over again. The number of angles can be predetermined based on the requirements of the game. For the Astro Sweeper game, later in this book, pre-calculating the Sines and Cosines of the 360 whole angles (in the unit circle) and storing them in Arrays can save some calculation time during the game. Listing 9.3 shows a MathTables class.

Listing 9.3 *A general purpose MathTables class*

```
class ch09.MathTables{

  static var sine:Array = new Array(360);   // sin table
  static var cosine:Array = new Array(360);  // cosine table
  static var PI:Number;
  static var angleDivisions:Number = 32;

  static var tablesInitialized:Boolean = initTables();

  public function MathTables(){
  }

  public static function initTables():Boolean {

    PI = Math.PI;
    // loop through all angles and add to the arrays

    for (var temp_ang = 360; temp_ang >= 0; temp_ang—) {
      sine[temp_ang] = Math.sin(PI*temp_ang/180.0);
      cosine[temp_ang] = Math.cos(PI*temp_ang/180.0);
    }

    return true;
  }

  public static function traceTables() {

    for (var temp_ang = 360; temp_ang >= 0; temp_ang—) {
      trace("Ang: " + temp_ang + ", Sin: " + sine[temp_ang]
          + ", Cos: " + cosine[temp_ang]);
    }
  }

  public static function setVelocity(angle_index:Number,
                    speed:Number, velocity:Object):Void {

    var shotAngle =
      360 - Math.floor((angle_index-1) * (360/angleDivisions));
    velocity.y = (cosine[shotAngle] * -1) * speed;
    velocity.x = (sine[shotAngle]   * -1) * speed;
  }
}
```

The MathTables class has four properties:

sine	An Array containing the Sine values for all 360 angles
cosine	An Array containing the Cosine values for all 360 angles
PI	The value for PI (same as Math.PI) for convenience
angleDivisions	The number of discrete angles that game objects can come to rest on as they rotate in a full circle. This is set to 32.

The initTables() method iterates through all 360 angles, calculates the Sine and Cosine for each, and stores the values in the respective array. The traceTables() method outputs the contents of the arrays to the Output window so that they can be verified. This method is used to check the contents of the arrays. Testing the MathTables.fla file (in the ch09 folder of the examples) generates the following output:

```
Ang: 360  Sin: -2.44921270764475e-16 Cos: 1
Ang: 359  Sin: -0.0174524064372844  Cos: 0.999847695156391
Ang: 358  Sin: -0.0348994967025008  Cos: 0.999390827019096
Ang: 357  Sin: -0.0523359562429444  Cos: 0.998629534754574
Ang: 356  Sin: -0.0697564737441248  Cos: 0.997564050259824
Ang: 355  Sin: -0.0871557427476583  Cos: 0.996194698091746
Ang: 354  Sin: -0.104528463267653   Cos: 0.994521895368273

....

Ang: 9    Sin: 0.156434465040231    Cos: 0.987688340595138
Ang: 8    Sin: 0.139173100960065    Cos: 0.99026806874157
Ang: 7    Sin: 0.121869343405147    Cos: 0.992546151641322
Ang: 6    Sin: 0.104528463267653    Cos: 0.994521895368273
Ang: 5    Sin: 0.0871557427476582   Cos: 0.996194698091746
Ang: 4    Sin: 0.0697564737441253   Cos: 0.997564050259824
Ang: 3    Sin: 0.0523359562429438   Cos: 0.998629534754574
Ang: 2    Sin: 0.034899496702501    Cos: 0.999390827019096
Ang: 1    Sin: 0.0174524064372835   Cos: 0.999847695156391
Ang: 0    Sin: 0                 .   Cos: 1

tempV before setVelocity: (0, 0)

tempV after setVelocity: (83.1646763271036,
                          391.259040293522)
```

Velocity Calculation

Finally, the setVelocity() method takes an angle index – a number from 1 to angleDivisions (32) – a speed value and a velocity object and it sets the x and y properties of the velocity object. Looking

up a value in a table is faster than calculating it, so as long as the values are accessed many times, the optimization will be worthwhile.

```
public static function setVelocity(angle_index:Number,
                        speed:Number,velocity:Object):Void {

  var shotAngle =
    360 - Math.floor((angle_index - 1) * (360/angleDivisions));
  velocity.y = (cosine[shotAngle] * -1) * speed;
  velocity.x = (sine[shotAngle]   * -1) * speed;
}
```

The angle_index parameter is a number from 1 to 32 because game objects in Astro Sweeper can have one of 32 rotation positions. This has to do with the way the MovieClips are set up: each object makes a complete rotation in 32 frames. The speed is a value in pixels per second. Velocity (a 2-dimensional "vector") is calculated by multiplying the speed (a 1-dimensional "scalar" value) with the cosine of the angle to get the y component and with the sine of the angle to get the x component. Together, these two components form the resulting velocity vector.

As the velocity parameter is an Object (a composite data type), it is passed to the setVelocity() method as a reference to an existing object. This allows the setVelocity() method to set the x and y properties of the original object, without having to pass back a value. This is important because a velocity has two components and a function can only return one value. The velocity parameter is a generic Object used as a container to hold the x and y components of a velocity. These components could be passed in separately as x:Number and y:Number, but grouping them as properties of an object is convenient and it allows them to be set directly by the setVelocity() method. The setVelocity() method is explained in more detail in later chapters.

The MathTables.fla in the examples invokes the traceTables() method to display the contents of the tables. It then calls MathTables.setVelocity() on a velocity object. The timeline code is:

```
import ch09.MathTables;

MathTables.traceTables();

var tempV:Object = new Object();
tempV.x = 0;
tempV.y = 0;

trace("\n");
trace("tempV before setVelocity: (" + tempV.x +", " + tempV.y
      + ")\n");

MathTables.setVelocity(16, 400, tempV);

trace("tempV after setVelocity: ("  +  tempV.x  +  ",  "  +
                              tempV.y + ")\n");
```

The FLA's classpath is set to "..".

Organizing Functions in a Flash Movie

Before ActionScript 2, it was often recommended – even by Macromedia – that code should be attached to MovieClips and Button throughout a Flash movie. The application was the sum of the code attached to these objects. With the release of Flash MX, a rudimentary object-oriented coding technique was introduced that made it possible to consolidate functions and variables inside classes – as methods and properties. At this time, many programmers began to centralize program code on the Main Timeline inside Action Frames, even going so far as to define one class per frame. This technique simulated the structure of class-oriented languages like Java and C++.

ActionScript 2 provides a real class definition mechanism that not only helps organize code, it allows the compiler to verify code and identify many potential bugs. For this reason, it is recommended (by the author) that all functions be defined as methods of appropriate classes. Code should be defined on the Main Timeline or within MovieClips only when it makes the best logical sense.

10 Arrays

Managing Data in Applications

Every application needs to keep track of some amount of information. It may be contact information, a list of current movies, or a host of asteroids and bullets. As explained in Chapter 8, variables act as containers for different types of information. One way to provide storage for application data is to declare the appropriate variables. For example:

```
var currentUserID:String;

var numberOfAteroids:Number;
```

It would even be possible to declare enough variables to hold contact information for a group of individuals. Doing so might look like this:

```
var user1Email:String;
var user2Email:String;
var user3Email:String;
var user4Email:String;
var user5Email:String;
var user6Email:String;
var user7Email:String;
var user8Email:String;
var user9Email:String;
var user10Email:String;
```

In this way, enough memory could easily be allocated for 10 e-mail addresses. The technique could even be used for hundreds or thousands of addresses. But the code would be unmanageable. And accessing the individual addresses would be cumbersome. In the early AS1 days, this technique was actually often used. It worked because variables exist as properties of the timeline on which they are defined. Since properties can be accessed by name using the [] operator, it is possible to access the above variables like:

```
var id:Number = 6;

this["user" + id + "Email"] = "joe@joe.com";

trace("Email (" + id + ") = " + this["user" + id + "Email"]);
```

The output would be:

```
Email (6) = joe@joe.com
```

This technique is awkward and the code can easily become confusing. It is also very inefficient since ActionScript has to first construct each String property name, and then use this String to search for the requested property. The above example can be seen in the BeforeArrays.fla in the ch10 folder of the examples.

Arrays

Fortunately, ActionScript has a built-in class called "Array". Instances of the Array class act as a special kind of container that can hold any number of elements. Arrays mirror what is going on at the hardware level in the computer's memory. Memory chips are made up of millions of memory locations, each with a unique address. Simplifying things for this discussion, every CPU (Intel, Motorola, Arm, etc.) has a way to store a value in a memory location and retrieve a value from a memory location. Data is stored in an Array using the Array access operator [] and it is retrieved using the same operator. Like a memory chip, an array can be thought of as a container with many compartments for data, each with a unique numerical address. When an Array is declared, the total number of required compartments is specified. In Array terminology, these compartments are called "elements". The following line of code declares an array with space for 10 elements:

```
var userEmail:Array = new Array(10);
```

The address of an element in an array is called its "index". The following line sets the first element of the userEmail Array by putting a value at index 0:

```
userEmail[0] = "joe@joe.com";
```

As is typical with computer languages, ActionScript Arrays are "zero indexed", meaning that the first element of an array is the 0th rather than the 1st. So, userEmail[1] is the second element in the Array. If zero indexing is a new concept, then it may take some getting used to.

Accessing an element of an array is done in a similar way:

```
var id:Number = 0;
trace("Email (" + id + ") = " + userEmail[id]);
```

The output looks like:

```
Email (0) = joe@joe.com
```

The above example can be seen in the Arrays.fla in the ch10 folder of the examples.

Arrays are a powerful tool and tend to be used extensively in all but the simplest applications. In addition to setting and getting elements using the [] access operator, data in arrays can be accessed and manipulated using the methods and properties of the Array class. Tables 10.1 and 10.2 show the methods and properties of the Array class, respectively.

Array Methods

Table 10.1 *The methods of the Array class*

Method	Description
concat()	Concatenates the elements specified in the parameters with the elements in an array and creates a new array.
join()	Converts the elements in an array to strings, inserts the specified separator between the elements, concatenates them, and returns the resulting string.
pop()	Removes the last element from an array and returns the value of that element.
push()	Adds one or more elements to the end of an array and returns the new length of the array.
reverse()	Reverses the array in place.
shift()	Removes the first element from an array and returns that element.
slice()	Returns a new array that consists of a range of elements from the original array, without modifying the original array.
sort()	Sorts the elements in an array.
sortOn()	Sorts the elements in an array according to one or more fields in the array.
splice()	Adds elements to and removes elements from an array.
toString()	Returns a string value representing the elements in the specified Array object.
unshift()	Adds one or more elements to the beginning of an array and returns the new length of the array.

Array Properties

Table 10.2 *The properties of the Array class*

Property	Description
length	A non-negative integer specifying the number of elements in the array.
CASEINSENSITIVE	Represents case-insensitive sorting.
DESCENDING	Represents a descending sort order.
NUMERIC	Represents numeric sorting instead of string-based sorting.
RETURNINDEXEDARRAY	Represents the option to return an indexed array as a result of calling the sort() or sortOn() method.
UNIQUESORT	Represents the unique sorting requirement.

Using Arrays

As mentioned above, Arrays are used in most applications. The typical uses of Arrays range from keeping track of simple lists to managing database-like collections of complex objects. ActionScript Arrays provide an especially rich set of functionality, as seen in the method and property descriptions above. These functionalities can be grouped into three categories:

- Adding and removing elements from an Array
 - concat()
 - pop()

- push()
- shift()
- slice()
- splice()
- unshift()
- Reordering an Array
 - reverse()
 - sort()
 - sortOn()
- Converting an Array to a different form
 - join()
 - toString()

An Array of MovieClips – Example

In Flash applications, Arrays are typically used to keep track of MovieClips, particularly MovieClips that are created programmatically (dynamically). Listing 10.1 shows the code from the Main Timeline of the ArrayOfDiamonds.fla, available in the ch10 folder of the examples. It references a class called "Diamond" which is used to create and draw diamond-shaped MovieClips. The Diamond class will be analyzed later in the chapter. First, timeline code:

Listing 10.1 *Timeline code from the ArrayOfDiamonds.fla*

```
import ch10.Diamond;

var diamonds:Array = new Array();
var newDiamond:Diamond;
var diamondCount = 10;
var sortAction = null;
var depth:Number;
var name:String;

for (var i=0; i<diamondCount; i++) {

  depth = this.getNextHighestDepth();
  name = "d_" + depth;
  var mc:MovieClip = this.createEmptyMovieClip(name, depth);
  var newDiamond:Diamond =
    new Diamond(20 + (i * 55), 70, 50, mc, name);
  diamonds.push(newDiamond);
  newDiamond.draw();
}
trace("The diamonds Array contains:");
trace(diamonds.length + " elements:\n");
trace(diamonds.toString());
```

```
depth = this.getNextHighestDepth();
this.createTextField("array_length_txt", depth, 5, 5,
                     100, 22);

onEnterFrame = function () {
  for (var i=0; i<diamonds.length; i++) {
    if (diamonds[i] != null) {
      if (diamonds[i].alive) {
        diamonds[i].move();
      } else {
        diamonds[i].destroy();
        diamonds[i] = null;
        diamonds.splice(i, 1);
      }
    }
  }

  array_length_txt.text = "Length: " + diamonds.length;
}
```

Analyzing the Timeline Code

After the import statement, the first line of code creates an Array to hold the MovieClips:

```
var diamonds:Array = new Array();
```

Then a "for loop" is used to fill the array with instances of the Diamond class:

```
for (var i=0; i<diamondCount; i++) {

  depth = this.getNextHighestDepth();
  name = "d_" + depth;
  var mc:MovieClip = this.createEmptyMovieClip(name, depth);
  var newDiamond:Diamond =
    new Diamond(20 + (i * 55), 70, 50, mc, name);
  diamonds.push(newDiamond);
  newDiamond.draw();
}
```

The Diamond class needs some explanation, and that will come in the next section. The important thing to notice in the above code is that each new Diamond instance is added to the diamonds Array using the push() method:

```
diamonds.push(newDiamond);
```

The push() method takes one parameter of any data type and inserts it at the very end of the specified array. Each time through the loop, a new Diamond object is created and then added to the

diamonds Array. When the loop is finished, the Array contains 10 elements (diamondCount = 10 and diamonds.length = 10). The next three lines of code send some information to the Output window about the length and contents of the new array:

```
trace("The diamonds Array contains:");
trace(diamonds.length + " elements:\n");
trace(diamonds.toString());
```

The output looks like:

```
The diamonds Array contains:
10 elements:

[object Object],[object Object],[object Object],
[object Object],[object Object],[object Object],
[object Object],[object Object],[object Object],
[object Object]
```

This confirms that there are 10 elements in the Array. The toString() method of the Array class is used to create a text representation of the contents of the array. Since each element is a Diamond object, the output shows 10 "[object Object]" elements. The output isn't very informative, in this case, but it helps to confirm that the Array is initialized correctly.

Next, a TextField object is created dynamically and placed in the upper left corner of the Movie window. It is used to display the current length of the array:

```
depth = this.getNextHighestDepth();
this.createTextField("array_length_txt", depth, 5, 5,
                     100, 22);
```

Finally, the Main Timeline's onEnterFrame event property is assigned a function that updates the diamond objects each frame. It also updates the contents of the array_length_txt TextField object.

```
onEnterFrame = function () {
  for (var i=0; i<diamonds.length; i++) {
    if (diamonds[i] != null) {
      if (diamonds[i].alive) {
        diamonds[i].move();
      } else {
        diamonds[i].destroy();
        diamonds[i] = null;
        diamonds.splice(i, 1);
      }
    }
  }
  array_length_txt.text = "Length: " + diamonds.length;
}
```

Diamond instances have several methods, including a move() method and a destroy() method. They also have a property called, "alive", which indicates whether or not the Diamond should be destroyed. The Diamond's destroy() method takes care of freeing up any resources that the Diamond no longer needs – such as the MovieClip instance. Then the reference to the Diamond can be removed from the Array. This is accomplished using the Array splice() method.

The Array splice() method is one of the methods listed above in the "Adding and removing elements from an Array" category. It takes two parameters and returns an Array object. The first parameter is the index of the first element in the Array that should be removed. The second parameter is the number of elements that should be removed, starting at the specified index. Calling diamonds.splice(i, 1) removes 1 element starting with the element at index i, and it returns a new Array containing the element that was removed – in case the code needs to do something more with it. This example code in Listing 10.1 has no use for the removed element, so it ignores it. If additional (optional) parameters are passed to splice(), they will be inserted into the Array in place of the element(s) that were removed.

When the ArrayOfDiamonds.fla example code is run, it displays an undulating row of blue diamonds, as seen in Figure 10.1.

Figure 10.1 *The ArrayOfDiamonds.swf*

The Diamond instances are able to move up and down because each Diamond's move() instance is called each frame by the onEnterFrame event handler function. Diamond objects have another interesting behavior. When a Diamond instance detects a mouse click on it, it sets its own alive property to false. This instructs the onEnterFrame event handler function to call the Diamond's destroy() method and remove it from the diamonds Array using splice().

The Diamond Class

The Diamond class uses special methods of the MovieClip class to draw a Diamond shape in a MovieClip instance. MovieClips and their properties and methods will be discussed in more detail in Chapter 13. The properties and methods of the Diamond class that are most relevant to this chapter are shown in Table 10.3:

Table 10.3 *The methods and properties of the Diamond class*

Property	Description
mc	The MovieClip controlled by the class
name	The unique name given to each Diamond instance
TextField	A TextField object used to identify each instance visually
alive	A Boolean that determines when an instance should be destroyed

Method	Description
Diamond()	The constructor
move()	The method called each frame to move the MovieClip
destroy()	The method that cleans up when an instance is no longer needed

Listing 10.2 shows the full code of the Diamond class:

Listing 10.2 *A simple class for drawing Diamonds*

```
class ch10.Diamond {
    var coords:Object;
    var drift:Object;
    var mc:MovieClip;
    var name:String;
    var size:Number;
    var top:Object;
    var right:Object;
    var bottom:Object;
    var left:Object;
    var textField:TextField;
    var alive:Boolean;

    public function Diamond(x:Number, y:Number, size:Number,
                           movie_clip:MovieClip, name:
                           String) {
```

```
coords = new Object();
drift = new Object();

coords.x = x;
coords.y = y;
this.size = size;
mc = movie_clip;
mc.owner = this;
this.name = name;
drift.x = 0;
drift.y = 0;
alive = true;

top = {x:size/2, y:0};
right = {x:size, y:size/2};
bottom = {x:size/2, y:size};
left = {x:0, y:size/2};

mc.createTextField(name, 10, 0, 0, 100, 20);
textField = mc[name];
textField.text = name;

mc.onRelease = function() {
  trace(this.owner.name);
  this.owner.alive = false;
}
}

public function move():Void {

  var period:Number = 2000;
  var phase:Number = getTimer() % period;
  var frequency:Number = 1;
  var angle:Number = phase/period * frequency * Math.PI*2;
  var movieWidth:Number = 600;
  var phaseOffest:Number =
    (coords.x / movieWidth) * Math.PI*2;
  var amplitude:Number = 25;
  var yOffset = Math.sin(angle + phaseOffest) * amplitude;

  mc._x = coords.x + drift.x;
  mc._y = coords.y + yOffset + drift.y;

  drift.x *= .9;
  drift.y *= .9;
}
```

```
public function moveTo(x:Number, y:Number):Void {

  drift.x = coords.x - x;
  drift.y = coords.y - y;
  coords.x = x;
  coords.y = y;
}

public function draw():Void {

  mc.clear();
  mc.colors = [0xFF0000, 0x0000FF];
  mc.alphas = [100, 100];
  mc.ratios = [0, 0xFF];
  mc.matrix = {matrixType:"box", x:12.5, y:12.5,
               w:25, h:25, r:(45/180)*Math.PI};
  mc.beginFill(0x0022CC, 80);
  mc.lineStyle(2, 0xFF9900, 100);
  mc.moveTo(top.x, top.y);
  mc.lineTo(right.x, right.y);
  mc.lineTo(bottom.x, bottom.y);
  mc.lineTo(left.x, left.y);
  mc.lineTo(top.x, top.y);
  mc.endFill();
}

public function destroy():Void {
  mc.removeMovieClip();
  delete this;
}
}
```

In the Diamond class's constructor method – Diamond() – a function is assigned to the onRelease event handler of "mc", the class's MovieClip instance. This function is called when a Mouse click is detected anywhere on the diamond-shaped MovieClip instance (mc). The code in the function sets the alive property of the clicked Diamond to false:

```
mc.onRelease = function() {
  trace(this.owner.name);
  this.owner.alive = false;
}
```

When the function is called, the "this.owner" property refers to the MovieClip's "owner" property which is also set in the Diamond constructor:

```
mc.owner = this;
```

By setting this property on the class's MovieClip (mc), the MovieClip can invoke properties and methods of the Diamond instance that created it. In this case, the MovieClip instance uses its owner property to reference and set the Diamond's alive property to false. So, clicking on a Diamond's MovieClip causes the Diamond instance to be destroyed. The next time the onEnterFrame handler function is called, the Diamond's alive property is checked and then its destroy() method is called. The destroy() method cleans up the MovieClip instance and then the Diamond deletes itself:

```
public function destroy():Void {
  mc.removeMovieClip();
  delete this;
}
```

As mentioned earlier, the final step is that the onEnterFrame event handler function removes the Diamond instance from the main Array.

When it isn't being destroyed, each Diamond instance is given an opportunity to move() once per frame. The Diamond's move() method is interesting because it uses Math.sin() to generate a nice, wave-like motion for each Diamond.

A Basic Object Manager Class

When an application has a lot of dynamically created objects it is advantageous to have a centralized system for creating and disposing of them. The ObjectManager class defined in Listing 10.3 handles some common administrative Array operations. It also serves as a container for the various object arrays that may be employed by an application. Finally, it serves as a "factory" for creating different object types. By centralizing the creation and management of objects, any future refinements to the process can be made in one place.

Listing 10.3 *A general purpose ObjectManager class*

```
import ch7.DepthManager;
import ch10.Diamond;

class ch10.ObjectManager {

  static var movieClipTarget:MovieClip;
  static var arrays:Object = new Object();

  public static function setTarget(target:MovieClip) {

    movieClipTarget = target;
  }

  public static function createDiamond(x:Number, y:Number,
                                       size:Number):
                                       Diamond {

    var depth = DepthManager.getNextObjectDepth();
```

```
    var name = "d_" + depth;
    var emptyMovieClip:MovieClip =
      movieClipTarget.createEmptyMovieClip(name, depth);
    var newDiamond:Diamond =
      new Diamond(x, y, size, emptyMovieClip, name);

    return newDiamond;
  }
  public static function addObject(object:Object,
                                   array_id: String) {

    if (arrays[array_id] == undefined) {
      arrays[array_id] = new Array();
    }
    arrays[array_id].push(object);
  }
  public static function removeObject(array_id:String,
                                      index: Number) {

    arrays[array_id].splice(index, 1);
  }
}
```

The ObjectManager class has no constructor because its properties and methods are intended to be used statically. They are always referenced through the class name, "ObjectManager". As discussed in earlier chapters, this effectively makes its properties and methods globally available. The class does need initialization, however. The ObjectManager's MovieClipTarget property contains a reference to the timeline on which MovieClips will be created. It is initialized via the setTarget() method. The class also has a property called, "arrays", a generic Object which is used to hold any object arrays that are created.

The createDiamond() method takes care of creating and returning Diamond instances. The code is the same as the code from the ArrayOfDiamonds.fla, but it is now centralized.

The addObject() and removeObject() methods do the work of maintaining the object arrays. The addObject() method takes two parameters. The first parameter is the object which should be added to an Array. The second is the array_id, a String that is used to reference a specific Array. When addObject() encounters a new array_id, it first has to create an Array and attach it to the arrays object. It can then use the Array push() method to add the object to the end of the Array:

```
    public static function addObject(object:Object,
                                     array_id: String) {

    if (arrays[array_id] == undefined) {
      arrays[array_id] = new Array();
```

```
      }
      arrays[array_id].push(object);
}
```

When an object needs to be removed from an array, the removeObject() method is used. The removeObject() method also takes two parameters. The first is the array_id of the Array that contains the object. The second is the index of the object to be removed. The removeObject() method uses the array_id String to get the specified Array from the arrays object, and then uses splice() to remove it:

```
public static function removeObject(array_id:String,
    index: Number) {

    arrays[array_id].splice(index, 1);
}
```

An example use of the ObjectManager class can be seen in the ArrayOfDiamondsOM.fla in the ch10 folder of the examples. In addition to using the ObjectManager for maintaining Arrays, the ArrayOf DiamondsOM.fla demonstrates the use of the Array reverse() method. The timeline code looks like:

```
import ch10.ObjectManager;
import ch10.Diamond;

ObjectManager.setTarget(this);

var diamonds:Array = new Array();
var newDiamond:Diamond;
var diamondCount = 10;
var sortAction = null;
var name:String;
var depth:Number;

for (var i=0; i<diamondCount; i++) {
  myDiamond = ObjectManager.createDiamond(20 + (i * 55),
                                          70,50);
  myDiamond.draw();
  ObjectManager.addObject(myDiamond, "diamonds");
}
trace("The diamonds Array contains:");
trace(ObjectManager.arrays["diamonds"].length + " elements:
      \n");
trace(ObjectManager.arrays["diamonds"].toString());

name = "array_length_txt";
depth = this.getNextHighestDepth();
this.createTextField(name, depth, 5, 5, 100, 22);
```

```
onEnterFrame = function () {
  var thisArray = ObjectManager.arrays["diamonds"];

  if (sortAction == "reverse") {
    thisArray.reverse();
    for (var i=0; i<thisArray.length; i++) {
      thisArray[i].moveTo(20 + (i * 55), 70);
    }
    sortAction = null;
  }

  for (var i=0; i<thisArray.length; i++) {

    var thisDiamond:Diamond = Diamond(thisArray[i]);

    if (thisDiamond != null) {
      if (thisDiamond.alive) {
        thisDiamond.move();
      } else {
        thisDiamond.destroy();
        thisDiamond = null;
        ObjectManager.removeObject("diamonds", i);
      }
    }
  }

  array_length_txt.text = "Length: " + thisArray.length;
}

sort_control.onRelease = function () {
  sortAction = "reverse";
}

name = "ctrl_txt";
depth = this.getNextHighestDepth();
this.createTextField("ctrl_txt", depth, 0, 0, 100, 22);
ctrl_txt._x = sort_control._x + 20;
ctrl_txt._y = sort_control._y - 10;
ctrl_txt.text = "Reverse the Array";
```

The sort_control MovieClip instance in the lower left corner of the Movie Window has an onRelease() event handler function. When clicked, it sets the sortAction variable to "reverse". This tells the onEnterFrame event handler function to invoke the reverse() method on the Array and then redistribute the Diamonds according to their place in the Array. This causes the Diamonds to move to their new locations. The drift property in the Diamond class is used to make the Diamond instance move gradually to their new locations. The result is a very visual representation of what is going on in the Array. Figure 10.2 shows the ArrayOfDiamondsOM.swf.

Figure 10.2 *The ArrayOfDiamondsOM.swf*

Just The Beginning

This chapter has just scratched the surface in terms of what Arrays can do and how they can be used. A more useful example will be seen later – in the Astro Sweeper game.

11 Inheritance and Polymorphism

Superclasses and Subclasses

Inheritance is what a person gets from his or her parents. In AS2 programming terms, inheritance is what a "subclass" gets from its "superclass". As discussed earlier in this book, classes provide a convenient way to group related methods and properties (functions and variables) together. But the real advantage of using classes is that one class can inherit the methods and properties of another. If a number of classes all need to share a core set of methods and properties then rather than define these methods and properties multiple times, they can be defined once in a superclass and then inherited by subclasses.

Fruit – A Superclass

If inheritance is a new concept, then it may be helpful to think about it in familiar terms. The concept of class inheritance is actually familiar to everyone, but the terminology may not be. Take fruit, for example. The word "fruit" refers to a class of objects that are – among other things – edible. To adequately describe a fruit, a number of properties are required. Some (unscientific) fruit properties include:

- color
- juiciness
- sweetness

These informal properties apply to all fruit: apples, oranges, bananas, grapes, etc. But apples have properties that bananas don't have, including:

- roundness
- sourness

And grapes have properties that neither apples, nor bananas have:

- cluster size
- translucence

The analogy can only go so far. Real fruit are more complex than any AS2 class will ever be, but the properties and relationships defined above can be described in AS2 terms. The code for a (whimsical) Fruit class would look something like the code in Listing 11.1.

Listing 11.1 *A Fruit class*

```
class ch11.Fruit {

  var name:String;
  var color:String;
  var juiciness:String;
  var sweetness:String;

  public function Fruit(fruit_name:String,
                        fruit_color:String,
                        fruit_juiciness:String,
                        fruit_sweetness:String) {

    name = fruit_name;
    color = fruit_color;
    juiciness = fruit_juiciness;
    sweetness = fruit_sweetness;
  }

  public function out():Void {

    trace("Fruit: " + name);
    trace(" Color: " + color);
    trace(" Juiciness: " + juiciness);
    trace(" Sweetness: " + sweetness);
  }
}
```

The Fruit class has four properties: name, color, juiciness, and sweetness. It has a constructor method that sets these properties when a fruit object is instantiated. And it has a method, out(), which outputs its values. All Fruits will have these core properties and methods.

Apple – A Subclass

The Apple class uses the general Fruit class as a starting point and makes it more specific. Listing 11.2 shows an Apple class.

Listing 11.2 *An Apple class*

```
import ch11.Fruit;

class ch11.Apple extends Fruit{

  var roundness:String;
  var sourness:String;

  public function Apple(fruit_name:String,
                        fruit_color:String,
                        fruit_juiciness:String,
```

```
                              fruit_sweetness:String,
                              apple_roundness:String,
                              apple_sourness:String) {

        super(fruit_name, fruit_color, fruit_juiciness,
                fruit_sweetness);

        roundness = apple_roundness;
        sourness = apple_sourness;
    }

    public function out():Void {

        super.out();
        trace(" roundness: " + roundness);
        trace(" sourness: " + sourness);
        trace("");
    }
}
```

The import statement lets the Apple class refer to the Fruit class, which it does in the class declaration. This is where the relationship between the Fruit (superclass) and the Apple (subclass) is stated:

```
class ch10.Apple extends Fruit{
```

The "extends" keyword in the class declaration states that the Apple class should extend the Fruit class, meaning that it should inherit all of its properties and methods, and that it will define some of its own. That's all there is to it. Even though the Apple class only defines two of its own properties, each Apple object instance will have six: two from the Apple class and four from the Fruit class. In object-oriented terminology, the Apple class is "derived" from the Fruit class.

The Super() Operator

The constructor method of the Apple class has the job of initializing all of the properties of each Apple instance. Since each Apple will have six properties, the constructor takes six parameters. The Apple constructor could handle the initialization of all of these properties directly, but since the Fruit class already knows how to use four of them, the Apple constructor invokes the Fruit constructor using the "super()" operator:

```
super(fruit_name, fruit_color, fruit_juiciness,
        fruit_sweetness);
```

In this example, the super() operator is used to call the superclass's constructor, and in this case, the superclass is Fruit. The Fruit constructor sets the four properties that are shared by all fruit. Invoking the Fruit constructor with the super() operator ensures that these properties will be set for all Apple instances. Once the Apple constructor passes the Fruit parameters to its superclass, it sets the two remaining properties that are unique to Apples: roundness and sourness.

The Super Keyword

Finally, the Apple class defines its own out() method. This method "overrides" the out() method of the Fruit superclass. When the out() method of a generic Fruit object is invoked, the generic out() method of the Fruit class will be executed. However, when the out() method of an Apple object is invoked, the more specific out() method of the Apple class will be invoked. The Apple's out() method is interesting because it uses the "super" keyword to force the generic Fruit out() method to be invoked:

```
public function out():Void {

    super.out();
    trace(" roundness: " + roundness);
    trace(" sourness: " + sourness);
    trace("");
}
```

The result is that the Apple out() method calls the Fruit out() method explicitly and the code from both methods is executed. The super keyword is related to the super operator and can be used to access methods and properties of a superclass.

Grape – Another Subclass

Similarly a Grape class might look like the code in Listing 11.3.

Listing 11.3 *A Grape class*

```
import ch11.Fruit;

class ch11.Grape extends Fruit{

    var cluster_size:String;
    var translucence:String;

    public function Grape(fruit_name:String,
                          fruit_color:String,
                          fruit_juiciness:String,
                          fruit_sweetness:String,
                          grape_cluster_size:String,
                          grape_translucence:String) {

        super(fruit_name, fruit_color, fruit_juiciness,
              fruit_sweetness);

        cluster_size = grape_cluster_size;
        translucence = grape_translucence;
    }
```

```
public function out():Void {

  super.out();
  trace(" Cluster size: " + cluster_size);
  trace(" Translucence: " + translucence);
  trace("");
}
}
```

Polymorphism

Inheritance gives rise to an important object-oriented programming concept called, "polymorphism". The term, polymorphism, literally means: having many forms. In the context of programming, polymorphism refers to the fact that one object can – as a result of inheritance – have more than one form. As defined above, an Apple instance is an Apple, but it is also a Fruit. A Grape instance is a Grape, but also a Fruit. However, an Apple instance is not a Grape. (And a Doughnut without a hole is a Danish.)

Because Apple is a subclass of Fruit it can do all the things that Fruit can. Therefore, if necessary, it can be treated as a generic Fruit. The same is true for a Grape. To illustrate this, consider an Array filled with instances of Apples, Grapes, and generic Fruit:

```
var fruitArray:Array = new Array(tempApple, tempGrape,
                                 tempFruit);
```

The Array does not know the type of its elements, it just knows that it contains three objects. For the purpose of this discussion, one of the requirements of the following example program is that the Array, fruitArray, must contain Fruit instances, but the instances can be any subclass of Fruit. The following code will iterate through the array and output the name property of each object. Because every instance is a Fruit, it is guaranteed to have a name property:

```
for (var i=0; i<fruitArray.length; i++) {

  trace("Fruit name: " + Fruit(fruitArray[i]).name);
}
```

The output looks like:

```
Fruit name: Apple
Fruit name: Grape
Fruit name: Generic
```

Because elements of Arrays can be any type, the above code explicitly "casts" each elements as a Fruit instance by using a technique called "type casting". The ActionScript syntax for type casting is *type(object)* where *type* is the desired data type and *object* is the object being cast. Objects can be cast from their actual type to another when their actual type has all the properties and methods of the new type. Casting does not change the object, it just instructs the compiler and the player to treat the object as the specified type. Again, this only works if the original type has the same properties

and methods of the new type. In other words, the new type has to be more general than the original type. In fact, the new type generally has to be a superclass of the original type. The following code will generate an error:

```
for (var i=0; i<fruitArray.length; i++) {

    trace("Fruit name: " +
        Fruit(fruitArray[i]).translucence); //ERROR
}
```

This is because not all Fruit instances have a translucence property. Only Grapes do.

The same technique can be used to invoke the method of an object. The following code invokes the out() method of each object in fruitArray:

```
for (var i=0; i<fruitArray.length; i++) {

    Fruit(fruitArray[i]).out();
}
```

The output looks like:

```
Fruit: Apple
  Color: Red
  Juiciness: very juicy
  Sweetness: sweet
  roundness: oblong
  sourness: sour

Fruit: Grape
  Color: Green
  Juiciness: very juicy
  Sweetness: very sweet
  Cluster size: large
  Translucence: clear

Fruit: Generic
  Color: Blue
  Juiciness: juicy
  Sweetness: semi-sweet
```

This works because every Fruit subclass has an out() method. Even if it doesn't have its own, it has the generic out() method defined in the superclass. Note that in this example, each subclass has its own out() method and the correct out() method is called for each object. The Apple out() method is called for the Apple, the Grape out() method for the Grape, and the generic Fruit out() method for the fruit. This demonstrates the real power of inheritance and polymorphism. When classes share a common superclass, they can be managed in a general way, but still exhibit specific behavior.

The instanceof Operator

If an application needs to know whether or not an object is an instance of a certain class, the "instanceof" operator can be used. The instanceof operator takes two operands: a class instance and a reference to a class. It returns a Boolean (true or false). If the instance (object) is derived from the specified class, then instanceof returns true. An object is derived from a class if it is an instance of that class or an instance of any of its subclasses. In the context of the Fruit example (with some extrapolation), the following would all be instances of the Fruit superclass:

Fruit
Apple
Delicious Apple
Hungarian Delicious Apple
Grape
Chardonnay Grape

All of these classes are ultimately derived from the Fruit class. The following code tests to see if the instances of the fruitArray are instances of the ch11.Fruit class:

```
for (var i=0; i<fruitArray.length; i++) {

  var thisFruit:Fruit = Fruit(fruitArray[i]);
  var isInstanceOf:Boolean =
     (thisFruit instanceof ch11.Fruit);
  if (isInstanceOf) {
    trace(thisFruit.name + " is an instance of ch11.Fruit");
  } else {
    trace(thisFruit.name +
       " is not an instance of ch11.Fruit");
  }
}
```

The output is:

```
Apple is an instance of ch11.Fruit
Grape is an instance of ch11.Fruit
Generic is an instance of ch11.Fruit
```

The next example performs a more specific test: to see if the instances of the fruitArray are instances of the ch11.Apple class.

```
for (var i=0; i<fruitArray.length; i++) {

  var thisFruit:Fruit = Fruit(fruitArray[i]);
  var isInstanceOf:Boolean =
     (thisFruit instanceof ch11.Apple);
  if (isInstanceOf) {
     trace(thisFruit.name + " is an instance of ch11.Apple");
  } else {
```

```
        trace(thisFruit.name +
            " is not an instance of ch11.Apple");
    }
}
```

The output is:

```
Apple is an instance of ch11.Apple
Grape is not an instance of ch11.Apple
Generic is not an instance of ch11.Apple
```

Note that Grape and the Generic Fruit instances are not instances of the Apple class. The Fruit examples can be seen in the Fruit.fla in the ch11 folder of the examples.

So far, the Fruit classes have been useful for illustrating inheritance and polymorphism. The next section describes an inheritance strategy for game objects.

A BaseObject Class for Game Objects

In a space arcade game like the one described in this book, game objects often have a lot of properties and methods in common. This presents an ideal scenario for employing inheritance. Some of the game objects in this particular game include:

debris (space junk)
phantom crystals
a space ship
bullets
powerups

All of these objects share a number of properties which include:

coordinates – a location in space
a MovieClip – the visual representation of the object
a unique name – to identify the object
velocity – rate and direction of movement
orientation – orientation in space
alive status – indicates whether or not the object is alive

In addition to these common properties, the game objects listed above also share a number of methods, including:

move to – sets the object coordinates to a particular point in space
move – moves the object through space based on velocity
draw – draws any dynamic visual elements
draw bounds – draws the bounding rectangle of the object for debugging
destroy – disposes the object when it is no longer needed

Listing 11.4 shows the definition of a BaseObject class that can serve as a general superclass for the game objects described above. The BaseObject class is an appropriate superclass for all game objects that will move around in space.

Listing 11.4 *A BaseObject superclass for game objects*

```
class ch11.BaseObject {

  var coords:Object;
  var mc:MovieClip;
  var name:String;
  var speed:Number;
  var velocity:Object;
  var angleIndex:Number;
  var alive:Boolean;

  public function BaseObject(x:Number, y:Number,movie_clip:
                             MovieClip, name:String) {
    coords = new Object();
    velocity = new Object();

    coords.x = x;
    coords.y = y;
    mc = movie_clip;
    this.name = name;
    velocity.x = 0;
    velocity.y = 0;
    angleIndex = 1;
    alive = true;

    mc.hit_target._visible = false;
    mc.owner = this;
  }

  public function draw():Void {
    //to be overridden by subclasses
  }

  public function drawBounds():Void {
    //to be overridden by subclasses
  }

  public function move():Void {
    //to be overridden by subclasses
    mc._x = coords.x;
    mc._y = coords.y;
  }
```

```
public function moveTo(x:Number, y:Number):Void {

  coords.x = x;
  coords.y = y;
}

public function destroy():Void {
  mc.removeMovieClip();
  delete this;
}
}
```

The BaseObject class is not intended to be instantiated directly. It serves as a common basis for a number of subclasses that will be instantiated during the game. The BaseObject class is very minimal. Interesting, specific behavior will be defined in the subclasses.

Bullet – A Subclass of the BaseObject class

Listing 11.5 defines the Bullet subclass.

Listing 11.5 *A Bullet subclass of the BaseObject class*

```
import ch11.BaseObject;
import ch09.Timer;
import ch09.MathTables;
import ch09.FrameTimeManager;

class ch11.Bullet extends BaseObject {

  var durationTimer:Timer;

  public function Bullet(x:Number, y:Number, bullet_speed:
                         Number, angle_index:Number, movie_
                         clip:MovieClip, name:String) {

    super(x, y, movie_clip, name);

    angleIndex = angle_index;
    speed = bullet_speed;

    mc.gotoAndStop(angleIndex);

    durationTimer = new Timer();
    durationTimer.restartTimer();
  }
```

```
public function move():Void {

  MathTables.setVelocity(angleIndex, speed, velocity);

  coords.x += velocity.x *
     FrameTimeManager.getFrameSeconds();
  coords.y += velocity.y *
     FrameTimeManager.getFrameSeconds();

  mc._x = coords.x;
  mc._y = coords.y;

  if (durationTimer.milliseconds() > 750) {
    alive = false;
  }
 }
}
```

The Bullet class introduces one new property, the durationTimer. This instance of the ch09.Timer class is used to limit the range of bullets. More powerful bullets are effective at greater ranges and can travel farther. The durationTimer measures the amount of time that a bullet has been "alive". If the time exceeds a specified threshold (initially 750 milliseconds), the bullet is automatically expired and destroyed (disposed of). This opens the door for a "power up" that could increase the life span of bullets, making them effective at longer distances.

To accommodate the durationTimer functionality, the Bullet class overrides the generic move() method. It uses the ch09.MathTables class to calculate the correct velocity for the Bullet instances, and it uses the ch09.FrameTimeManager class to move Bullet instances the right distance per frame – based on elapsed time. Because it doesn't have to reproduce the methods and properties that it inherits from BaseObject, the Bullet class is very concise. Only Bullet-specific details need to be included.

Using the Bullet Class

Using the Bullet class is as easy as making a new Bullet instance and then invoking its move() method every frame. The timeline code in Listing 11.6 (from SingleBullet.fla in the ch11 folder of the examples) will make one Bullet and send it shooting off into space (for 750 milliseconds).

Listing 11.6 *Timeline code for using the Bullet class*

```
import ch11.ObjectManager;
import ch11.Bullet;
import ch09.FrameTimeManager;

var depth = this.getNextHighestDepth();
var name = "bullet_" + depth;
var tempMovieClip:MovieClip =
  this.attachMovie("bullet_type", name, depth);
```

```
var newBullet:Bullet =
  new Bullet(300, 400, 400, 1, tempMovieClip, name);

trace(newBullet.mc);

onEnterFrame = function () {
  FrameTimeManager.calculateFrameTime();
  if (newBullet.alive) {
    newBullet.move();
  } else {
    newBullet.destroy();
    newBullet = null;
  }
}
```

Note that the above example uses the FrameTimeManager class from Chapter 9. The Bullet's move() method uses the FrameTimeManager.getFrameSeconds() method to determine how far to move the Bullet each frame. Figure 11.1 shows the SingleBullet.swf.

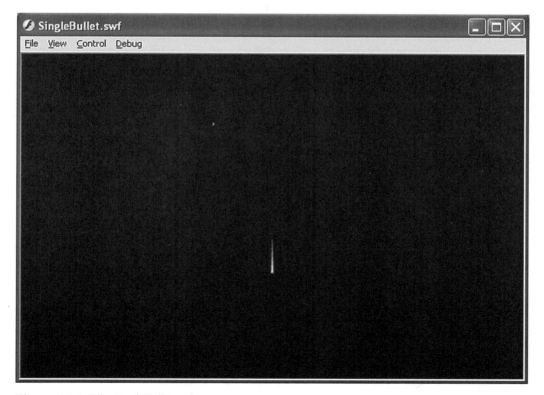

Figure 11.1 *The SingleBullet.swf*

To create and manage a number of Bullet instances, it makes sense to use the ObjectManager class which was introduced in Chapter 10. This class needs to be modified slightly to be able to handle Bullet objects. To preserve the code in the Chapter 10 examples, a copy of the ObjectManager class will be made for this Chapter (11). The new ch11.ObjectManager class will have the following additional method to create Bullet instances:

```actionscript
public static function createBullet(x:Number, y:Number,
                                    bullet_speed:Number,
                                    angle_index:Number):
                                    Bullet {

  var depth = GameDepthManager.getNextObjectDepth();
  var name = "bullet_" + depth;
  var tempMovieClip:MovieClip =
    movieClipTarget.attachMovie("bullet_type", name,
                                depth);

  var newBullet:Bullet =
    new Bullet(x, y, bullet_speed, angle_index,
               tempMovieClip, name);

  return newBullet;
}
```

With the addition of the createBullet() method, the ch11.ObjectManager is ready to be used. A full example can be seen in the ManyBullets.fla in the ch11 folder of the examples. The timeline code looks like:

```actionscript
import ch11.ObjectManager;
import ch11.BaseObject;
import ch11.Bullet;
import ch09.FrameTimeManager;
import ch09.Timer;

ObjectManager.setTarget(this);

var tempBullet:Bullet;
var fireTimer:Timer = new Timer();

onEnterFrame = function () {

  FrameTimeManager.calculateFrameTime();

  if (fireTimer.milliseconds() > 33) {
    var randomAngle:Number = Math.floor(Math.random() * 31);
    tempBullet =
      ObjectManager.createBullet(300, 200, 400,
                                 random Angle);
```

```
       ObjectManager.addObject(tempBullet, "collision");
       fireTimer.restartTimer();
   }

   var thisArray = ObjectManager.arrays["collision"];

   for (var i=0; i < thisArray.length; i++) {

     var tempObject:BaseObject = BaseObject(thisArray[i]);

     if (tempObject != null) {
       if (tempObject.alive) {
         tempObject.move();
       } else {
         tempObject.destroy();
         tempObject = null;
         ObjectManager.removeObject("collision", i);
       }
     }
   }
}
```

Notice how the objects in the object list are cast as generic BaseObject instances:

```
   var tempObject:BaseObject = BaseObject(thisArray[i]);
```

This anticipates the need for the "collision" object list to contain a variety of BaseObject subclasses, in addition to Bullet instances. As discussed above, because ActionScript allows for Polymorphism, the move() method can be invoked on every element of the "collision" object list. Depending on the subclass of each object, the appropriate move() method will be invoked. In this case, since all objects in the list are Bullet instances, the Bullet move() method is automatically invoked by the line:

```
   tempObject.move();
```

This chapter has explained how inheritance can be used to create a foundation for game objects in a game application. The Bullet is used as a specific example. The rest of the game object subclasses will be constructed in later chapters. Figure 11.2 shows the ManyBulletst.swf.

Reusability

Notice how easy it is to reuse classes from one example application to another. With the exception of the ObjectManager class, which had to copied and modified to preserve the integrity of the Chapter 10 examples, all the classes constructed in previous chapters can be used in this chapter. They don't have to be moved or copied, they can simply be referenced, a la "import ch09.Timer", etc. Using classes makes it possible to maintain a library of code that can be shared among many

Figure 11.2 *The ManyBullets.swf*

Flash applications. This library can also be shared among many Flash developers, either by keeping it in a central location on a shared file system, or by using a source code management system like concurrent versions system (CVS). A discussion of source code management is beyond the scope of this book, but there are many free and easy to use systems available.

Inheritance – Finding a Balance

After getting the hang of classes and inheritance, everything starts to look like a subclass. It is easy to get carried away. Like anything, inheritance can be taken too far. Sometimes, rather than defining a subclass it might make more sense to just use an extra property or two. The goal of inheritance is to make life easier down the road. The extra setup time has to payoff in terms of simpler development, easier maintenance, portability, reusability, sanity, etc. Knowing the right balance comes with experience.

BUILT-IN CLASSES

03

12 Built-in Classes

Built-in Classes

ActionScript 2 makes it possible to create new, custom classes, but it also includes some essential, ready-to-go classes authored by Macromedia. Through these classes, Flash provides functionality that would otherwise be impossible to achieve. AS2's built-in classes are special because they actually act as interfaces to underlying low-level program code. This low-level code interacts directly with the computer's hardware to control the display, audio output, file I/O, and to get input from the keyboard, mouse, network, etc.

AS2 utilizes many built-in classes, but there are several which are important to this book and which deserve special attention. These include:

The **MovieClip** Class
The **Key** Class
The **Sound** Class
The **XML** Class

In the next few chapters, each of these classes will be described in detail with typical usage examples.

The MovieClip Class

In many ways, the MovieClip is the class that everything else in the Flash universe revolves around. MovieClips are the onstage performers and the offstage workers that make every Flash application what it is.

In early versions of Flash, MovieClips were constructed and arranged on the stage manually using the Flash design tools. This is still often the case, but the MovieClip class gives the AS2 programmer the ability to create and manipulate MovieClips programmatically through code. The result is dynamically controlled MovieClips that can be used as fancy user-interface elements, game objects, etc.

The Key Class

The Key Class provides access to the computer's keyboard hardware. When users press, hold, release, and toggle keys, the Key object can detect and report this to the application.

The Sound Class

The Sound Class provides access to the computer's audio hardware. When an application needs to make some noise, the Sound Class provides the interface to load, play, and control sounds.

The XML Class

The XML Class provides an extremely powerful mechanism that allows Flash applications to import and export large amounts of structured data. It can be used to load xml files containing application data, or to send application data to a remote server. The XML Class can also provide a persistent network connection that can be used to implement multiplayer games or live chat applications. As a topic, it deserves a book all to itself.

Other Built-in Classes

In addition to the built-in classes in the previous chapters, there are several others worth mentioning because they provide the only mechanism for accomplishing certain important hardware-related functions. These include:

The **Camera** Class
The **LoadVars** Class
The **Microphone** Class
The **MovieClipLoader** Class
The **PrintJob** Class
The **SharedObject** Class
The **Video** Class

The Camera Class

The Camera Class gives AS2 the ability to capture video from a video camera. When this is used in conjunction with the Flash Communication Server, it is possible to achieve peer-to-peer video chat, for instance. Without the Flash communication Server, it can still be interesting. In a standalone application, the Camera Class can be used to monitor the activity of one or more local cameras.

The LoadVars Class

The **LoadVars** Class is a workhorse class that has been an important part of Flash for a long time. LoadVars provides a mechanism for importing and exporting data to and from an external source, like a URL. LoadVars requires the data from the source to be formatted in name-value pairs separated by ampersands, for example score=20&user_name=Andrew&...

This used to be the only way to get data in and out of Flash movies. Now there are several ways which are often preferable. In particular, the XML class provides a much nicer way to import and export lots of structured data.

The Microphone Class

The Microphone Class is like the Camera Class in that it is used primarily with the Flash Communication Server to provide two-way audio communication with other Flash applications. In a standalone application, it can be used to monitor audio input.

The MovieClipLoader Class

The MovieClipLoader Class is a recent addition to Flash, available only in the Flash Player 7 and later. It provides a way to dynamically load swf files and JPEG image files into MovieClips. These file types are often large and take time to load, so the MovieClipLoader class keeps track of and reports the loading progress of such files.

The PrintJob Class

The PrintJob Class is another recent addition to Flash, also available only in the Flash Player 7 and later. It provides a nice way to print content from a Flash application. Flash also has a global Print function that has been around longer, but the PrintJob Class provides better functionality and control over printing tasks.

The SharedObject Class

For security reasons, the Flash Player is not allowed to write files onto the local computer's file system. This means that Flash applications cannot store long-term data simply by writing a data file. However, The SharedObject Class provides a safe way to allow Flash applications to store some long-term data on the file system. It can also be used to store data on a remote server. It can be used in any number of ways. For example, a Flash game could use the SharedObject Class to maintain a high score list.

The Video Class

The Video Class provides control over a streaming video source. Instances of Videos need to be constructed and arranged on the stage manually using the Flash design tools. The Video instance can then be attached to a streaming video source using its attachVideo() method. Video instances can be positioned programmatically on the stage like MovieClips, using their _x and _y properties, etc.

13 Built-in Classes: The MovieClip Class

The MovieClip Class

The MovieClip Class is arguably the most important ActionScript class. Without it, Flash wouldn't be Flash. Just about every other element in a Flash application plays a supporting role to one or more MovieClips. MovieClips perform a wide variety of roles in Flash applications. This is reflected in the large number of methods, properties, and event handlers that make up the MovieClip class. Covering all of these in detail is beyond the scope of this book. This chapter will focus on a core set of MovieClip features that are applicable in just about every ActionScript 2 application. These features will be demonstrated in the MovieClipClass.fla, available in the MovieClipClass folder of the examples.

The following tables list and briefly describe the methods and properties of the MovieClip class. The tables are organized as follows:

- General Methods relevant to this book.
- Drawing Methods relevant to this book.
- Other Methods.
- Methods for Flash Player 8 only.
- Properties.
- Properties for Flash Player 8 only.
- Events Handler Properties.

General Methods Relevant to This Book

The MovieClip Class has many methods. Table 13.1 describes those that are especially relevant to this book.

Drawing Methods Relevant to This Book

Table 13.2 describes the methods of the MovieClip class that are used to dynamically draw lines, shapes, etc.

Other Methods

Table 13.3 describes methods of the MovieClip class that are not discussed specifically in this book, but are nonetheless important.

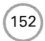

Table 13.1 *Some Methods of the MovieClip class*

Method	Description
attachMovie()	Creates a new instance of a MovieClip symbol from the Library.
createEmptyMovieClip()	Creates an empty MovieClip.
createTextField()	Creates a new, empty text field.
duplicateMovieClip()	Creates a new instance of the specified MovieClip.
getBounds(bounds:Object)	Returns the bounding rectangle of the specified MovieClip.
getDepth()	Returns the depth of the MovieClip instance.
getNextHighestDepth()	Determines a depth value that won't interfere with another clip.
localToGlobal()	Converts coordinates from a MovieClip's (local) coordinates to the Stage's (global) coordinates.
gotoAndPlay()	Moves the playhead to the specified frame and starts playing.
gotoAndStop()	Moves the playhead to the specified frame and stops it.
hitTest()	Checks to see if two MovieClips overlap.
nextFrame()	Moves the playhead to the next frame and stops it.
play()	Instructs the playhead to start playing from the current frame.
prevFrame()	Moves the playhead to the previous frame and stops it.
removeMovieClip()	Removes a dynamically created MovieClip instance.
startDrag()	Instructs the MovieClip to be dragged by the Mouse.
stop()	Stops a MovieClip from playing.
stopDrag()	Ends a MovieClip.startDrag() method.
swapDepths()	Used to trade depths between MovieClips.

Table 13.2 *Drawing Methods of the MovieClip class*

Method	Description
beginFill()	Used to fill a drawing path with a solid color.
beginGradientFill()	Used to fill a drawing path with a gradient.
clear()	Removes all the graphics created by the MovieClip draw methods.
curveTo()	Draws a curve using the current line style from the current drawing position to using the specified control point.
endFill()	Applies a fill to the lines and curves added since the last call to beginFill() or beginGradientFill().
lineStyle()	Specifies the line style to be used for subsequent calls to lineTo() and curveTo().
lineTo()	Draws a line using the current line style from the current drawing position to the given coordinates.
moveTo()	Moves the current drawing position to the given coordinates.

Table 13.3 *More Methods of the MovieClip class*

Method	Description
attachAudio()	Specifies the audio source to be played.
getBytesLoaded()	Returns the number of bytes that have already loaded (streamed) for the movie clip specified by my_mc.
getBytesTotal()	Returns the size, in bytes, of the movie clip specified by my_mc.
getInstanceAtDepth()	Determines if a particular depth is already occupied by a movie clip.
getSWFVersion()	Returns an integer that indicates the Flash Player version for which my_mc was published.
getTextSnapshot()	Returns a TextSnapshot object that contains the text in all the static text fields in the specified movie clip; text in child movie clips is not included.
getURL()	Loads a document from the specified URL into the specified window.
globalToLocal()	Converts the pt object from Stage (global) coordinates to the movie clip's (local) coordinates.
loadMovie()	Loads SWF, JPEG, GIF, or PNG files into a movie clip in Flash Player while the original SWF file is playing.
loadVariables()	Reads data from an external file and sets the values for variables in my_mc.
setMask()	Makes the movie clip in the parameter mc a mask that reveals the movie clip specified by my_mc.
unloadMovie()	Removes the contents of a movie clip instance.

Table 13.4 *Methods of the MovieClip class for the Flash Player 8*

Method	Description
attachBitmap	Attaches a bitmap image to a movie clip.
beginBitmapFill	Fills a drawing area with a bitmap image.
getRect	Specified by my_mc for the bounds parameter, excluding any strokes on shapes.
lineGradientStyle	Specifies a line style that Flash uses for subsequent calls to lineTo() and curveTo() until you call lineStyle() or lineGradientStyle() with different parameters.

Methods For Flash Player 8 Only

Table 13.4 describes the methods of the MovieClip class that are new to Flash 8. They can only be used in Flash applications that will run on the new Flash 8 Player.

Properties of the MovieClip Class

Table 13.5 describes the properties of the MovieClip class.

Properties for Flash Player 8 Only

Table 13.6 describes the properties of the MovieClip class that are for use with the Flash Player 8.

Event Handler Properties of the MovieClip Class

Table 13.7 describes the event handler properties of the MovieClip class. These are used to detect and handle a wide range of event types.

Table 13.5 *Properties of the MovieClip class*

Property	Description
_alpha	The alpha transparency value of the movie clip specified by my_mc.
_currentframe	Returns the number of the frame in which the playhead is located in the Timeline specified by my_mc.
_droptarget	Returns the absolute path in slash syntax notation of the movie clip instance on which my_mc was dropped.
_focusrect	A Boolean value that specifies whether a movie clip has a yellow rectangle around it when it has keyboard focus.
_framesloaded	The number of frames that are loaded from a streaming SWF file.
_height	The height of the movie clip, in pixels.
_highquality	Deprecated as of Flash Player 7. This function was deprecated in favor of _quality. Specifies the level of anti-aliasing applied to the current SWF file.
_lockroot	Specifies what _root refers to when a SWF file is loaded into a movie clip.
_name	The instance name of the movie clip specified by my_mc.
_parent	A reference to the movie clip or object that contains the current movie clip or object.
_quality	Flash only Property (global); sets or retrieves the rendering quality used for a SWF file.
_rotation	The rotation of the movie clip, in degrees, from its original orientation.
_soundbuftime	Specifies the number of seconds a sound prebuffers before it starts to stream.
_target	Returns the target path of the movie clip instance specified by my_mc in slash notation.
_totalframes	Returns the total number of frames in the movie clip instance specified in the MovieClip parameter.
_url	Retrieves the URL of the SWF, JPEG, GIF, or PNG file from which the movie clip was downloaded.
_visible	A Boolean value that indicates whether the movie clip specified by my_mc is visible.
_width	The width of the movie clip, in pixels.
_x	An integer that sets the x coordinate of a movie clip relative to the local coordinates of the parent movie clip.
_xmouse	Returns the x coordinate of the mouse position.
_xscale	Determines the horizontal scale (percentage) of the movie clip as applied from the registration point of the movie clip.
_y	Sets the y coordinate of a movie clip relative to the local coordinates of the parent movie clip.
_ymouse	Indicates the y coordinate of the mouse position.
_yscale	Sets the vertical scale (percentage) of the movie clip as applied from the registration point of the movie clip.
enabled	A Boolean value that indicates whether a movie clip is enabled.
focusEnabled	If the value is undefined or false, a movie clip cannot receive input focus unless it is a button.
hitArea	Designates another movie clip to serve as the hit area for a movie clip.
menu	Associates the specified ContextMenu object with the my_mc movie clip.
tabChildren	Determines whether the children of a movie clip are included in the automatic tab ordering.
tabEnabled	Specifies whether my_mc is included in automatic tab ordering.
tabIndex	Lets you customize the tab ordering of objects in a movie.
trackAsMenu	A Boolean value that indicates whether or not other buttons or movie clips can receive mouse release events.
useHandCursor	A Boolean value that indicates whether the hand cursor (pointing hand) appears when the mouse rolls over a movie clip.

Table 13.6 *Properties of the MovieClip class for the Flash Player 8*

Property	Description
blendMode	The blend mode for this movie clip.
cacheAsBitmap	If set to true, Flash Player caches an internal bitmap representation of the movie clip.
filters	An indexed array containing each filter object currently associated with the movie clip.
opaqueBackground	The color of the movie clip's opaque (not transparent) background of the color specified by the number (an RGB hexadecimal value).
scale9Grid	The rectangular region that defines the nine scaling regions for the movie clip.
scrollRect	Larger content.
transform	An object with properties pertaining to a movie clip's matrix, color transform, and pixel bounds.

Table 13.7 *Event Handler Properties of the MovieClip class*

Event handler property	Description
onData	Invoked when a movie clip receives data from a MovieClip. loadVariables() or MovieClip.loadMovie() call.
onDragOut	Invoked when the mouse button is pressed and the pointer rolls outside the object.
onDragOver	Invoked when the pointer is dragged outside and then over the movie clip.
onEnterFrame	Invoked repeatedly at the frame rate of the SWF file.
onKeyDown	Invoked when a movie clip has input focus and a key is pressed.
onKeyUp	Invoked when a key is released.
onKillFocus	Invoked when a movie clip loses keyboard focus.
onLoad	Invoked when the movie clip is instantiated and appears in the Timeline.
onMouseDown	Invoked when the mouse button is pressed.
onMouseMove	Invoked when the mouse moves.
onMouseUp	Invoked when the mouse button is released.
onPress	Invoked when the user clicks the mouse while the pointer is over a movie clip.
onRelease	Invoked when the mouse button is released over a movie clip.
onReleaseOutside	Invoked after the mouse button has been pressed inside the movie clip area and then released outside the movie clip area.
onRollOut	Invoked when the pointer moves outside a movie clip area.
onRollOver	Invoked when the pointer moves over a movie clip area.
onSetFocus	Invoked when a movie clip receives keyboard focus.
onUnload	Invoked in the first frame after the movie clip is removed from the Timeline.

Putting the MovieClip Class to Work

The tables above describe the many methods and properties of the MovieClip class. In this section, some of the most useful MovieClip functionality will be discussed in the context of the MovieClipClass.fla, available in the MovieClipClass folder of the examples. Testing the MovieClipClass.fla (<CTRL><ENTER>) reveals an application that has some of the basic characteristics of a game. Figure 13.1 shows the MovieClipClass.swf.

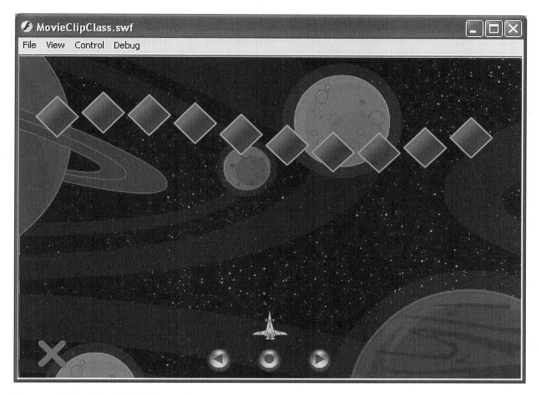

Figure 13.1 *MovieClipClass.swf*

Techniques from Previous Chapters

The MovieClipClass.fla example is the culmination of the examples from the previous chapters. The following techniques were introduced in previous chapters and are utilized in this chapter:

- From Chapter 2
 - Controlling MovieClip animation with gotoAndPlay() and gotoAndStop().
 - Controlling MovieClip movement by setting the _x and _y properties.
 - The Ship MovieClip and its nested MovieClip organization – including the callback technique to inform the controller class when animation cycles are complete.
 - The use of attachMovie() to dynamically create instance of the Ship and Buller MovieClips.
 - The use of createEmptyMovieClip() to create completely new MovieClips dynamically.

- From Chapter 3
 - The use of event handler functions,
 - onRollOver,
 - onRollOut,
 - onChanged,
 - onEnterFrame,
 - the use of listeners,
 - addListener().
- From Chapter 4
 - The use of external class files.
- From Chapters 5 and 6
 - The use of custom classes.
- From Chapter 7
 - The use of the GameDepthManager class.
- From Chapter 8
 - The use of basic language features including variables, operators, statements.
- From Chapter 9
 - The use of custom and built-in functions.
 - The use of the FrameTimeManager class.
 - The use of the Timer class.
 - The use of the MathTables class for optimizing sine and cosine calculations.
- From Chapter 10
 - The use of Arrays to manage game objects.
 - The use of the ObjectManager class – modified for use in this chapter.
 - The use of the Diamond class – modified for use in this chapter.
 - MovieClip movement controlled by math.
- From Chapter 11
 - The use of inheritance to create subclasses.
 - The use of the BaseObject class.
 - The use of the Bullet class.

It is easier to learn about all of the listed topics and concepts when they are analyzed separately and in no particular context. However, the true power of ActionScript becomes apparent when they are combined.

New Techniques for This Chapter

In addition to combining the techniques from previous chapters, this chapter introduces a few new techniques that help further demonstrate the power of MovieClips. These include:

- Collision detection using the hitTest() method.
- The use of the beginGradientFill() method.
- The use of the getBounds() method.
- Drag-and-Drop functionality.

- The use of the TextFormat class.
- A preliminary Ship class to control a space ship object and its associated MovieClip – this will be completed in later chapters.

Timeline Organization

The Main Timeline of the MovieClipClass.fla example is relatively simple. There are two layers for code named: "functions" and "event handlers". There is one layer called "controls" for the buttons and control symbols. And there is one layer called "space bg" for the scenic backdrop.

The "functions" layer contains function definitions that will be referenced by the code on the "event handler" layer. Separating the timeline code into two layers helps to improve the readability of the code. When there are more than a couple of pages of code on a single action frame it may makes sense to break it up over multiple frames – especially if the code can be divided into related sections. In this case, the code which is directly related to event handling is grouped together, as is the code which initializes and controls the game objects. Figure 13.2 shows the MovieClassExample.fla open in the workspace with the Actions panel open in a floating window. On the Stage, the space backdrop is visible as well as the three ship controls and the drag-and-drop-object-delete control (the red X).

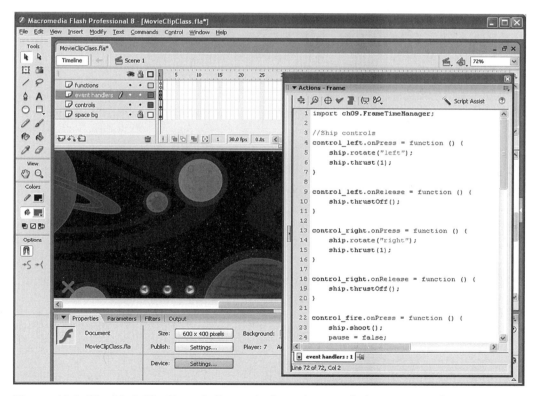

Figure 13.2 *The MovieClassExample.fla open in the workspace with the Actions panel open in a floating window*

The New Diamonds

In this chapter's example FLA, the Diamonds from Chapter 10 are back, and they are slightly modified. This is immediately obvious because they are drawn with a gradient fill instead of a solid fill. What is not immediately obvious is that they now have a simple drag-and-drop behavior, and when they are hit with a Bullet, they display their bounding rectangle. This is helpful for debugging collision testing. The new Diamonds also set the font characteristics of their labels to white Arial for better visibility against the space backdrop. To implement this new functionality, two new properties have been added to the Diamond class:

```
var textFormat:TextFormat;
var dragging:Boolean;
```

The "textFormat" property holds a TextFormat object used to control the type style of the Diamond's TextField label. The "dragging" property is used to determine whether a Diamond instance is in the process of being dragged.

More importantly, the new Diamond class extends the BaseObject class from Chapter 11. It is now a subclass of the BaseObject class. Since Bullets and Diamonds now have the same superclass, polymorphism can be used to invoke their common BaseObject methods.

Analyzing the New Diamond Methods

The new and modified Diamond methods include:

- A modified draw() method which used a gradient fill.
- A new drawBounds() method which draws the bounding rectangle of the mc MovieClip.
- A dragDiamond() method which prepares the Diamond to be dragged.
- A stopDragDiamond() method which updates the Diamond's properties when it is released after being dragged.

draw()

The draw() method is the same except for the gradient fill. The gradient fill is similar to the solid fill, except that it needs parameters that define the nature of the gradient. There are a variety of gradient types. This example shows the use of the simplest: a rectangular gradient. The supplied parameters include:

- A "box" matrix which makes the gradient rectangular.
- Coordinates for the center of the gradient (relative to the containing MovieClip).
- Width and height of the gradient.
- The angle of the gradient.

```
public function draw():Void {

  mc.clear();
  mc.colors = [0xFF0000, 0x0000FF];
  mc.alphas = [100, 100];
```

```
        mc.ratios = [0, 0xFF];
        mc.matrix = {matrixType:"box", x:12.5, y:12.5,
                        w:25, h:25, r:(45/180)*Math.PI};
        mc.beginGradientFill("linear", mc.colors, mc.alphas,
                                mc.ratios, mc.matrix);
        mc.lineStyle(2, 0xFF9900, 100);
        mc.moveTo(top.x, top.y);
        mc.lineTo(right.x, right.y);
        mc.lineTo(bottom.x, bottom.y);
        mc.lineTo(left.x, left.y);
        mc.lineTo(top.x, top.y);
        mc.endFill();
    }
```

drawBounds()

The drawBounds() method uses the getBounds() method of the MovieClip class to get the bounding rectangle of the MovieClip. The bounding rectangle is the smallest rectangle that completely encloses all of the graphical elements in the MovieClip. The getBounds() method returns an object with four properties: xMin, xMax, yMin, and yMax. These properties are used to determine the corners of the bounding rectangle, and the lineTo() method is used to draw the outline.

```
    public function drawBounds():Void {

        var bounds:Object;

        bounds = mc.getBounds(mc);
        mc.moveTo(bounds.xMin, bounds.yMin);
        mc.lineTo(bounds.xMax, bounds.yMin);
        mc.lineTo(bounds.xMax, bounds.yMax);
        mc.lineTo(bounds.xMin, bounds.yMax);
        mc.lineTo(bounds.xMin, bounds.yMin);

        textField.text = name;
        textField.setTextFormat(textFormat);
    }
```

dragDiamond() and stopDragDiamond()

The dragDiamond() method simply sets the "dragging" property to true, indicating to the move() method that the Diamond is under user-control. When dragging is true, the move() method does not try to update the Diamond's position. The stopDragDiamond() method sets the "drift" property to the distance that the Diamond was dragged and then sets the dragging property to false, so the move() method can resume control of the Diamond's movement. This causes the Diamond to slowly return to its original location. The label is also drawn with the specified text format.

```
public function dragDiamond():Void {
  dragging = true;
}

  public function stopDragDiamond(drop_target:String):Void {
    dragging = false;
    drift.x = mc._x - coords.x;
    drift.y = mc._y - coords.y;

    textField.text = name;
    textField.setTextFormat(textFormat);
  }
```

Readying the mc Property for Drag and Drop

In the constructor of the Diamond class, there is another modification. The Diamond's MovieClip (mc) is assigned two event handler functions for its onPress and onRelease properties. The code looks like:

```
mc.onPress = function() {
  this.startDrag();
  this.owner.dragDiamond();
};

mc.onRelease = function() {
  this.stopDrag();
  this.owner.stopDragDiamond(this._droptarget);
};
```

The onPress handler calls the built-in startDrag() MovieClip method which assigns control of the MovieClip instance to the mouse. It also calls the Diamond's dragDiamond() method which sets the dragging property to true.

The onRelease handler calls the built-in stopDrag() MovieClip method which releases the MovieClip instance from the mouse's control. It then calls the Diamond's stopDragDiamond() method which updates the drift property and sets the dragging property to false.

The new Diamond behaviors can be seen by testing the FLA (<CTRL><ENTER>).

The Ship Class

The Ship class described in this chapter is the foundation for the full-featured space ship in the next section. The Ship uses the nested MovieClip technique which was explained in Chapter 2. To recap, the hierarchy of the nested Ship components is:

- Ship
 - Ship_anim
 - Ship_body
 - Ship_pods

- Ship_shield_anim
 - Ship_shield_cycle
 - Ship_shield
- Ship_thrust_anim
 - Ship_thrust_cycle
 - Ship_thrust

The elements of the Ship can be seen in the Library, as shown in Figure 13.3.

Figure 13.3 *The elements of the Ship in the Library*

The Ship_anim MovieClip, which is nested inside the Ship MovieClip, contains the animations for the various visual states of the ship: idle, shoot, hit, and over. The shoot animation causes the "pods" to cycle, the hit animation causes the Ship to shudder, and the over animation replaces the Ship with an explosion.

At the end of the shoot, hit and over animations, the ship invokes methods of the object designated as its owner. In this example the Ship MovieClip's owner is the Ship class instance. These "callbacks" inform the Ship instance that the current animation cycle has finished and it can either be retriggered, or another animation can begin.

Methods and Properties of the Ship Class

Like the Bullet and Diamond classes, the Ship class extends the BaseObject class. This keeps the code in the Ship class focused on Ship-specific features, and it means that Ship instances can be treated as BaseObjects when necessary. Table 13.8 shows the methods and properties of the Ship class.

Table 13.8 *Properties of the Ship class*

Method	Description
setShielded()	Sets the shield state
move()	Overrides the BaseObject move() method
setAnimation()	Determines the appropriate animation to play
doneShooting()	A callback method for the MovieClip to signal the end of a shooting cycle
thrust()	Activates the thrusters
thrustOff()	Deactivates the thrusters
rotate()	Sets the orientation of the ship by stopping the Ship MovieClip on one of the 32 frames in its complete rotation
shoot()	Creates and launches a new Bullet instance
die()	Sets the alive property to false, ultimately triggering the game over sequence

Property	Description
over	Determines if the over animation should play
anim	The label of the current animation
animPrev	The label of the previous animation
shooting	Determines if the Ship is shooting
hit	Determines if the Ship is hit
animDone	Determines if the current animation is done
shieldOn	Determines if the shield is on
thrustOn	Determines if the thruster is on
shieldPlaying	Determines if the shield animation is playing
thrustPlaying	Determines if the thrust animation is playing

The full Ship class definition can be seen in Listing 13.1.

Listing 13.1 *The Preliminary Ship Class Definition*

```
import MovieClipClass.ObjectManager;
import ch11.BaseObject;
import ch11.Bullet;

class MovieClipClass.Ship extends BaseObject {

  var over:Boolean;
  var anim:String;
  var animPrev:String;
  var shooting:Boolean = false;
  var hit:Boolean = false;
  var animDone:Boolean = true;
  var shieldOn:Boolean = false;
  var thrustOn:Boolean = false;
  var shieldPlaying:Boolean = false;
  var thrustPlaying:Boolean = false;

  public function Ship(x:Number, y:Number,
                       movie_clip:MovieClip, name:String) {
    super(x, y, movie_clip, name);

    //mc._visible = false;
    mc.gotoAndStop(1);
    mc.ship_shield._visible = false;
    mc.ship_thrust._visible = false;
    mc.ship_anim.owner = this;
  }

  public function setShielded(state:Boolean):Void {
    shieldOn = state;
  }

  public function move():Void {
    mc._x = coords.x;
    mc._y = coords.y;

    setAnimation();
  }

  public function setAnimation():Void {

    if (animDone){

      //set animation state
      if (over) {
```

```
        anim = "over";
        animDone = false;
    } else if (hit) {
        anim = "hit";
        animDone = false;
    } else if (shooting) {
        anim = "shoot";
        animDone = false;
    } else {
        anim = "idle";
    }

    //set thrust visibility
    if (thrustOn) {
      mc.ship_thrust._visible = true;
      if (!thrustPlaying) {
        mc.ship_thrust.gotoAndPlay("on");
        thrustPlaying = true;
      }
    } else {
      mc.ship_thrust._visible = false;
      thrustPlaying = false;
    }

    //set shield visibility
    if (shieldOn) {
      if (!shieldPlaying) {
        mc.ship_shield._visible = true;
        mc.ship_shield.gotoAndPlay("on");
        shieldPlaying = true;
      }
    } else {
      mc.ship_shield._visible = false;
      shieldPlaying = false;
    }

    if (anim != animPrev) {

      mc.ship_anim.gotoAndPlay(anim);
      animPrev = anim;
    }
  }
}
```

```
public function doneShooting():Void {

  trace("Done Shooting");
  animDone = true;
  shooting = false;
  hit = false;
  anim = "idle";
  animPrev = "";
}

public function reset():Void {

}

public function thrust(direction:Number):Void {

  thrustOn = true;
}

public function thrustOff():Void {
  thrustOn = false
}

public function rotate(direction:String):Void {

  if (direction == "right") {
    if (angleIndex == 32) {
      angleIndex = 1;
    } else {
      angleIndex += 1;
    }
  } else if (direction == "left") {
    if (angleIndex == 1) {
      angleIndex = 32;
    } else {
      angleIndex -= 1;
    }
  }
  mc.gotoAndStop(angleIndex);
}

public function shoot():Void {

  var tempBullet:Bullet

  if (alive && !shooting) {

    shooting = true;
    tempBullet = ObjectManager.createBullet(coords.x,
      coords.y, 400, angleIndex);
```

```
            ObjectManager.addObject(tempBullet, "bullets");
        }
    }

    public function die():Void {

        alive = false;
        animDone = true;

    }
}
```

Analyzing the Ship Class

Most of the Ship code is straightforward. Very similar code has been explained earlier in the book. It has been stated several times now, but one of the advantages of using classes, particularly with inheritance, is that it makes it very easy to reuse existing code. The Ship class is a perfect example. There are a few things that should be explained, however.

The move() method in this "preliminary" version of the Ship class does not yet actually move this Ship since there is no way (yet) to change the Ship's coordinate. It does, however, invoke the setAnimation() method, which controls the Ship's MovieClip's animation cycles. The shoot cycle is used in this example, and the thrust clip is activated and deactivated.

The setAnimation() method controls the three nested MovieClips inside the Ship container MovieClip. The Ship_anim, Ship_thrust_anim, and Ship_shield_anim clips are all distinct MovieClip instances and can be controlled independently.

The doneShooting() and die() methods are the "callback" method that are invoked from within the Ship_anim clip at the end of each animation cycle. The Ship tells the MovieClip (contained in mc) what to do, and the MovieClip uses the callback methods to tell the Ship object when it is done.

Finally, the shoot() method creates a new Bullet instance with the same coordinates as the Ship, a velocity of 400 pixels per second, and the same orientation as the Ship. The ObjectManager adds the new Bullet instance to the "bullets" list and the application takes care of it from there.

The Timeline Code

The final pieces of this example are the scripts on the Main Timeline of the FLA. As mentioned above, there are two action frames in this example: one on the "functions" layer and one on the "event handlers" layer.

Timeline Functions

There are three functions defined on the first frame of the functions layer:

createDiamonds() Creates the specified number of Diamonds and distributes them across the Stage.

moveObjects() Calls the move() method on all the objects in the specified Array.

checkCollision() Checks for collisions between an Array of objects and an Array of projectiles. Projectile MovieClips need to have a nested "hit_target" MovieClip that is used to focus the hitTest() method.

The checkCollision() function iterates over the two referenced Arrays, checking every object in one against every object in the other. The built-in hitTest() method of the MovieClip class is used to see if the objects' MovieClips overlap. If they do, the alive property of both objects is set to false, and during the next execution of the moveObjects() function they are destroyed. Listing 13.2 shows the timeline code for the functions layer.

Listing 13.2 *Timeline Code for the "functions" Layer*

```
import MovieClipClass.ObjectManager;
import ch11.BaseObject;
import MovieClipClass.Diamond;
import MovieClipClass.Ship;

var diamonds:Array = new Array();
var ship:Ship;
var pause:Boolean = false;

createDiamonds = function(count:Number):Void {
  for (var i:Number=0; i<count; i++) {

    var newDiamond:Diamond =
       ObjectManager.createDiamond(20 + (i * 55),70,50);
    newDiamond.draw();
    ObjectManager.addObject(newDiamond, "diamonds");
  }
}

moveObjects = function(array_id:String):Void {

  var thisArray:Array = ObjectManager.arrays[array_id];
  for (var i:Number=0; i [<] thisArray.length; i++) {

    var thisObject:BaseObject = BaseObject(thisArray[i]);
    if (thisObject.alive) {
      thisObject.move();
    } else {
      thisObject.destroy();
      thisObject = null;
      ObjectManager.removeObject(array_id, i);
    }
  }
}
```

```
checkCollision = function(object_array_id:String,
                        projectile_array_id:String):Void {

  var objectArray:Array =
    ObjectManager.arrays[object_array_id];
  var projectileArray:Array =
    ObjectManager.arrays[projectile_array_id];

  for (var i:Number=0; i < objectArray.length; i++) {
    for (var j:Number=0; j < projectileArray.length; j++) {

      var object:BaseObject = BaseObject(objectArray[i]);
      var projectile:BaseObject =
          BaseObject(projectileArray[j]);

      if (projectile.alive) {
        if (projectile.mc.hit_target.hitTest(object.mc)) {
          pause = true;
          object.drawBounds();
          projectile.mc.hit_target._visible = true;
          object.alive = false;
          projectile.alive = false;
        }
      }
    }
  }
}

ObjectManager.setTarget(this);
createDiamonds(10);
ship = ObjectManager.createShip(300, 340);
```

Timeline Event Handlers

The event handlers layer contains the code that defines how the controls will function. There are four controls in the example:

control_left	The green left arrow button, which rotates the ship counterclockwise.
control_right	The green right arrow button, which rotates the ship clockwise.
control_fire	The green round dot button, which tells the Ship to fire a Bullet.
control_delete	The red X, which deletes Diamonds that it is dropped on.

The event handlers defined for the three Ship controls all call methods of the Ship class to control the ship. The onPress handler for the control_delete instance simply initiates the built-in drag-and-drop behavior. The onRelease handler checks to see what MovieClip it was dropped on, and then

sets the alive property of the MovieClip's owner to false. If the red X is dropped on a Diamond, it will be destroyed. Finally a TextField called "point_txt" is defined in the top left corner of the Stage. Listing 13.3 shows the timeline code for the event handlers layer. A mouseListener Object is defined to continually update the TextField's contents with the coordinates of the red X. The coordinates are displayed in two forms: (1) The local coordinates, relative to the registration point of the red X, and (2) the global coordinates, relative to the top left corner of the Stage. The translation from local to global coordinates is accomplished using the built-in localToGlobal() MovieClip method.

Listing 13.3 *Timeline Code for the Event Handlers Layer*

```
import ch09.FrameTimeManager;
//Ship controls
control_left.onPress = function () {
  ship.rotate("left");
  ship.thrust(1);
}

control_left.onRelease = function () {
  ship.thrustOff();
}

control_right.onPress = function () {
  ship.rotate("right");
  ship.thrust(1);
}

control_right.onRelease = function () {
  ship.thrustOff();
}

control_fire.onPress = function () {
  ship.shoot();
  pause = false;
  ship.thrustOff();
}

//Drag-and-drop delete control
control_delete.onPress = function() {
  this.startDrag();
};

control_delete.onRelease = function() {
  this.stopDrag();
  var targetClip:MovieClip = eval(this._droptarget);
  targetClip.owner.alive = false;
  this._x = 40;
  this._y = 370;
};
```

```
control_delete.swapDepths(5001);

this.createTextField("point_txt", this.getNextHighestDepth(),
                     5, 5, 200, 22);
var textFormat:TextFormat = new TextFormat();
textFormat.color = 0xFFFFFF;
textFormat.font = "Arial";

var mouseListener:Object = new Object();

mouseListener.onMouseMove = function() {
  var top:Object = {x:0, y:0};
  point_txt.text = "Local: x:"+top.x+", y:"+top.y;
  control_delete.localToGlobal(top);
  point_txt.text += "; Global: x:"+top.x+", y:"+top.y;
  point_txt.setTextFormat(textFormat);
};

Mouse.addListener(mouseListener);

//Main application loop
onEnterFrame = function () {

  FrameTimeManager.calculateFrameTime();

  if (!pause) {

    moveObjects("diamonds");
    moveObjects("bullets");
    ship.move();
    checkCollision("diamonds", "bullets");

  }
}
```

Seeing Collisions in Action

Using the controls defined above, the Ship can be aimed at Diamonds and it can then fire Bullets at them and destroy them. For illustrative purposes, whenever a collision occurs, the application is paused – the "pause" property is set to true. At the same time, the drawBounds() method is called on the Diamond instance, revealing its bounding rectangle. The Bullet's hit_target clip is also made visible. This freezes the action so the collision can be analyzed. Firing again un-pauses the application until the next collision occurs.

Even when the application is paused, the Ship can be controlled. This is because the ship is controlled directly by asynchronous Mouse events that are handled immediately by the controls' event handlers. For this example, everything is fine, but this could cause problems. For example, a new Bullet is instantiated and added to the "bullets" array whenever the "fire" control is clicked,

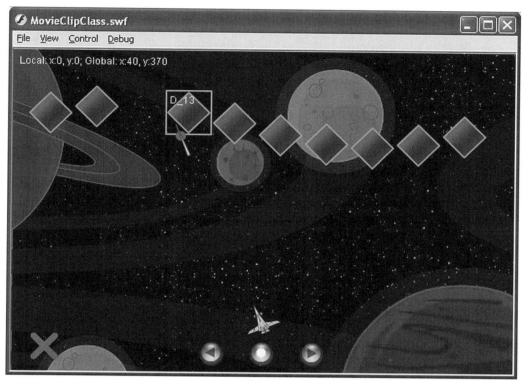

Figure 13.4 *The MovieClipClass.fla example stopped in mid-collision*

potentially right in the middle of what the moveObjects() or checkCollisions() functions are doing. Adding an object to an array while it is being used could cause unwanted results. Fortunately, Flash does a lot of behind-the-scenes work to prevent anything really bad from happening, but it is something worth keeping in mind.

The MovieClipClass.fla example, stopped in mid-collision, can be seen in Figure 13.4.

More to Know

Many useful MovieClip features have been discussed in this chapter, but there are many more to discover. Once the basic mechanics of using MovieClips becomes familiar, the rest of the features are easy to master.

14 Built-in Classes: The Key Class

The Key Class

The Key Class is used to capture keyboard input. Although some applications may only make use of the mouse, most will get some input from the user via the keyboard.

The Key Class has a number of useful methods, including:

getCode()	Returns the keyboard code of the latest key press
getAscii()	Returns the ASCII code of the latest key press
isDown(keycode:Number)	Returns true if the specified key is down
isToggled(keycode:Number)	Returns true if the specified modifier key is down
addListener(listener:Object)	Registers an object to receive Key events
removeListener(listener:Object)	Un-registers an object as a Key listener

There are essentially three strategies for capturing keyboard activity:

- **Event Handling**: Keyboard events are captured and interpreted by Button and MovieClip event handler methods. Interpreting the key events is accomplished using the getCode() and getAscii() methods.
- **Polling**: The application repeatedly checks to see if a key has been pressed. This is accomplished using the isDown() method.
- **Callback Notification**: The Key class calls a method in one of the application's classes when certain keyboard events are detected. This is accomplished using the addListener() method.

Event Handling

Event Handling is often the easiest and most appropriate way to process keyboard input. Both Buttons and MovieClips have event handlers that automatically listen for Key events.

Whenever a key is pressed, three events occur: keyPress, keyDown, and keyUp. The keyPress event is used by buttons. The keyDown and keyUp events are used by MovieClips.

For Buttons, the event handling code looks like this:

```
on (keyPress "a") {
  trace("Key Pressed: Code: " + Key.getCode());
  trace("Key Pressed: ASCII: " + Key.getAscii());
}
```

Note that the Button's event handler needs to know what key to listen for. When this code is assigned to a Button, this message will be displayed in the Output Window whenever the "a" key is pressed:

```
Key Pressed: Code: 65
Key Pressed: ASCII: 97
```

For Movieclips, the event handling code looks like this:

```
onClipEvent(keyDown) {

    trace("Key Pressed: Code: " + Key.getCode());
    trace("Key Pressed: ASCII: " + Key.getAscii());
}

onClipEvent(keyUp) {

    trace("Key Released: Code: " + Key.getCode());
    trace("Key Released: ASCII: " + Key.getAscii());
}
```

When this code is assigned to a Button, a similar message will be displayed when ANY key is pressed. When the "a" is pressed, the messages looks like:

```
Key Pressed: Code: 65
Key Pressed: ASCII: 97
Key Released: Code: 65
Key Released: ASCII: 97
```

But when another key, say the "b" key, is pressed, the messages will be:

```
Key Pressed: Code: 66
Key Pressed: ASCII: 98
Key Released: Code: 66
Key Released: ASCII: 98
```

The MovieClip's keyboard event handler doesn't need to know what key to listen for. It responds to all keys that are pressed. For this reason, it is often easier to manage key events within a MovieClip. But for some simple applications, handling key events inside buttons may make sense. An even better solution is to detect Key events in a special class. This approach is discussed later in this chapter.

Detecting the Key event is the first step. Determining which key has been pressed is the next. With Buttons, the on() event handler simply responds to the specified key event. But with MovieClips, because the event handler responds to any key event, one of two methods is used to determine which key has been pressed. Both of these methods return a number representing the pressed key:

```
getCode()
getAscii()
```

The getCode() method returns a numerical reference to the actual, physical key. For instance, if "A" is pressed, Key.getCode() returns 65 – the number which represents the "A" key. If SHIFT-"A"

is pressed, Key.getCode() still returns 65, because the same physical key was pressed. A separate test, Key.isToggled(Key.SHIFT), can detect whether or not the Shift key is also pressed.

The getAscii() method returns a numerical reference to letter that was typed. If "A" is pressed, Key.getAscii() returns 97 – the ASCII number which represents the lowercase letter "a". But if SHIFT-"A" is pressed, Key.getAscii() returns 65, the ASCII code for the uppercase letter "A".

If an application needs to differentiate between uppercase and lowercase, then the getAscii() method is required. But many applications just need to know which key is pressed, regardless of case. This is when getCode() comes in handy.

By the way, "ASCII" is an acronym for the American Standard Code for Information Interchange. ASCII has been around for a long time and is still used extensively. It provides a standard numerical encoding for all of the characters that are typically used by American English machines. To accommodate other characters – in Europe and other parts of the world – new encodings have been developed. But that is beyond the scope of this book.

The full list of Key Codes and ASCII codes is included in the online Documentation that comes with Flash. An easy way to find out key codes is to use the example above and simply type keys to find their codes. Some useful key codes are shown in Table 14.1.

Table 14.1 *Some key codes defined in the Key class*

Property (code)	Description	Value
Key.BACKSPACE	The key code value for the Backspace key	8
Key.CAPSLOCK	The key code value for the Caps Lock key	20
Key.CONTROL	The key code value for the Control key	17
Key.DELETEKEY	The key code value for the Delete key	46
Key.DOWN	The key code value for the Down Arrow key	40
Key.END	The key code value for the End key	35
Key.ENTER	The key code value for the Enter key	13
Key.ESCAPE	The key code value for the Escape key	27
Key.HOME	The key code value for the Home key	36
Key.INSERT	The key code value for the Insert key	45
Key.LEFT	The key code value for the Left Arrow key	37
Key.PGDN	The key code value for the Page Down key	34
Key.PGUP	The key code value for the Page Up key	33
Key.RIGHT	The key code value for the Right Arrow key	39
Key.SHIFT	The key code value for the Shift key	16
Key.SPACE	The key code value for the Spacebar	32
Key.TAB	The key code value for the Tab key	9
Key.UP	The key code value for the Up Arrow key	38

Polling

Another useful strategy for processing keyboard input is called, "Polling." As the name implies, polling involves repeatedly checking to see which key – or keys – are down. Polling is especially

useful if an application needs to know if several keys are being pressed simultaneously. This is made possible by the following two methods:

```
isDown()
isToggled()
```

The isDown() and isToggled() methods return a Boolean value (true or false).

Since polling code needs to be executed repeatedly, a good place to put it is on a frame on the main timeline. Polling code assigned to the main timeline's onEnterFrame handler would look like this:

```
this.onEnterFrame = function() {

  if (Key.isDown(Key.SPACE)) {
    trace("The Spacebar is down");
  }
}
```

By attaching it to the main timeline's onEnterFrame handler, the above function gets called each frame and checks to see if the SpaceBar is down. If it is, the output looks like this:

```
The Spacebar is down
```

A slight modification can allow the code to check the status of a modifier key, like the Caps Lock key:

```
this.onEnterFrame = function() {

  if (Key.isDown(Key.SPACE)) {
    trace("The Spacebar is down");
  }

  if (Key.isToggled(Key.CAPSLOCK)) {
    trace("The Shift Key is down");
  }
}
```

When the Caps Lock key is toggled on, the following message is displayed repeatedly:

```
The Shift Key is down
```

As mentioned above, one of the chief benefits of polling is that simultaneous key presses can be detected. The following code can detect when both the Space Bar and the Up Arrow are pressed.

```
this.onEnterFrame = function() {

  if (Key.isDown(Key.SPACE)) {
    trace("The Spacebar is down");
  }
```

```
  if (Key.isDown(Key.SPACE) && Key.isDown(Key.UP)) {
    trace("The Spacebar and the Up Arrow are down");
  }

  if (Key.isToggled(Key.CAPSLOCK)) {
    trace("The Caps Lock Key is on");
  }
}
```

Detecting simultaneous key presses is essential for games. In even the most basic Space-shooter-style game, the player needs to be able to accelerate and shoot at the same time.

Callback Notification

Callback Notification is a third strategy for handling key events in which the global Key object is instructed to send certain key event information to an application object. It does this by calling back (invoking) a predetermined method of a designated application object. An application object that receives callback notifications is referred to as a "Listener" because it effectively listens for Key event notifications and handles them via a predetermined callback method. For example, code to set up an application object called myKeyListener might look like this:

```
var myKeyListener = new Object();

myKeyListener.onKeyDown = function () {
  trace("myKeyListener: Key Down: " + Key.getCode());
}

myKeyListener.onKeyUp = function () {
  trace("myKeyListener: Key Up: " + Key.getCode());
}

Key.addListener(myKeyListener);
```

In this code, a generic object called "myKeyListener" is created and a method is defined on it called "onKeyDown". The name of this method is important because the global Key object expects all listener objects to have both an onKeyDown() method and an onKeyUp() method. The Key.addListener(myKeyListener) code tells the global Key object to add the myKeyListener object to the list of objects that will be notified about key events. When a key event occurs, each listener object registered with the Key object will have its onKeyDown() or onKeyUp() callback method invoked.

Putting the above code on the first frame of a movie's main timeline will ensure that the key listener is instantiated and registered appropriately. After this, pressing and releasing the "G" key, for instance, will produce the following output:

```
myKeyListener: Key Down: 71
myKeyListener: Key Up: 71
```

Constructing a General InputManager Class

Listing 14.1 describes a general InputManager class suitable for a game. It is essentially a wrapper for the built-in Key class. It adds functionality to easily detect simultaneous key events.

This InputManager class is similar to the Key class in that it is not intended to have instances. There is never a line like:

```
im:InstanceManager = new InstanceManager(); //INCORRECT!!!
```

Instead, it has "static" class methods and class properties that are accessed through the class name directly. This design choice is based on the assumption that there will never be more than one InputManager — it is the manager, after all. If multiple instances of the InputManager became necessary, then it would have to be redesigned.

Accessing static class properties is easy. There is no need to maintain a reference to an InputManager instance. To get the contents of an InputManager property, for example, it is reference statically, like:

```
quitCode = InputManager.QUIT;
```

To invoke a static InputManager method, it is called statically, like:

```
quitKeyDown = InputManager.checkInputState(quitCode);
```

Or even better:

```
quitKeyDown =
    InputManager.checkInputState(InputManager.QUIT);
```

Listing 14.1 *An InputManager Class*

```
class InputManager {

    static var QUIT:Number = 0;
    static var ROTATE_LEFT:Number = 1;
    static var ROTATE_RIGHT:Number = 2;
    static var FORWARD:Number = 3;
    static var BACK:Number = 4;
    static var SHOOT:Number = 5;
    static var SUPER_SHOOT:Number = 6;
    static var USE_POWERUP:Number = 7;
    static var SHIELD:Number = 8;
    static var XTRA:Number = 9;
    static var NUM_STATES:Number = 10;
    static var keyMap:Array = new Array(NUM_STATES);
    static var inputState:Array = new Array(NUM_STATES);

    static var keyMapInitialized:Boolean = initKeymap();
```

```
public static function initKeymap():Boolean {

  keyMap[QUIT]                 = 81; //Q
  keyMap[ROTATE_LEFT]          = Key.LEFT;
  keyMap[ROTATE_RIGHT]         = Key.RIGHT;
  keyMap[FORWARD]              = Key.UP;
  keyMap[BACK]                 = Key.DOWN;
  keyMap[SHOOT]                = Key.SPACE;
  keyMap[SUPER_SHOOT]          = 88; //X
  keyMap[USE_POWERUP]          = Key.SHIFT;
  keyMap[SHIELD]               = 83; //S
  keyMap[XTRA]                 = 88; //X

  inputState[QUIT]             = false;
  inputState[ROTATE_LEFT]      = false;
  inputState[ROTATE_RIGHT]     = false;
  inputState[FORWARD]          = false;
  inputState[BACK]             = false;
  inputState[SHOOT]            = false;
  inputState[SUPER_SHOOT]      = false;
  inputState[USE_POWERUP]      = false;
  inputState[SHIELD]           = false;
  inputState[XTRA]             = false;

  return true;
}

public static function processInput():Void {

  if (!keyMapInitialized) keyMapInitialized = initKeymap();
  processKeyboardInput();
}

public static function processKeyboardInput():Void {

  inputState[QUIT]            = Key.isDown(keyMap[QUIT]);
  inputState[ROTATE_LEFT]     = Key.isDown
                                  (keyMap[ROTATE_LEFT]);
  inputState[ROTATE_RIGHT]    = Key.isDown
                                  (keyMap[ROTATE_RIGHT]);
  inputState[FORWARD]         = Key.isDown
                                  (keyMap[FORWARD]);
  inputState[BACK]            = Key.isDown(keyMap[BACK]);
  inputState[SHOOT]           = Key.isDown
                                  (keyMap[SHOOT]);
  inputState[SUPER_SHOOT]     = Key.isDown
                                  (keyMap[SUPER_SHOOT]);
```

```
inputState[USE_POWERUP]     = Key.isDown
                                (keyMap[USE_POWERUP]);
inputState[SHIELD]          = Key.isDown
                                (keyMap[SHIELD]);
inputState[XTRA]            = Key.isDown(keyMap[XTRA]);
}

    public static function checkInputState
        (keyMapIndex: Number):Boolean {

        return inputState[keyMapIndex];
    }
}
```

Detecting Simultaneous Key Presses

The main task of this InputManager class is to maintain an Array that keeps track of which keys are pressed at any given moment. Each element of the array contains the state of one of the keys that is being tracked. If one of these keys is down, its state in the array will be "true".

Analyzing the Code

The code from Listing 14.1 (above) defines a simple class with the basic class elements. First, there is the class declaration which describes the name of the class, "InputManager":

```
class KeyClass.InputManager{
```

Note that the InputManager class is referred to as KeyClass.InputManager. This is because the example code lives in a folder called "KeyClass". In turn, the KeyClass folder lives in the main "Examples" folder. In order for Flash to find the code, two things have to happen.

1. The "classpath" needs to be set in the File->Publish Settings menu. This is accomplished by clicking the "Settings" button on the Publish Settings dialog and adding a classpath entry that consists of two dots: ".." This tells Flash to look up one folder level to find the KeyClass folder.
2. The reference to the AudioController class has to be fully qualified as KeyClass.InputManager.

Next is the block of properties. Note that they are all declared static so they can be accessed statically as class properties:

```
static var QUIT:Number = 0;
static var ROTATE_LEFT:Number = 1;
static var ROTATE_RIGHT:Number = 2;
static var FORWARD:Number = 3;
static var BACK:Number = 4;
```

```
static var SHOOT:Number = 5;
static var SUPER_SHOOT:Number = 6;
static var USE_POWERUP:Number = 7;
static var SHIELD:Number = 8;
static var XTRA:Number = 9;
static var NUM_STATES:Number = 10;
static var keyMap:Array = new Array(NUM_STATES);
static var inputState:Array = new Array(NUM_STATES);

static var keyMapInitialized:Boolean = initKeymap();
```

The first 10 properties of the InputManager class are codes that will be used to keep track of events that are important to the application. This InputManager is designed to be part of the game that will be discussed later, so its codes reflect events that will be relevant to the game. These codes will be used to access members of the keyMap and inputState arrays, so they are numbers. It would be an option to just use numbers directly, and always remember that 3 is the code for the Move Forward event. But that can make reading the application code very difficult. Instead, properties with nice, readable names are defined to contain these important numbers.

The property, "NUM_STATES" keeps track of the number of application events that the InputManager must track, and it is used to make the keyMap and inputState Arrays the right size.

keyMap and inputState are Arrays that each have NUM_STATES (10) elements. The keyMapInitialized property is special because it ensures that the keyMap array is initialized only once. It is initialized by calling initKeyMap(). This ensures that the InputManager will be initialized as soon as it is first accessed.

After the class properties come the class methods. The first of these is the initKeyMap method which initializes the two InputManager arrays:

```
public static function initKeymap():Boolean {

    keyMap[QUIT]                = 81; //Q
    keyMap[ROTATE_LEFT]         = Key.LEFT;
    keyMap[ROTATE_RIGHT]        = Key.RIGHT;
    keyMap[FORWARD]             = Key.UP;
    keyMap[BACK]                = Key.DOWN;
    keyMap[SHOOT]               = Key.SPACE;
    keyMap[SUPER_SHOOT]         = 88; //X
    keyMap[USE_POWERUP]         = Key.SHIFT;
    keyMap[SHIELD]              = 83; //S
    keyMap[XTRA]                = 88; //X

    inputState[QUIT]            = false;
    inputState[ROTATE_LEFT]     = false;
    inputState[ROTATE_RIGHT]    = false;
```

```
inputState[FORWARD]        = false;
inputState[BACK]           = false;
inputState[SHOOT]          = false;
inputState[SUPER_SHOOT]    = false;
inputState[USE_POWERUP]    = false;
inputState[SHIELD]         = false;
inputState[XTRA]           = false;

return true;
}
```

The function definition specifies that initKeyMap() is a static class function and that it will return a Boolean value:

```
public static function initKeymap():Boolean {
```

In the body of the method, initKeymap() does two things. It fills the keyMap Array with the physical key codes that will trigger each application event. For instance:

```
keyMap[QUIT] = 81; //Q
```

This set's the first (0th) element of the keyMap Array to 81, which is the key code for the "Q" key. Remember: Arrays are indexed starting with 0, so the first element is a position 0. After filling the keyMap Array, initKeyMap() fills the inputState Array elements with the value "false". The elements of the inputState array indicate whether or not the associated key is down. In its initialized state, that array indicates that no keys are down. The following line sets the second (1st) element of the inputState Array to false:

```
inputState[ROTATE_LEFT] = false;
```

Finally, the initKeyMap() method returns "true":

```
return true;
```

Since initKeyMap() is invoked in the initialization of the keyMapInitialized property, the keyMapInitialized property is immediately set to "true".

The next method is processInput(). It is also declared to be static, and it returns no value (Void).

```
public static function processInput():Void {

    if (!keyMapInitialized) initKeymap();
    processKeyboardInput();
}
```

When invoked, the first thing it does is make sure that the keyMap is initialized – just in case. Then it calls processKeyboardInput(); an obvious expansion would be to add a method to process Mouse input. It is were added, it would probably be called here as well.

The processKeyboardInput() method does the bulk of the work of the InputManager:

```
public static function processKeyboardInput():Void {
    inputState[QUIT]          = Key.isDown(keyMap[QUIT]);
    inputState[ROTATE_LEFT]   = Key.isDown
                                (keyMap[ROTATE_LEFT]);
    inputState[ROTATE_RIGHT]  = Key.isDown
                                (keyMap[ROTATE_RIGHT]);
    inputState[FORWARD]       = Key.isDown(keyMap[FORWARD]);
    inputState[BACK]          = Key.isDown(keyMap[BACK]);
    inputState[SHOOT]         = Key.isDown(keyMap[SHOOT]);
    inputState[SUPER_SHOOT]   = Key.isDown
                                (keyMap[SUPER_SHOOT]);
    inputState[USE_POWERUP]   = Key.isDown
                                (keyMap[USE_POWERUP]);
    inputState[SHIELD]        = Key.isDown(keyMap[SHIELD]);
    inputState[XTRA]          = Key.isDown(keyMap[XTRA]);
}
```

Whenever it is called, it calls Key.isDown() for every key code in the keyMap Array. If the key is down, it sets the corresponding element in the inputState Array to "true". The final method, checkInputState(), is used by the application to check the state of any key:

```
public static function checkInputState
    (keyMapIndex: Number):Boolean {

    return inputState[keyMapIndex];
}
```

From within an application, checkInputState() is invoked like this:

```
if (InputManager.checkInputState
    (InputManager.ROTATE_LEFT)) {

    trace("ROTATE_LEFT");
}
```

Trying it Out

A working version of the InputManager class can be seen in the "InputManagerClass.fla" file included with the example code in the "KeyClass" folder.

In later chapters, the InputManager class will be used in the Astro Sweeper game.

15 Built-in Classes: The Sound Class

The Sound Class

The Sound class is used to control sounds within an application. Simple sounds can be added manually to the Main Timeline and to the timelines of MovieClips and Buttons. But to have the most control over the audio in an application, sounds are controlled through instances of the Sound class.

Sound instances are created in the usual way:

```
mySound:Sound = new Sound(target);
```

The parameter, "target", specifies the MovieClip that this sound instance will be attached to. If the target parameter is omitted, the Sound instance will be attached to the Main Timeline. Choosing the associated MovieClip is important because all sounds attached to a given MovieClip will share certain properties like volume, pan, and transform. In other words, if several Sound instances are associated with a particular MovieClip, then changing the volume for one of these instances will change the volume for all the instances. To control the volume of sounds independently, the sounds must be attached to different MovieClips. This may be counterintuitive at first, but it is easy enough to deal with. It also makes it possible to treat the sounds associated with a particular MovieClip as a group, and set certain properties of theses sounds all at once.

Sound Files

Flash doesn't provide any way to generate sounds programmatically, so all sound data needs to be available in the form of sound files. These files can be included in the FLA manually at authoring time, or they can be loaded dynamically at run time. Sound files typically exist as WAV, AIFF, AU, or MP3 files. All of these types can be included in an FLA at run time. However, only MP3 files can be loaded dynamically.

When sounds are imported into an FLA file during authoring, they become available in the Library. To use these sounds via ActionScript, the Linkage Identifier needs to be set — just as with MovieClips.

Adding Sounds to an FLA

This section references the SoundClass.fla included with the example code. If the examples are unavailable, a suitable FLA can be prepared in a few short steps. If the SoundClass.fla is available,

simply open it with Flash and type <CTRL><ENTER> to generate and test the SWF. The following steps can be used to recreate the FLA. The FLA should be created in a folder called, "SoundClass".

1. Create a new FLA.
 File->New->Flash Document
2. Import a WAV file to the Library.
 File->Import->Import To Library
3. Right-click on the sound in the Library and choose Linkage.
4. Check the "Export for ActionScript" checkbox.
5. Type "test_sound" in the Identifier field.
6. Click OK.
7. Double-click on the name of the first layer (Layer 1) and change the name to "actions".
8. Click on the first frame of the actions layer and type the F9 key to bring up the Actions window.
9. Enter the code in Listing 15.1.

Listing 15.1 *Timeline code for attaching and playing a sound*

```
var sound_target:MovieClip;

sound_target =
    this.createEmptyMovieClip("sound_target", 500);
testSound = new Sound(sound_target);
testSound.attachSound("test_sound");
testSound.start();
```

10. Save the FLA as "SoundClass.fla"
11. Type <CTRL><ENTER>to generate and test the SWF.

The test sound should play. This is the most basic way to control sounds programmatically. Full control is achieved by using the various methods and properties of the Sound class. Table 15.1 describes some of the methods and properties of the built-in Sound class.

Table 15.1 *Methods and properties of the built-in Sound class*

Method	Description
attachSound()	Attaches a sound to a MovieClip by referencing the sound's Linkage Identifier in the Library
start()	Starts playing a sound
stop()	Stops playing a sound
setVolume()	Sets the volume of a sound and of any other sounds attached to the containing MovieClip
getBytesLoaded()	Returns the number of bytes received so far while a sound is being dynamically loaded from a file or URL

Table 15.1 (*Continued*)

getBytesTotal()	Returns the number of bytes in a sound file that is being dynamically loaded from a file or URL
getPan()	Returns the pan setting for the specified sound
getTransform()	Returns the transform setting for the specified sound
getVolume()	Returns the volume setting for the specified sound
loadSound()	Dynamically loads a sound from a file or URL
setPan()	Sets the pan setting for the specified sound
setTransform()	Sets the transform setting for the specified sound
setVolume()	Sets the volume setting for the specified sound

Property	Description
duration	The time duration of a sound
id3	The MP3 ID3 data for a dynamically loaded sound
position	The current time position for a sound that is being played

Event handler properties	Description
onSoundComplete	A reference to a function that is called when a sound finishes playing
onID3	A reference to a function that is called when ID3 data is detected in a dynamically loaded sound
onLoad	A reference to a function that is called when a dynamically loaded sound is completely loaded

Sound Class Control

As can be seen in the code in Listing 15.1 (above) (from SoundClass.fla) the attachSound() method associates a sound from the Library with a Sound class instance. Once this association has been made, the sound can be controlled using various Sound class methods.

Playback Control

Playback control is accomplished using the start() and stop() methods. The stop() method simply stops a sound instance from playing. Start() can be used with or without two optional parameters. The first optional parameter is "secondOffset". When a Number is supplied for this parameter, the sound will begin playing at a point that is the specified number of seconds from the start of the sound. The second optional parameter is "loops". By default, when the start() method is invoked a sound will play once and then stop automatically. When a Number is supplied for the loops parameter, the sound will play this number of times before stopping automatically.

Two of the Sound class's properties can also be useful when controlling playback. The "duration" property indicates how long a sound is in milliseconds. The "position" property indicates the number of milliseconds that a sound has been playing. If the sound is looping, the position property is reset to 0 at the beginning of each loop.

Using these two properties in conjunction with start() and stop(), code can be written that will stop a sound at a particular time during its playback. A useful example might involve a sound file that contains a voice narration of a countdown from 10 to 1 at 1-second intervals. "Ten, nine, eight, seven, …" To start the countdown at any number from 10 to 1, the start command could be used like:

```
var countdownSound:Sound = new Sound();
countdownSound.attachSound("countdown_sound");
var startCount:Number = 10;
countdownSound.start(10-startCount);
```

To stop the sound at a certain point, the position property can be checked every frame:

```
var stopCount:Number = 1;

this.onEnterFrame = function() {
   if (countdownSound.position >= (10-stopCount+1)* 1000)
      countdownSound.stop();
}
```

A working example can be found in the "CountdownSound.fla" file from the "SoundClass" folder of the examples.

Volume, Pan, and onSoundComplete

In addition to starting and stopping sounds, ActionScript can be used to control the Volume and Pan. SetVolume() sets the volume of a sound. Volume is specified as a number from 0 to 100, representing the percentage of full volume. When a sound is first created, its volume is 100, by default. SetPan() sets the balance of a sound – the distribution of the sound's volume between the left and right speakers. Pan is specified as a number from −100 to 100. A Pan value of −100 will make the sound audible in the left speaker only. A Pan value of 100 will make the sound audible in the right speaker only. By default, the Pan value of a sound is 0, placing the sound in the left and right speakers equally.

Note: Pan is especially appropriate for mono sounds, which have one channel of audio. Stereo sounds have two channels of audio which can be distributed between two speakers. To get full control of the balance of a stereo sound, the setTransform() method can be used. The Flash documentation does a nice job of explaining the setTransform() method.

A brief example showing the typical usage of setVolume() and setPan() can be seen in the SoundClass2.fla. The timeline code is shown in Listing 15.2.

Listing 15.2 *Timeline code for controlling the pan of a sound*

```
var sound_target:MovieClip;

sound_target = this.createEmptyMovieClip("sound_target",
                                         500);
```

```
testSound = new Sound(sound_target);

testSound.attachSound("test_sound");

panArray = new Array(3);
panArray[0] = 0;
panArray[1] = -100;
panArray[2] = 100;

playSound = function() {
   var randomPanIndex = Math.floor(Math.random()*3);
   var randomVolume = Math.floor(Math.random()*100);
   testSound.setPan(panArray[randomPanIndex]);
   testSound.setVolume(randomVolume);
   trace("Pan: " + panArray[randomPanIndex])
   trace("Volume: " + randomVolume);
   testSound.start();
}

testSound.onSoundComplete = playSound;

testSound.start();
```

In the above code, the Array called "panArray" is used to hold three easy-to-discern pan setting: 0 = center, −100 = full left, 100 = full right. A random number is used to choose the pan setting:

```
var randomPanIndex = Math.floor(Math.random()*3);
```

The above line uses the random() method of the built-in Math class to generate a random number 0−0.999. When multiplied by 3, this returns a number from 0 to 2.999. Then the Math.floor() method is used to chop off the decimal fraction and the result is a number from 0 to 2. So, each time the playSound function is called, one of the three pan setting in panArray is chosen randomly.

Similarly, Math.random() and Math.floor() are used to generate a random volume from 0 to 99.

Probably the most interesting part of this code example is the use of the onSoundComplete property of the testSound instance:

```
testSound.onSoundComplete = playSound;
```

The onSoundComplete property specifies a function to be called when a sound is done playing. Setting testSound's onSoundComplete function to playSound makes it so that the sound will be replayed over and over again.

When the SoundClass2.fla is tested (<CTRL><ENTER>) the sound will be played repeatedly, each time with a different volume and different pan.

Constructing a General AudioController Class

The listings in this section describe a general AudioController class that will be used in the game later in the book. Like the InputManager class, it is a wrapper for the built-in Sound class. It provides a central mechanism for controlling game sounds, and it adds some useful functionality. It uses the GameDepthManager class from Chapter 7. It also uses a new class called GameSound which is a sub-class of the built-in Sound class. By extending the Sound class, GameSound inherits all of the functionality of Sound.

Extending the Sound Class

Listing 15.3 *The GameSound class*

```
class GameSound extends Sound {

    var soundClip:MovieClip;
    var AC:AudioController;
    var soundID:String;
    var soundURL:String;
    var isStreaming:Boolean;
    var playWhenLoaded:Boolean;

    public function GameSound(clip:MovieClip,
        audio_controller:AudioController, id:String,
        url:String, is_streaming:Boolean,
        play_when_loaded:Boolean) {

        super(clip);
        soundClip = clip;
        AC = audiocontroller;
        soundID = id;
        soundURL = url;
        isStreaming = is_streaming;
        playWhenLoaded = play_when_loaded;
    }
}
```

The first line of this listing is the most important:

```
class GameSound extends Sound {
```

The "extends" keyword associates this new class with the existing Sound class. As a result, GameSound automatically has all the methods and properties of the Sound class. It is perfectly valid, for instance, to invoke the attachSound() method on a GameSound instance. Of course the reason for doing this is expressed in the additional properties that GameSound defines. These are described in Table 15.2.

Table 15.2 *Properties of the GameSound class*

Property	Description
soundClip	A reference to the MovieClip that this sound is associated with
AC	A reference to the AudioController instance that created this sound. This will be used to notify the AudioController when the onLoad, onID3, and onSoundComplete events are received
sounded	The String identifier that the AudioController uses to reference this sound
soundURL	The filename of this sound. This may come in handy when debugging and troubleshooting
isStreaming	Whether or not this sound was created as a streaming sound
playWhenLoaded	Whether or not this sound should be automatically played when it is loaded. This will be used for streaming sounds that are loaded dynamically. By default, streaming sounds are automatically started when they load, but this may not always be desirable

The GameSound() method is the constructor for this class. The first thing it does is invoke the constructor of the Sound superclass using the super() call. This takes care of all of the basic setup required for sounds. Then the constructor initializes all of the properties that are unique to GameSound instances.

The AudioController Class

The AudioController class provides a general and centralized way for game sounds to be controlled. The full code is shown in Listing 15.4.

Listing 15.4 *The AudioController class*

```
import SoundClass.GameSound;
import ch7.GameDepthManager;

class SoundClass.AudioController {

  var soundClip:MovieClip;
  var soundList:Object;
  var soundClipContainer:Object;

public function AudioController(container:Object) {

  soundClipContainer = container;

  var depth:Number =
     GameDepthManager.getNextAudioClipDepth();
  var name:String = "sound_clip_" + depth;
  soundClip =
     soundClipContainer.createEmptyMovieClip(name, depth);
```

```
        soundList = new Object();
}

public function registerSound(sound_id:String):Void {
    soundList[sound_id] = new GameSound(soundClip, this,
                                        sound_id);
    soundList[sound_id].attachSound(sound_id);
}

public function loadSound(sound_id:String, sound_url: String,
                          is_streaming:Boolean,
                          play_when_loaded:Boolean
                          ):GameSound {

    var thisSound:GameSound;

    thisSound = new GameSound(soundClip, this, sound_id,
                              sound_url, is_streaming,
                              play_when_loaded);

    soundList[sound_id] = thisSound;
      thisSound.loadSound (sound_url, is_streaming);

    thisSound.onLoad = function() {

      var tempSound:GameSound = GameSound(this);
      tempSound.stop();
      tempSound.AC.onSoundLoaded(tempSound.soundID);
    }

    thisSound.onID3 = function() {

      var tempSound:GameSound = GameSound(this);
      tempSound.AC.onID3Detected(this.soundID);
    }

    return thisSound
}

public function onSoundLoaded(sound_id:String):Void {
    var thisSound:GameSound = soundList[sound_id];

    if (thisSound.playWhenLoaded) thisSound.start();
}

public function onID3Detected(sound_id:String):Void {

    var thisSound:GameSound = soundList[sound_id];

    trace("onID3Detected: soundID: " + sound_id);
    for (var prop in thisSound.id3) {
```

```
      trace(prop + ": " + thisSound.id3[prop]);
   }
}

public function playSound(sound_id:String, loop:Boolean):
                         Void {

  var thisSound:GameSound = soundList[sound_id];

  //first stop all sounds managed by this controller
  for (var prop in soundList) {
    stopSoundNow(prop);
  }

  if (loop) {
    thisSound.onSoundComplete = function() {

      var tempSound:GameSound = GameSound(this);

      trace("SoundInstance: looping: " + this);
      tempSound.start();
    }
  } else {
    thisSound.onSoundComplete = null;
  }
  thisSound.start();
}

public function stopSoundNow(sound_id:String):Void {
  var thisSound:GameSound = GameSound(soundList[sound_id]);

  thisSound.onSoundComplete = null;
  thisSound.stop();
}

public function stopSoundAtEndOfLoop(sound_id:String):
                                     Void {

  var thisSound:GameSound = GameSound(soundList[sound_id]);

  if (thisSound.onSoundComplete! = undefined) {
    thisSound.onSoundComplete = undefined;
  } else {
    thisSound.stop();
  }
}

public function setSoundVolume(sound_id:String, volume:
                               Number):Void
```

```
    {
        var thisSound:GameSound = GameSound(soundList[sound_id]);
                            thisSound.setVolume(volume);
    }
}
```

Unlike the InputManager class from Chapter 14, which is designed to have no instances, the AudioController class must be instantiated and can have any number of instances. Having multiple AudioControllers can provide a way to control groups of sounds.

Analyzing the Code

The first thing to notice is the class declaration:

```
class SoundClass.AudioController {
```

Note that the AudioController class is referred to as SoundClass.AudioController. This is because the example code lives in a folder called "SoundClass". In turn, the SoundClass folder lives in the main "Examples" folder. In order for Flash to find the code, two things have to happen.

1. The "classpath" needs to be set in the File->Publish Settings menu. This is accomplished by clicking the "Settings" button on the Publish Settings dialog and adding a classpath entry that consists of two dots: ".." This tells Flash to look up one folder level to find the SoundClass folder.
2. The name of the AudioController class has to be fully qualified as SoundClass.AudioController.

The AudioController class depends on two other classes: the GameDepthManager class and the GameSound class. These need to be "imported" so that Flash will know where to find them. The two import lines at the top of the listing take care of this.

```
import SoundClass.GameSound;
import ch7.GameDepthManager;
```

Note that the GameDepthManager class lives in the ch7 folder which also lives in the main Examples folder, so it is referenced as ch7.GameDepthManager.

Properties

The AudioController class has three properties:

soundClip	A reference to the MovieClip that the AudioController sounds are associated with
soundList	An Object that holds the list of all the AudioController's sounds
soundClipContainer	The timeline on which the soundClip will be created.

The soundClip property holds a reference to the MovieClip that the AudioController sounds are associated with. All the sounds that are controlled by an AudioManager instance are associated

with the same MovieClip. This makes it possible for an AudioController instance to control the volume of all its sound instances by setting the volume for any one sound.

The soundList property is an Object that holds the list of all the AudioController's sounds. This could have been implemented as an Array, but then accessing sounds would have to be done using numbers. Instead, for each sound, the text name of the sound is used to add a property to the soundList object. The value of this property is a reference to the actual sound. This will be described in more detail later in this section.

The soundClipContainer is the TimeLine on which the soundClip will be created. This could be the Main Timeline or a MovieClip. In most cases it will make be the Main Timeline.

Methods of the AudioController Class

The constructor for the AudioController class is fairly simple:

```
public function AudioController(container:Object) {

  soundClipContainer = container;

  var depth:Number =
     GameDepthManager.getNextAudioClipDepth();
  var name:String = "sound_clip_" + depth;
  soundClip =
     soundClipContainer.createEmptyMovieClip(name, depth);

  soundList = new Object();
}
```

When the AudioController class is instantiated, it expects one parameter, a reference to the timeline that the soundClip will be created on. This is stored in the soundClipContainer property for future reference. The soundClip is created using the createEmptyMovieClip() method, and it gets the depth parameter for this call from the GameDepthManager class. The call to GameDepthManager.getNextAudioClipDepth() assures that the depth used for this clip won't interfere with the depth for any other clip. Finally, soundList is initialized with a new, blank object.

registerSound()

The registerSound() method simply creates a new GameSound instance and associates it with a sound from the Library.

```
public function registerSound(sound_id:String):Void {

  soundList[sound_id] = new GameSound(soundClip, this,
                                      sound_id);
  soundList[sound_id].attachSound(sound_id);
}
```

By design, registerSound() assumes that there is an appropriate sound in the Library who's Linkage Identifier matches the sound_id parameter. The new GameSound instance that is created takes as its three parameters: a reference to the soundClip, a reference to the AudioController (this), and the name of the sound (sound_id). A property is added to the soundList Object to keep track of this new GameSound. If, for example, the sound_id parameter is "main_loop", then a "main_loop" property is created on the soundList object and the value of this property is set to be a reference to the new GameSound instance. From then on, the GameSound instance can be accessed by name like soundList["main_loop"] or soundList[sound_id].

loadSound()

The loadSound() method is more complicated. It is used to load a sound dynamically into a GameSound instance. It invokes the loadSound() method that the GameSound instance inherits from the built-in Sound class. Since dynamically loaded sounds are always MP3 files, they can have ID3 tags describing the Author, Genre, Album, etc. of the sound. The loadSound() method provides a way to detect and use these tags using the sound's onID3 property. It also sets the onLoad property so the AudioController will know when the sound is loaded.

```
public function loadSound(sound_id:String, sound_url:
                         String, is_streaming:Boolean,
                         play_when_loaded:Boolean):
                         GameSound {

  var thisSound:GameSound;

  thisSound = new GameSound(soundClip, this, sound_id,
                            sound_url, is_streaming,
                            play_when_loaded);
  soundList[sound_id] = thisSound;
  thisSound.loadSound(sound_url, is_streaming);

  thisSound.onLoad = function() {

    var tempSound:GameSound = GameSound(this);
    tempSound.stop();
    tempSound.AC.onSoundLoaded(tempSound.soundID);
  }

  thisSound.onID3 = function() {

    var tempSound:GameSound = GameSound(this);
    tempSound.AC.onID3Detected(this.soundID);
  }

  return thisSound
}
```

The GameSound instance is given the needed parameters which include the URL of the sound file, a flag indicating whether or not the sound should be streamed, and a flag indicating whether or not the sound should be played when loaded.

```
thisSound = new GameSound(soundClip, this, sound_id,
                          sound_url, is_streaming,
                          play_when_loaded);
```

The onLoad property is set to a function which stops the sound so it won't automatically start playing. This function then calls the AudioController's onSoundLoad() method with a reference to the sound. When the sound is done loading and the onLoad function is called, the "this" property refers to the sound object. The "this" property can then be cast as a GameSound object:

```
var tempSound:GameSound = GameSound(this);
```

As a result, tempSound refers to the GameSound instance and its properties can be accessed. Since every GameSound instance contains a reference to its AudioController and its own name, the function can then call the AudioController's onSoundLoaded method and pass it the name of the sound that just finished loading:

```
tempSound.AC.onSoundLoaded(tempSound.soundID);
```

The same strategy is used in the function assigned to the onID3 property.

When the AudioController's onSoundLoaded method is called, it checks to see if the sound should be played. If so, it starts the sound.

```
public function onSoundLoaded(sound_id:String):Void {

  var thisSound:GameSound = soundList[sound_id];

  if (thisSound.playWhenLoaded) thisSound.start();
}
```

In this version of the AudioController, ID3 tags are not important, so they are simply sent to the Output window using trace().

```
public function onID3Detected(sound_id:String):Void {

  var thisSound:GameSound = soundList[sound_id];

  trace("onID3Detected: soundID: " + sound_id);
  for (var prop in thisSound.id3) {
    trace(prop + ": " + thisSound_id3[prop]);
  }
}
```

playSound()

The playSound() method plays sounds and sets up a mechanism for looping sounds.

```
public function playSound(sound_id:String, loop:Boolean):
                            Void {

    var thisSound:GameSound = soundList[sound_id];

    //first stop all sounds managed by this controller
    for (var prop in soundList) {
        stopSoundNow(prop);
    }

    if (loop) {
        thisSound.onSoundComplete = function() {

            var tempSound:GameSound = GameSound(this);

            trace("SoundInstance: looping: " + this);
            tempSound.start();

        }
    } else {
        thisSound.onSoundComplete = null;
    }
    thisSound.start();

}
```

The first thing it does is stop all the sounds controlled by this AudioController instance. This is a design decision that might need to be modified for other applications, but for the game, it is important to stop one soundtrack loop before another is started. To have simultaneously playing sounds, more than one AudioController instance can be used. After stopping all its sounds, the sound controller checks to see if the current sound should be looped. If so, it assigns a function to the onSoundComplete property that will automatically restart the sound when it is done playing. Then it starts the sound.

stopSoundNow() and stopSoundAtEndOfLoop()

The stopSoundNow() method is straightforward. It stops the specified sound. The stopSoundAtEndOfLoop() method is more interesting. It doesn't directly stop the sound, it simply set the onSoundComplete property to "undefined". When the sound ends it won't be restarted. This makes for a less abrupt end to a looped sound. If the onSoundComplete property is already undefined, then the sound isn't looping and it is stopped immediately;

```
public function stopSoundAtEndOfLoop(sound_id:String):
                                        Void {

    var thisSound:GameSound = GameSound(soundList[sound_id]);
```

```
    if (thisSound.onSoundComplete!= undefined) {
      thisSound.onSoundComplete = undefined;
    } else {
      thisSound.stop();
    }
  }
```

A brief example showing a simple use of the AudioController class can be seen in the AudioController.fla. The timeline code is shown in Listing 15.5.

Listing 15.5 *The timeline code from the AudioController.fla example*

```
import KeyClass.InputManager;
import SoundClass.AudioController;

var soundTrackController:AudioController;

soundTrackController = new AudioController();

soundTrackController.registerSound("main_loop");

soundTrackController.playSound("main_loop", true);

this.onEnterFrame = function () {

  InputManager.processInput();

  if (InputManager.
      checkInputState(InputManager.ROTATE_RIGHT)) {
      soundTrackController.playSound("main_loop", true);
  }

  if (InputManager.checkInputState(InputManager.FORWARD)) {
      soundTrackController.stopSoundNow("main_loop");
  }

  if (InputManager.checkInputState(InputManager.BACK)) {
      soundTrackController.stopSoundAtEndOfLoop("main_loop");
  }
}
```

Putting the AudioController Class to Work

In Chapter 20 – Phase III of the Astro Sweeper game – the AudioController is used to control both sound effects and soundtrack loops. The soundtrack loops are actually controlled by a sub-class of AudioController called SoundtrackController. The SoundtrackController is explained in Chapter 16 in the context of the built-in XML class. It loads soundtrack playlists from external XML files.

16 Built-in Classes: The XML Class

XML

XML is a big topic; too big for this book, really. But it is important enough – and useful enough – to deserve a brief description. The term, XML, stands for eXtensible Markup Language and this can mean a lot of things. A close relative of XML is HTML (HyperText Markup Language) which is familiar to many people. HTML is used to format Web pages. It uses a pre-determined set of "tags" to specify formatting options for the text, images, and controls that make up Web pages. The following snippet of HTML includes formatting tags to center text on the page and make the text display as bold:

```
<center>
<b>This text will be centered, and bold.</b>
</center>
```

The tags in this HTML example are used in pairs. The open tag, <center>, and the close tag, </center>. The formatting of all the text between pairs of tags is determined by the tag type.

Like HTML, XML also makes use of tags to specify properties of text data. But with XML, there is no predetermined set of tags. The tags needed for a particular application are defined and the interpreted according to the needs of the application.

XML at Amazon.com

Amazon.com uses XML to share data about the products that they sell. Vendors who have partnerships with Amazon.com can easily get up-to-date product info in the form of XML files that are delivered over the Internet. Details about this service are available at:

```
http://www.amazon.com/xml
```

By registering as a Web Services developer (for free) at Amazon.com, a developer is automatically given a developer id that can be used in an http to get product info. The developer id allows Amazon.com to keep track of who is making requests; presumably to prevent abuse of the system. For example, the following request (with a valid developer id supplied) will get information about this book:

```
http://xml.amazon.com/onca/xml3?t=webservices-20
&dev-t=[developer-id-here]&AsinSearch=
  0240519914&type=lite&f=xml
```

The information comes in the form of text with different types of data encapsulated between pairs of Amazon.com-specific tags. Tags can be nested inside other tags, creating a hierarchy of data. As the data in an XML file is accompanied by embedded information about its type, XML files are said to contain "structured data". In general, the order in which the tags and data appear is not important, as long as the structure is correct. Listing 16.1 shows the XML returned by the above request.

Listing 16.1 *XML returned by an http request to Amazon.com*

```
<?xml version="1.0" encoding="UTF-8"?>
<ProductInfo xmlns:xsi=
  "http://www.w3.org/2001/XMLSchema-instance"
xsi:noNamespaceSchemaLocation=
  "http://xml.amazon.com/schemas3/dev-lite.xsd">
  <Request>
    <Args>
      <Arg value="1GYK5A7ZRQC7W7QZ5579" name="RequestID">
      </Arg>

      <Arg value="0240519914" name="AsinSearch">
      </Arg>

      <Arg value="us" name="locale">
      </Arg>

      <Arg value="1EKAG66CK684N8S2J7R2" name="dev-t">
      </Arg>

      <Arg value="webservices-20" name="t">
      </Arg>

      <Arg value="xml" name="f">
      </Arg>

      <Arg value="lite" name="type">
      </Arg>
    </Args>
  </Request>

  <Details
  url="http://www.amazon.com/exec/obidos/ASIN/0240519914/
    webservices-20?
  dev-t=[dev-id-here]%26camp=2025%26link_code=xm2">
    <Asin>0240519914</Asin>

    <ProductName>
      Understanding Macromedia Flash 8 ActionScript 2
    </ProductName>

    <Catalog>Book</Catalog>
```

```
      <Authors>
        <Author>Andrew Rapo</Author>
        <Author>Alex Michael</Author>
      </Authors>

      <ReleaseDate>21 February, 2006</ReleaseDate>

      <Manufacturer>Focal Press</Manufacturer>

      <ImageUrlSmall>
        http://images.amazon.com/images/P/
          0240519914.01.THUMBZZZ.jpg
      </ImageUrlSmall>

      <ImageUrlMedium>
        http://images.amazon.com/images/P/
          0240519914.01.MZZZZZZZ.jpg
      </ImageUrlMedium>

      <ImageUrlLarge>
        http://images.amazon.com/images/P/
          0240519914.01.LZZZZZZZ.jpg
      </ImageUrlLarge>

      <Availability>Not yet released.</Availability>

      <ListPrice>$29.95</ListPrice>

      <OurPrice>$19.77</OurPrice>
    </Details>
  </ProductInfo>
```

There is a lot of structured data in Listing 16.1. Most of it is easy to make sense of. The section which is encapsulated by <Author> tags lists the authors of this book:

```
  <Authors>
    <Author>Andrew Rapo</Author>
    <Author>Alex Michael</Author>
  </Authors>
```

One important thing to note is that there can be a variable number of <Author> tags inside a pair of <Authors> tags. Books can have many different author combinations. XML can support this, and it is up the application to "parse" the XML file correctly and accommodate variable numbers of tags.

XML in Flash

Flash provides a rich set of XML-related classes that make it easy to incorporate XML data into applications. XML is a widely used data format and just about every modern programming language has libraries (pre-written code) for managing XML files. The Flash classes for manipulating

XML data are based on standards that have been adopted industry-wide. This standardization is one of the main reasons why XML is as powerful as it is.

XML Documents and XML Nodes

By definition, XML files are hierarchical in nature. Tags can be nested inside tags, inside tags, ad infinitum. The term, "node", is used to describe any branch of this hierarchy. Taken as a whole, an XML document is a node. The section-describing authors is a node. Even a single pair of tags is a node. When a node contains other nodes, the containing node is referred to as the "parent". The nodes that it contains are referred to as "children". The general process for parsing an XML document is to get the "root" node – the complete XML "tree" – and then "recursively" parse each of its child nodes. "Recursion" is the process of following (traversing) all of the branches in a tree until the ends of every branch are reached. The ends of the branches in a tree are sometimes called "leaves".

XML comes with its own, new terminology. Fortunately this terminology is the same in just about every XML implementation. Tables 16.1 and 16.2 describe the methods and properties of

Table 16.1 *The methods and properties of the XML class*

Method	Description
addRequestHeader()	Adds or changes the HTTP request headers (such as Content-Type or SOAPAction) that are sent with POST actions.
createElement()	Creates a new XML element.
createTextNode()	Creates a new XML text node containing the specified text.
getBytesLoaded()	Returns the number of bytes loaded (streamed) for the XML document.
getBytesTotal()	Returns the size, in bytes, of the XML document.
load()	Loads an XML document from the specified URL, and replaces the contents of the specified XML object with the downloaded XML data.
parseXML()	Parses the XML text specified in the value parameter, and populates the specified XML object with the resulting XML tree.
send()	Encodes the specified XML object into an XML document, and sends it to the specified URL using the POST method in a browser.
sendAndLoad()	Encodes the specified XML object into an XML document, sends it to the specified URL using the POST method, downloads the server's response, and loads it into the resultXMLobject specified in the parameters.

Property	Description
contentType	The MIME content type that is sent to the server when you call the XML.send() or XML.sendAndLoad() method.
docTypeDecl	Specifies information about the XML document's DOCTYPE declaration.
ignoreWhite	When true, the XML object ignores "white space", like spaces, returns, tabs, etc. Default setting is false.
loaded	Indicates if the XML document has successfully loaded.
status	Automatically sets and returns a numeric value that indicates whether an XML document was successfully parsed into an XML object.
xmlDecl	A string that specifies information about a document's XML declaration.

Table 16.2 *The methods and properties of the XMLNode class*

Method	Description
appendChild	Appends the specified node to the XML object's child list.
cloneNode	Constructs and returns a new XML node of the same type, name, value, and attributes as the specified XML object.
getNamespaceForPrefix	Returns the namespace URI that is associated with the specified prefix for the node.
getPrefixForNamespace	Returns the prefix that is associated with the specified namespace URI for the node.
hasChildNodes	Specifies whether or not the XML object has child nodes.
insertBefore	Inserts a newChild node into the XML object's child list, before the insertPoint node.
removeNode	Removes the specified XML object from its parent.
toString	Evaluates the specified XML object, constructs a textual representation of the XML structure, including the node, children, and attributes, and returns the result as a string.

Property	Description
attributes	An object containing all of the attributes of the specified XML instance.
childNodes	An array of the specified XML object's children.
firstChild	Evaluates the specified XML object and references the first child in the parent node's child list.
lastChild	An XMLNode value that references the last child in the node's child list.
localName	The local name portion of the XML node's name.
namespaceURI	The URI of the namespace to which the XML node's prefix resolves.
nextSibling	An XMLNode value that references the next sibling in the parent node's child list.
nodeName	A string representing the node name of the XML object.
nodeType	A nodeType value, either 1 for an XML element or 3 for a text node.
nodeValue	The node value of the XML object.
parentNode	An XMLNode value that references the parent node of the specified XML object, or returns null if the node has no parent.
prefix	The prefix portion of the XML node name.
previousSibling	An XMLNode value that references the previous sibling in the parent node's child list.

the XML and XMLNode classes, respectively. The XML class is used to manage whole XML documents. The XMLNode class is used to recursively parse the nodes of an XML document.

Using the XML and XMLNode Classes

One popular feature in games is the ability to play a custom soundtrack while playing the game. When the game is authored, there is now way for the developers to know what tracks the player will want to hear during a game. And only the player will know which tracks are available and where they live on the player's computer. Listing 16.2 shows the contents of the soundtrack.xml XML file which contains custom soundtrack data for the Astro Sweeper game.

Listing 16.2 *XML returned by an http request to Amazon.com*

```
<soundtrack>

  <phase id="title_loop">
    <track>../shared_assets/TitleLoop.mp3</track>
  </phase>

  <phase id="main_loop">
    <track>../shared_assets/09 Extraordinary Girl.mp3</track>
    <track>../shared_assets/11 Wake Me Up When September
      Ends.mp3</track>
    <track>../shared_assets/03 Holiday.mp3</track>
    <track>../shared_assets/04 Boulevard Of Broken
      Dreams.mp3</track>
    <track>../shared_assets/MainLoop.mp3</track>
  </phase>

  <phase id="level_loop">
    <track>../shared_assets/LevelLoop.mp3</track>
  </phase>

</soundtrack>
```

In this document, the root node, <soundtrack>, has three children. The children are <phase> nodes that describe the three soundtrack phases of the game: title_loop, main_loop, and level_loop. Each of these phases has at least one <track> node which contains the path to an audio file on the player's computer.

The SoundtrackController Class

The SoundtrackController class uses the soundtrack.xml file to determine which audio tracks should be played during the phases of the game. When the SoundtrackController encounters the track nodes in a phase node, it adds each track to an Array. When the SoundtrackController is asked to play a soundtrack phase, it chooses a random track from the track list of the specified phase. For instance, when the main_loop phase is played, one of the five track nodes will be chosen randomly and played.

To add tracks to the playlist for a game phase, the player just needs to add track nodes the XML file. This is easily done using a text editor. Listing 16.3 shows the full source code of the SoundtrackController class.

Listing 16.3 *The source code of the SoundtrackController Class*

```
import SoundClass.AudioController;
import XMLClass.SoundtrackXML;
```

```
class XMLClass.SoundtrackController extends AudioController {
  public var xmlDoc:SoundtrackXML;
  public var xmlFile:String;
  public var phases:Object;
  public var activePhase:String;

  public function SoundtrackController(container:Object,
    xml_file:String)
  {
    super(container);
    xmlFile = xml_file;

    phases = new Object();
    xmlDoc = new SoundtrackXML(this);
    xmlDoc.ignoreWhite = true;
    loadXML();
  }

  public function loadXML() {
    xmlDoc.onLoad = function(success:Boolean) {
      this.owner.parseXML();
    }
    xmlDoc.load(xmlFile);
  }

  public function parseXML() {
    for (var prop:String in xmlDoc.firstChild.childNodes) {
      trace(prop + ' ' + xmlDoc.firstChild.childNodes[prop].
        nodeName);
      if (xmlDoc.firstChild.childNodes[prop].nodeName ==
          "phase") {
        parsePhase(xmlDoc.firstChild.childNodes[prop]);
      }
    }
  }

  public function parsePhase(node:XMLNode) {
    for (var prop:String in node.childNodes) {
      trace(" " + prop + ' ' + node.childNodes[prop].
        nodeName + ", " + node.attributes["id"]);
      if (node.childNodes[prop].nodeName == "track") {
        parseTrack(node.childNodes[prop],
          node.attributes["id"]);
      }
```

```
      }
   }

   public function parseTrack(node:XMLNode, phase:String) {
      trace(" " + node.firstChild.nodeValue);

      if (phases[phase] == undefined) {
         phases[phase] = new Array();
      }

      phases[phase].push(node.firstChild.nodeValue);
   }

   public function playTrack(phase:String, loop:Boolean) {
      var randomIndex =
         Math.floor(Math.random() * phases[phase].length);
      stopSoundNow(phase);
      activePhase = phases[phase][randomIndex];
      loadSound(phase, activePhase, false, true);
      playSound(phase, loop);
   }
}
```

The SoundtrackController class extends the AudioController class from Chapter 15. This means that it inherits all of the AudioController methods and properties. Table 16.3 describes the methods and properties of the SoundtrackController class.

Table 16.3 *The methods and properties SoundtrackController class*

Method	Description
SoundtrackController()	The constructor. Initializes the class's properties.
loadXML()	Sets the onLoad event handler function of the xmlDoc instance and loads the specified XML file. When the file loads completely, the onLoad handler calls the parseXML() method of the SoundtrackController instance – using the "owner" property of the xmlDoc instance.
parseXML()	Iterates through the child nodes (phases) of the XML document's root node.
parsePhase()	Invokes parseTrack() for each track node in the phase.
parseTrack()	Adds each track node to the Array of tracks for the specified phase.
playTrack()	Uses the inherited AudioController playSound() method to play the randomly chosen track from the given phase's Array of tracks.

Property	Description
xmlDoc	Contains the soundtrack.xml document.
xmlFile	The file name of the XML file to be loaded.
phases	An Object instance that serves as a container for the Arrays that contain the phase track lists.
activePhase	Contains the name of the actively playing phase.

The SoundtrackXML Class

The SoundtrackController class relies on a class called SoundtrackXML which extends the built-in XML class. SoundtrackXML adds one property to the XML class: "owner", a reference to the SoundtrackController that owns it. This allows a SoundtrackXML instance to inform its SountrackController when an XML document is fully loaded. This same technique was used in Chapter 15 when the built-in Sound class was subclassed as GameSound. Listing 16.4 shows the source code for the SoundtrackXML class.

Listing 16.4 *The source code of the SoundtrackXML Class*

```
class XMLClass.SoundtrackXML extends XML {

  public var owner:Object;

  public function SoundtrackXML(owner:Object) {
    super();
    this.owner = owner;
  }
}
```

Trying it Out

The Soundtrack.fla in the XMLClass folder of the examples demonstrates how the SoundtrackController can be used. The SoundtrackController class is also used in Phase III of the Astro Sweeper game. Its play and stop buttons invoke the SoundtrackController. The timeline code looks like:

```
import XMLClass.SoundtrackController;

soundtrackAudio =
    new SoundtrackController(gameTimeline, "soundtrack.xml");
```

The play button code looks like:

```
on (release) {
  soundtrackAudio.playTrack("main_loop", true);
  track_name_txt.text = soundtrackAudio.activePhase;
}
```

The stop button code looks like:

```
on (release) {
  soundtrackAudio.stopSoundNow("main_loop");
  track_name_txt.text = "";
}
```

The track_name_txt TextField displays the filename of the currently playing track. Figure 16.1 shows the Soundtrack.swf.

Figure 16.1 *The Soundtrack.swf*

More XML

Flash has additional XML-related classes, including the XMLSocket class which can be used to maintain a persistent connection with a chat server or a multiplayer game server. Again, XML is used in so many ways that there are many books devoted solely to XML. This chapter provides a simple introduction to a very large topic.

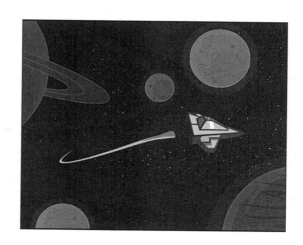

USING ACTIONSCRIPT TO BUILD A GAME – ASTRO SWEEPER

04

17 Designing a Game

Ready to Build

The previous chapters have discussed and described the elements and techniques that are required to create any Flash application. Developers often refer to these basic programming elements as a "toolbox". An even better analogy might be a "workshop", with tools, materials, references, etc. And for some developers, including the author, the best analogy is a big box of Legos. There are some basic elements (blocks), some advanced elements (gears, shafts, wheels), and a lot of techniques which are inspired by the instructions, but which are perfected by hours experimentation.

This final section of this book represents the phase in the learning process that really starts to be fun (or rewarding, or profitable). The first two sections of the book introduced the tools, materials, and techniques for using ActionScript 2. Mastering this material probably feels like work to most people. In fact, it is hard work, but the reward is in sight. This final section reveals the process for actually building something. At this point, the reader has a toolbox, a workshop, a box of Legos: these represent potential. For what? That is the first important question to answer.

What to Build?

There are rare times when this is really the question. Usually, the answer is predetermined by requirements at work, school, etc. But occasionally – perhaps for a few moments at the end of a big project – there is an opportunity to contemplate something new. Reading a book like this may be one of those open ended, unbounded times to ask, "What can really be done with all of this ActionScript stuff?" One of the best answers to that question is: build a game. But what kind of game? A shooting-debris-in-space game, of course. Why not start where all computer games started?

Architecture

The term, "architecture", refers to both the pragmatic and esthetic natures of a structure. When applied to buildings, the term refers to the structural integrity, the functionality, and to the beauty of a building. The same is true when the term is applied to a Flash application. The structural integrity of an application is its capacity to withstand modification, enhancement, expansion. The functionality of an application is what the end user experiences. The beauty is what other programmers see when they look at the code. Naturally, functionality is what most people care about and how most applications are – at least initially – evaluated. If it works like it is supposed to, then most people are happy. But the value of code is directly related to its structural integrity and even its beauty.

For the most part, ActionScript 1 development was (is) focused on functionality. The language, itself, stands in the way of integrity and beauty. It is just too easy to make a mess, and too hard to really do

things in a nice way. Programmers have a professional term for code that lacks integrity and beauty: "spaghetti". There are plenty of disciplined developers who have made beautiful ActionScript 1 applications, but for every one of these applications there are many more with spaghetti code that works, but that will never be used again. It is a shame, and it might as well be blamed on ActionScript 1.

ActionScript 2, however, provides the structure and language features to make spaghetti code a thing of the past. Instead of distributing ActionScript 1 code throughout an FLA, tucking little bits on buttons and on hidden movie clips nested several levels deep, code can now be organized in centralized, reusable classes. And these classes, once created, can be reused over and over again, often without modification. This multiplies the value of the code and the initial effort to develop it. Determining how to distribute an application's functionality among classes requires some up-front analysis.

Analyzing the Game

Probably the best way to begin analyzing a game (or any application) is to describe it in prose. In general, the nouns and verbs of the description can be translated directly into game classes, their properties (variables), and their methods (functions). For example:

> Astro Sweeper is a game in which a space ship travels through space seeking out debris and cleaning it up by shooting it with laser bullets. The space ship's mission gets more and more difficult on each level because the quota of debris which must be cleared increases, and hostile crystals appear. These crystals are not passive drifters, like the debris, they actively pursue the Space Ship. Whenever the Space Ship collides with debris or crystals, some basic shield energy is lost until the ship is made completely vulnerable and destroyed.

> This ship's rotation, thrust and laser cannon can be controlled via the keyboard.

> Fortunately, the ship is provided with assistance in the form of powerups which seek out the ship and bestow upon its special powerful features. These include: fully restored energy, multiple simultaneous bullets, a tail gun which simultaneously shoots bullets aft-ward, and a super-shield which prevents the ship from colliding with debris and crystals.

> The Ship can move through an area of space that is viewed through a small (600 × 400 pixel) view port.

Classes: The Nouns and Verbs

In the description above, several nouns stand out as candidates for classes, others for the classes' properties, and the related verbs, for the class's methods. In the following list, the nouns that are candidates for classes are capitalized. Nouns that are candidates for properties are indented under their respective classes, and lowercase. Verbs that are candidates for methods are indented under their respective classes, lowercase, and followed by parentheses – indicating that they are functions:

Space Ship
 travlel()
 seek()
 clean()
 shoot()
 collide()
 energy

 lose_energy()
 destroy()
 rotate()
 thrust()

Space

Debris
 drift()

Bullet

Mission / Level
 quota
 increase()

Crystals
 hostile
 appear()
 pursue()

Keyboard
 input()

Powerups
 seek()
 bestow()
 energy
 multiple bullets
 tailgun
 shield

View port
 Space

This preliminary list comes very close to describing the core set of classes that are used by the Astro Sweeper game. A few additional paragraphs of description can just about capture the rest:

Points are awarded for each Debris object that is cleared. In addition, at the end of each level, if the level is completed within a specified amount of time, bonus points are awarded for all the lives (energy) remaining. The total score is the sum of points earned clearing Debris and bonus points.

While the game is playing, sound effects are triggered and then stopped for actions like shooting, collision, acquiring powerups, and activating thrusters. In addition, there are separate soundtracks that are triggered and looped for the title page, the main game, and the post-level pause.

The game has several screens for: loading, title, instructions, level complete, win, game over, and credits. During the game, a heads-up-display shows important statistics like the bonus time remaining, the current level, debris cleared vs. the quota, a simple radar showing debris locations relative to the Ship, and a timer indicating how long the active powerup will continue to function.

The game ends when all of the Ship's lives (energy) are used up.

Based on these last few paragraphs, the additional class candidates look like:

Points/Score
 bonus points
 debris-clearing points
 total points
 allowed bonus time
 award()

Sound
 shoot
 collide
 acquire powerup
 activate thruster
 title loop
 game loop
 inter-level loop
 trigger()
 stop()
 loop()

Title Screen
Instructions Screen
Level Complete Screen
Win Screen
Game Over Screen
Credits Screen

HUD
 Radar
 Powerup Timer
 Statistics display

The "classes" listed above form an informal inventory of the structure and functionality of the application. They will be formalized over the next three chapters and the goal will be to end up with code that also has a degree of beauty.

Assets

In addition to identifying the necessary code, the informal class inventory above can also be used to derive the game's rough asset list. These can generally be divided in to visual and audio assets. Based on the class list, these assets will include (at least):

MovieClips
 Space Ship★★
 Space Scene (background)

> Debris★
> Bullet★
> Crystal★
> Powerups★
> Title Screen★
> Instructions Screen
> Level Complete Screen
> Win Screen
> Game Over Screen
> Credits Screen

HUD
> Radar
> Powerup Timer★
> Statistics display

Sounds
> shoot
> collide
> acquire powerup
> activate thruster
> title loop
> game loop
> inter-level loop

The elements followed by an asterisk (★) are good candidates for animation, and in the case of the Ship, multiple animations (★★).

The Basic Game Architecture

Most games have a core, common architecture. There is generally a mechanism for managing pre- and post-game screens. And there is a mechanism for handling in-game processing. This generally takes the form of a "main loop". In turn-based games, like chess or blackjack, the main loop consists of: game processing, then waiting for a player to make a move, then more processing, then waiting, then processing, etc. In "real-time" games, like Astro Sweeper, the main loop consists of continual processing that includes checking for and responding to user input. Processing happens in chunks called "frames". The term, "frames", refers to the fact that games are visual and each screen update is analogous to a frame of film in a movie. The visual experience of watching a game is very similar to the experience of watching a movie. For a game to be appealing, the "frame rate" has to just about as high (fast) as a movie – or higher. This means that the game needs to be able to update the screen at least 24 times a second. And this means that all the processing for one frame has to happen in less than 1/24th of a second or 0.0417 seconds. Fortunately, computers are fast and that actually sounds like a lot of time to a Pentium 4 or a G5.

Astro Sweeper: The Main Loop

The pre- and post-game screens typically do not require as much processing as the actual game frames, and they tend to utilize a relatively small amount of processing power. As a result, they often do not need to be optimized carefully. But the main loop can bring a processor to its knees, and usually this is the goal: to use every bit of the processor's power without going over. When designing a main loop, only the activity that absolutely needs to be processed each frame should be included. The main loop for the completed Astro Sweeper game (from the GameController class) looks like:

```
public function mainLoop():Void {
    InputManager.processKeyboardInput();
    handleInput();

    FrameTimeManager.calculateFrameTime();

    if (!pause) {

      if (checkGameOver()) {
        gameTimeline.gotoAndPlay("gameOver");
      } else if (checkLevelComplete() && !ship.over) {
          gameTimeline.gotoAndPlay("levelComplete");
      } else {
          moveObjects("objects");
          moveObjects("bullets");
          ship.move();
          checkCollision("objects", "bullets");
          checkShipCollision("objects");
          BGManager.sync(ship.coords);
      }
      HudManager.update();
      spawnPowerups();
      spawnDebris();
      spawnCrystals();
    }
}
```

The English equivalent would be:

Calculate the elapsed time since the last frame
 For use in per-frame calculations
Check for Keyboard input
Take the appropriate action based on Keyboard input
Check to see if the game is over
Check to see if the level is complete

Move all the general objects
Move all of the bullets
Move the ship

Check for collisions between bullets and objects
Check for collisions between objects and the ship
Move the background relative to the ship

Update the HUD
Spawn new powerups
Spawn new debris
Spawn new crystals

This is the minimal set of instructions that needs to be executed every frame of the game. Of course, all of the function calls represent blocks of code, many of which contain additional function calls. The concise block of mainLoop() code represents a lot of supporting code. But the top-level view of the frame-by-frame execution of the game reveals a design that is clean and efficient. The details are covered in the next three chapters.

The Formal Class List

Earlier in this chapter, an informal class list was derived from the prose description of the Astro Sweeper game. The corresponding formal class list is detailed below. The formal class name is listed in **bold**. The corresponding informal class name from the earlier list is in parentheses. Indented under the class name are the actual properties and the methods of the class. The method names are followed by parentheses () to indicate that they are functions. Constructor methods are in *italics*.

Ship (Space Ship) extends BaseObject
over
anim
animPrev
shooting
hit
animDone
shieldOn
thrustOn
shieldPlaying
thrustPlaying
multiShot
tailGun
readyTimer
shipAudio

Ship()
setShielded()
move()
friction()
updateCoords()
setAnimation()
doneShooting()
reset()

thrust()
rotate()
shoot()
die()

BGManager (Space)
mc
SCREEN_ORIGIN
shipBounds
worldBounds

initialize()
sync()

Debris (Debris) extends BaseObject
size

Debris()
move()
setSize()

Bullet (Bullet) extends BaseObject
durationTimer

Bullet()
move()

LevelManager (Mission / Level)
BASE_POWERUP_INTERVAL
BASE_DEBRIS_INTERVAL
BASE_CRYSTAL_INTERVAL
HIT_MULTIPLIER
TIME_PER_LEVEL

getPowerupInterval()
getDebrisInterval()
getCrystalInterval()
getTargetHits()
setSpawnInfo()

Crystal (Crystals) extends BaseObject
size
autoPilotTimer

Crystal()
move()
friction()
updateCoords()
autoPilot()

InputManager (Keyboard)
 QUIT
 ROTATE_LEFT
 ROTATE_RIGHT
 FORWARD
 BACK
 SHOOT
 SUPER_SHOOT
 USE_POWERUP
 SHIELD
 XTRA
 NUM_STATES
 keyMap
 inputState

 initKeymap()
 processInput()
 processKeyboardInput()
 checkInputState()

Powerup (Powerups) extends BaseObject
 type
 autoPilotTimer
 durationTimer

 Powerup()
 move()
 friction()
 updateCoords()
 autoPilot()

(View port): see **BGManager** (above)

ScoreManager (Points/Score)
 MAX_LIVES
 levelScore
 levelBonus
 score
 bonus
 totalScore
 level
 lives
 hits
 levelTimer
 resetLevelScore()

resetLevelTimer()
getBonusTimeRemaining()
getBonusTimeRemainingDisplay()
updateLevelScore()
updateScore()
reset()

AudioController (Sound)
soundClip
soundList
soundClipContainer
lastSoundID

AudioController()
registerSound()
loadSound()
onSoundLoaded()
onID3Detected()
playSound()
stopSoundNow()
stopSoundAtEndOfLoop()
setSoundVolume()

HUDManager (HUD/Statistics display)
mc
levelScoreTextField
levelTextField
scoreTextField
bonusTextField
timerTextField

initialize()
update()
registerStatsTextFields()
setHudVisibility()

RadarManager (Radar)
mc

initialize()
update()

PowerupManager (Powerup Timer)
TOTAL_FRAMES
POWERUP_LIFESPAN
POWERUP_DURATION

mc
currentFrame
elapsedTime
powerupTimer
activePowerup

initialize()
reset()
update()
activatePowerup()
deactivatePowerup()
invoke()
revoke()

BaseObject (superclass for several game classes)

cords
mc
name
speed
velocity
angleIndex
alive

BaseObject()
draw()
setAngleIndex()
move()
moveTo()
destroy()

Class Descriptions

The following descriptions are for the classes listed above:

Ship	The central Space Ship, the player object. There is only one instance of this class
BGManager	Manages the game world, primarily the space-themed background
Debris	Instances of this class are the space junk that the Space Ship needs to clean up
Bullet	Instances of this class are the laser bullets used to clear out space debris and defend against phantom crystals
LevelManager	Manages the parameters that make levels successively more difficult
Crystal	Instances of this class are the phantom crystals that threaten the Space Ship
InputManager	Manages detection of Keyboard input
Powerup	Instances of this class are the special objects that give the Space Ship temporary super abilities

ScoreManager	Manages the scoring in the game and keeps track of score related statistics like lives remaining, current level, points, bonus, etc.
AudioController	Instances of this class control groups of game sounds like soundtracks and effects
HUDManager	Manages the heads up display
RadarManager	Manages the radar functionality of the heads up display
PowerupManager	Manages the activation and deactivation of super abilities granted to the Space Ship by powerups
BaseObject	This class serves as a foundation for a variety of game objects that share common properties and methods, including: The Ship, Bullets, Debris, Crystals, and Powerups (from Chapter 11)

Behind the Scenes: Helper Classes

Finally, a few behind-the-scenes helper classes are needed. Knowing this comes from experience. In Astro Sweeper, these classes include:

GameController	This class coordinates all aspects of the game
ObjectManager	This class is responsible for creating all of the game object instances. It is a "factory" for objects
AIManager	This class centralizes the game's Artificial Intelligence elements (very primitive)
FrameTimeManager	This class keeps track of the frame time for per-frame calculations
GameDepthManager	This class generates MovieClips depths that are guaranteed not to interfere with each other
MathTables	This class performs some optimized mathematical calculations (from Chapter 9)
Timer	This class manages general timer functions (from Chapter 9)
VectorMath	This class performs calculations on coordinates

Building the Game

In this chapter, the Astro Sweeper game has been described and analyzed. The results of this analysis are several important game design elements: the prose description, the main loop organization, the class inventory, and the asset list. Taken together, these elements define the architecture of the game and will serve as a blueprint for the construction process.

Game development is most often an iterative process. That is, the ultimate goal is achieved by making successive playable, testable "builds" that converge on the final result. At each iteration, the design is re-evaluated and corrections are made. With large-scale commercial games, the iterations can happen over months or years. With Astro Sweeper, the iterations happen over the next three chapters.

18 Building the Game – Phase I: The FLA and the GameController

Making the Most of the FLA

With ActionScript 2, application code should be contained in external .as files, but the core of most Flash applications is still the FLA. In general, the FLA is where the application's visual assets are organized and where the user interface is developed. In this chapter, the basic structure of the game's FLA is constructed. The process involves:

- Setting up the Timeline
- Organizing assets in the Library
- Constructing a basic GameController class

This chapter makes use of the "GamePhaseI.fla" and various classes from the GamePhaseI folder of the examples.

Setting up the Timeline

For the Astro Sweeper game, the Main Timeline of the FLA is used to map out the basic phases of the game. This can be seen in Figure 18.1.

The timeline is a powerful tool for visually organizing sequences of events. The Astro Sweeper game is made up of a number of phases which can be described on a timeline:

Astro Sweeper Game Phases:

- loading
- start
- title
- instructions
- play
- nextLevel
- ready
- mainLoop
- levelComplete
- win
- gameOver

Figure 18.1 *The main timeline of the GamePhaseI.fla*

Collaboration Between Designers and Programmers

From the point of view of a programmer, the Main Timeline is unnecessary. ActionScript can be used to dynamically control MovieClips for game objects, user interface screens, etc. Almost nothing actually needs to be on the Main Timeline. But putting the basic user interface elements on the Main Timeline makes it easier for designers to control the visual aspects of the interface.

One of the primary advantages of using ActionScript 2 is that it simplifies collaboration between designers and programmers. The Astro Sweeper game illustrates this by completely separating the visual elements of the game from the game code. All of the visual elements of the game are included in the FLA. The Main Timeline contains all of the game screens, and the Library contains the rest of the MovieClips that will be dynamically added to the game. When Astro Sweeper was originally being developed for this book, the designer was able to work on the FLA independently of the programmer. As code was developed and improved, the external .as files were simply updated. There was never a need for the programmer to open up the FLA and surgically update the code – because there is no code in the FLA.

This "de-coupling" would have been clumsy before ActionScript 2. But now it is easy and can dramatically improve the workflow during development. Astro Sweeper employs this strategy to

the fullest extent possible. To make this strategy work, a significant amount of up-front analysis has to be done to understand the best way to separate the visuals from the code. Every application will have unique requirements, but Astro Sweeper can serve as a point of reference.

Timeline Layers and Labels

The game's phases are indicated on the timeline using labels on the "labels" layer. In addition to describing the contents of the timeline's frames, these labels are used by ActionScript to tell the timeline to go to the specified game phase.

In addition to the labels layer, there are layers for:

- actions
- stops
- offstage blocker
- pre-loader
- screens
- background

These can also be seen in Figure 18.1.

Keeping actions on their own "actions" layer improves the readability of the code. Another helpful technique is to keep "stop()" actions on their own "stops" layer. Stops are like the period at the end of a sentence. Being able to see all the stops at a glance gives a developer an immediate sense of the flow of an application.

The "offstage blocker" layer simply holds a graphic element that obscures any offstage elements. Without this, game players may inadvertently get a behind-the-scenes look at the game if the Flash player window is scaled manually and the aspect ratio changes. The blocker just insures that no matter what, only elements in the official stage area will be seen by players.

The "pre-loader" layer holds a simple MovieClip that plays while the game is loading.

The "screens" layer contains the various screens that the player will see during phases of the game. These screens include:

- Title screen
- Instructions screen
- HUD (Heads Up Display)
- Next level screen
- Win screen
- Game over screen

Note that the screen displayed while the game is actually playing consists of the background and the HUD, in addition to the dynamic elements like the space ship, astro debris, phantom crystals, bullets, etc.

The "background" layer contains the background graphic (actually a MovieClip) and it is only seen while the game is playing. It provides the spacey backdrop against which the action takes place.

Organizing Assets in the Library

Perhaps the most important function of the FLA is that it contains the Library of assets used by the game. In Phase I, the important assets include:

- The game screens
 - Title screen
 - Instruction screen
 - The HUD
 - Level complete screen
 - Win screen
 - Game Over screen
 - Buttons
- The background
- The game objects
 - Ship
 - Bullet
 - Powerups
 - Debris
 - Crystal
- Game audio
- The pre-loader

The Astro Sweeper Library uses folders to organize all of these elements. This can be seen in Figure 18.2.

The Timeline Actions

The "actions" layer contains all of the code in the FLA. This code is limited, and is only used to move the playhead to the appropriate phase of the game. All of the actual game code is external.

Actions: loading

The timeline code associated with the "loading" frame label is used to implement a simple "pre-loader". The pre-loader is used to communicate the loading status to the user while the game loads. The Astro Sweeper pre-loader is simplest kind. It waits until the "start" frame is completely loaded before allowing the game to continue. While it is waiting, a simple "Loading…" message is displayed. The "start" frame contains the title screen, so when it is loaded, the title screen is ready to be displayed. The timeline code from frame 1 looks like:

```
Object.prototype.gameTimeline = this;

ifFrameLoaded ("start") {

  gotoAndPlay("start");

}
```

Figure 18.2 *The GamePhaseI.fla Library*

The first line creates a new property on the "prototype chain" of the built in "Object" object. The property is called "gameTimeline" and it is set to refer to "this", the Main Timeline. This is complicated to fully explain, but the result is that every object (MovieClip, Button, etc.) from this point on will inherit the new game Timeline property which will point to the game's Main Timeline. It will be a convenient way to talk to the Main Timeline from anywhere in the FLA.

Then next three lines do the simplest, AS1-style check to see if the "start" frame is completely loaded. If it is, the game will jump to the "start" frame and continue. If not, the next frame will

play. Frame 2 has one line of code on it:

```
gotoAndPlay(1);
```

This send the playhead back to frame 1 to check again.

Actions: start

The timeline code associated with the "start" frame label imports the code necessary to instantiate the GameController object. This GameController class will be explained later, but it is the interface between the FLA and the game code. It listens to the FLA for input and game phase changes, and it updates the game accordingly. The new instance of the GameController class is called, "GC". It is referenced whenever the GameController needs to be informed about timeline events. The code looks like:

```
import GamePhaseI.GameController;
GC = new GameController(this);
GC.start();
```

The start frame is reached only once per game.

Actions: title

The timeline code associated with the "title" frame label simply lets the GameController know that the title phase has been reached. The code is simple:

```
GC.title();
```

This invokes the title() method of the GameController. It is up to the GameController to do the right thing. In addition to the above code, the "title" frame also contains the Title screen MovieClip (screen_title), on the "screens" layer. Figure 18.3 shows the title screen MovieClip.

The "screen_title" MovieClip contains an animation of the space ship, the logo, and two buttons: Play Game and Instructions. The code on these buttons tells the Main Timeline to jump to either the "play" label or the "instructions" label. The code on the play button looks like:

```
on (release) {
  gameTimeline.gotoAndPlay("play");
}
```

As explained above: on frame 1, "gameTimeline" was set to refer to the Main Timleline. Because it is a property of every object, it can be reference from anywhere in the FLA. The above code tells the Main Timeline to go to the "play" frame and continue. The code on the instructions button is similar:

```
on (release) {
  gameTimeline.gotoAndPlay("instructions");
}
```

Figure 18.3 *The title screen MovieClip*

Actions: instructions

There is no timeline code associated with the "instructions" frame label, but on the screens layer is the Instructions screen MovieClip (screen_instr). This screen can be seen in Figure 18.4.

The Play button on the instructions screen tells the Main Timeline to go to the "play" label and continue:

```
on (release) {
  gameTimeline.gotoAndPlay("play");
}
```

Actions: play

The timeline code associated with the "play" frame label tells the Game Controller (GC) that the play phase has been reached:

```
GC.play();
```

The "play" frame also contains the HUD (hud) screen – on the screens layer. The HUD consists of a statistics panel in the lower left, a radar in the lower right and a powerup meter in the upper right. The HUD code is described later.

Figure 18.4 *The instructions screen MovieClip*

Actions: nextLevel

The timeline code associated with the "nextLevel" frame label tells the GameController that the next level should be started:

```
GC.nextLevel();
```

Actions: mainLoop

The timeline code associated with the "mainLoop" frame label tells the GameController to process one game frame:

```
GC.mainLoop();
```

This code needs to be executed every frame, so the next frame tells the timeline to back up and play it again.

```
gotoAndPlay(_currentframe - 1);
```

This happens repeatedly while the game is playing. This is a very "visual" way to implement a main loop. It can also be implemented using an onEnterFrame event handler. The above method is very designer-friendly.

Actions: levelComplete

The timeline code associated with the "levelComplete" frame label tells the GameController that the levelComplete phase has been reached:

```
GC.levelComplete();
```

Then, a few frames later, there is code that pauses for a few seconds so that the levelComplete screen can be read by the player. It then starts the next level automatically:

```
if (GC.levelPauseTimer.seconds() > 3) {
    gameTimeline.gotoAndPlay("nextLevel");
}
```

On the screens layer is the Level Compete screen MovieClip (screen_level_complete). It contains a few fields for displaying the score information and it has a button that will start the next level. The screen can be seen in Figure 18.5.

The fields on the Level Complete, Win, and Game Over screens are all filled-in automatically by the GameController class, which is described later. For this to work, the fields need to have

Figure 18.5 *The Level Compete screen MovieClip*

specific instance names. In these cases, the instance names are:

- level_bonus_txt
- level_score_txt
- bonus_txt
- score_txt
- total_score_txt

This is part of the up-front planning that is required to make it possible to de-couple code and visuals.

Actions: win

The timeline code associated with the "win" frame label lets the GC know that the win phase has been reached:

```
GC.win();
```

Figure 18.6 shows the Win screen MovieClip (screen_win). The play again button on both the Win and Game Over screens does the same thing. It returns the game to the title phase:

```
on (release) {
    gameTimeline.gotoAndPlay("title");
}
```

Figure 18.6 *The Win screen MovieClip*

Actions: gameOver

The timeline code associated with the "gameOver" frame label lets the GC know that the gameOver phase has been reached:

```
GC.gameOver();
```

Figure 18.7 shows the Game Over screen MovieClip.

Figure 18.7 *The Game Over screen MovieClip*

The Core Classes

The first phase of developing the full Astro Sweeper game introduces several new classes. These include:

- ScoreManager
- LevelManager
- HudManager
- RadarManager
- GameController

In addition to these new classes, two familiar classes are minimally updated:

- ObjectManager
- Ship

The ScoreManager Class

The ScoreManager class is responsible for keeping track of the game score and related statistics. By centralizing this functionality, it is easy to change the scoring mechanism for the game by making modifications in one place. The ScoreManager class depends on the LevelManager class. The full listing of the ScoreManager class can be seen in Listing 18.1.

Listing 18.1 *The ScoreManager class*

```
import ch09.Timer;
import GamePhaseI.LevelManager;

class GamePhaseI.ScoreManager{

  static var MAX_LIVES:Number = 10;

  static var levelScore:Number = 0;
  static var levelBonus:Number = 0;
  static var score:Number = 0;
  static var bonus:Number = 0;
  static var totalScore:Number = 0;
  static var level:Number = 1;
  static var lives:Number = MAX_LIVES;
  static var hits:Number = 0;
  static var levelTimer:Timer = new Timer();

  static public function resetLevelScore():Void {
    levelScore = 0;
    levelBonus = 0;
    hits = 0;
  }

  static public function resetLevelTimer():Void {
    levelTimer.restartTimer();
  }

  static public function getBonusTimeRemaining():Number {
    return levelTimer.remaining(LevelManager.
      getLevelTime());
  }

  static public function getBonusTimeRemainingDisplay():
    String {
```

```
    return levelTimer.displayRemaining(LevelManager.
       getLevelTime());
  }

  static public function updateLevelScore(points:Number):
    Void {
    levelScore += points;
  }

  static public function updateScore():Void {
    if (getBonusTimeRemaining() > 0) {
       levelBonus = level * lives * 10;
    }
    score += levelScore;
    bonus += levelBonus;
    totalScore = score + bonus;
    level ++;
  }

  static public function reset():Void {

    score = 0;
    bonus = 0;
    levelScore = 0;
    levelBonus = 0;
    totalScore = 0;
    level = 1;
    lives = MAX_LIVES;
    hits = 0;
  }
}
```

Table 18.1 describes the methods and properties of the ScoreManager class.

The LevelManager

The LevelManager class is responsible for determining the difficulty of the current level. Half the fun of developing a game is "balancing" it – making it hard enough to be challenging, but still playable enough to be satisfying. The LevelManager class is intended to centralize all of the game-balancing controls. The full source code for the LevelManager class can be seen in Listing 18.2.

Listing 18.2 *The LevelManager class*

```
    import GamePhaseI.ScoreManager;

    class GamePhaseI.LevelManager{
```

Table 18.1 *The methods and properties of the ScoreManager class*

Method	Description
resetLevelScore()	Resets the score for a new level
resetLevelTimer()	Resets the level timer
getBonusTimeRemaining()	Returns the time remaining for a bonus
getBonusTimeRemainingDisplay()	Returns a text version the above
updateLevelScore()	Increments the levelScore with the supplied value.
updateScore()	Calculates the score at the end of the level, including a bonus if the bonus time has not run out. The bonus is based on the number of lives remaining
reset()	Resets all of the score statistics for a new game

Property	Description
MAX_LIVES	The maximum number of lives
levelScore	The score earned in a given level
levelBonus	The bonus earned in a given level
score	The cumulative score
bonus	The cumulative bonus
totalScore	The sum of score and bonus
level	The current level
lives	The current number of lives remaining
hits	The number of times debris has been shot
levelTimer	The elapsed time for the current level

```
public static var BASE_POWERUP_INTERVAL:Number = 15000;
public static var BASE_DEBRIS_INTERVAL:Number = 5000;
public static var BASE_CRYSTAL_INTERVAL:Number = 5000;
public static var HIT_MULTIPLIER:Number = 10;
public static var TIME_PER_LEVEL:Number = 30000;

public static function getPowerupInterval():Number {
  return BASE_POWERUP_INTERVAL -
    (500 * ScoreManager.level);
}

public static function getDebrisInterval():Number {
  return BASE_DEBRIS_INTERVAL -
    (500 * ScoreManager.level);
}

public static function getCrystalInterval():Number {

  if (ScoreManager.level < 3) {
      return 100 * 1000 * 1000; //effectively infinite
```

```
        } else {
            return BASE_CRYSTAL_INTERVAL -
              (500 * ScoreManager.level);
        }
    }

    public static function getTargetHits():Number {
        return ScoreManager.level * HIT_MULTIPLIER;
    }

    public static function getLevelTime():Number {
        return ScoreManager.level * TIME_PER_LEVEL;
    }
}
```

The methods and properties of the LevelManager class are described in Table 18.2.

Table 18.2 *The methods and properties of the LevelManager class*

Method	Description
getPowerupInterval()	Calculates the time between new powerups based on the current level
getDebrisInterval()	Calculates the time between new debris objects based on the current level
getCrystalInterval()	Calculates the time between new crystal objects based on the current level
getTargetHits()	Calculates the hits required to finish the level based on the current level
getLevelTime()	Calculates the bonus time allowed based on the current level

Property	Description
BASE_POWERUP_INTERVAL	The base time between new powerups
BASE_DEBRIS_INTERVAL	The base time between new debris
BASE_CRYSTAL_INTERVAL	The base time between new crystals
HIT_MULTIPLIER	The number of required hits per level
TIME_PER_LEVEL	The allowed bonus time per level

The HUDManager

The HUDManager class controls the elements of the in-game heads-up display. These elements can be seen in Figure 18.8.

In Phase I, the stats panel (lower left) and the radar panel (lower right) are functional.

The stats panel has three text fields for displaying: the remaining time, level bonus, and level score. The HUDManager keeps these up-to-date. It also has an energy bar which is a visual representation

Figure 18.8 *The Heads-up Display MovieClip*

of the number of remaining lives. The HUDManager controls the horizontal scale of this bar based on the number of lives remaining. This makes the bar appear to shrink as lives are used up.

The radar panel contains a number of "blip" MovieClips that are positioned by the HUDManager to represent objects in the game world.

The code to control all of this is seen in Listing 18.3.

Listing 18.3 *The HUDManager class*

```
import GamePhaseI.RadarManager;
import GamePhaseI.ScoreManager;

class GamePhaseI.HudManager {
  public static var ENERGY_BAR_WIDTH:Number = 87.4;

  public static var mc:MovieClip;
  public static var levelScoreTextField:TextField;
  public static var levelTextField:TextField;
  public static var scoreTextField:TextField;
```

```
public static var bonusTextField:TextField;
public static var timerTextField:TextField;

public static function initialize(hud_clip){
  mc = hud_clip;

  RadarManager.initialize(mc.radar);
  registerStatsTextFields();
}

public static function update():Void {
  RadarManager.update();

  var tempScore:String =
    ScoreManager.levelScore.toString() +
      "/" + ScoreManager.totalScore.toString();
  levelScoreTextField.text = tempScore;
  levelTextField.text = "Level: " + ScoreManager.level;
  timerTextField.text =
    ScoreManager.getBonusTimeRemainingDisplay();
  mc.stats.energy_meter.energy_bar._width =
    ScoreManager.lives /
    ScoreManager.MAX_LIVES * ENERGY_BAR_WIDTH;
}

public static function registerStatsTextFields():Void {
  levelScoreTextField = mc.stats.level_score;
  levelTextField = mc.stats.level;
  timerTextField = mc.stats.timer;
}
}
```

The methods and properties of the HUDManager class are described in Table 18.3.

The RadarManager

The RadarManager class is responsible for keeping the radar panel – in the HUD – up-to-date. It moves the blips on the radar display to indicate where game objects are in the game world.

The RadarManager code can be seen in Listing 18.4. It is relatively simple. The one property of the RadarManager class, "mc", is used to hold a reference to the radar MovieClip. The initialize() method sets this property. The one other method, update(), keeps the radar panel up-to-date by moving the blips to represent the locations of objects in the "diamonds" array. In this implementation, there are 10 red blip MovieClips, so the radar is limited to tracking 10 objects. There are also 5 special orange blips for tracking powerup–later. The visible area of the radar panel is 1/15th the size of the game window, so all world coordinates are scaled accordingly.

Table 18.3 *The methods and properties of the HUDManager class*

Method	Description
initialize()	Sets the mc property, initializes the RadarManager, and sets the TextFields that need to be updated by the HUDManager
update()	Called each frame by the GameController, this method updates the RadarManager and updates all of the stats TextFields and the energy meter bar.
registerStatsTextFields()	sets the TextField references to the text fields in the stats MovieClip.

Property	Description
ENERGY_BAR_WIDTH	The full width of the energy meter bar
mc	The main HUD MovieClip
levelScoreTextField	The text field currently being used to display the levelScore
levelTextField	The text field currently being used to display the level
scoreTextField	The text field currently being used to display the score
bonusTextField	The text field currently being used to display the bonus
timerTextField	The text field currently being used to display the remaining bonus time

Listing 18.4 *The RadarManager*

```
import GamePhaseI.ObjectManager;
import ch11.BaseObject;
import MovieClipClass.Diamond;

class GamePhaseI.RadarManager {
  public static var mc:MovieClip;

  public static function initialize(radar_clip){
    mc = radar_clip;
  }

  public static function update():Void {
    for (var i = 1; i <= 10; i++) {
      mc.blips["blip_" + i]._visible = false;
    }

    for (var i = 1; i <= 5; i++) {
      mc.blips["blip_pu_" + i]._visible = false;
    }

    var blipCount:Number = 0;
    var blipPUCount:Number = 0;

    var thisArray:Array = ObjectManager.arrays["diamonds"];
    for (var i:Number=0; i < thisArray.length; i++) {
```

```
var thisObject:BaseObject = BaseObject(thisArray[i]);
if (thisObject instanceof Diamond) {
    blipCount += 1;
    mc.blips["blip_" + blipCount]._x =
        (thisObject.mc._x - ObjectManager.ship.mc._x)
        / 15;
    mc.blips["blip_" + blipCount]._y =
        (thisObject.mc._y - ObjectManager.ship.mc._y)
        / 15;
    mc.blips["blip_" + blipCount]._visible = true;
    }
  }
 }
}
```

The GameController

The real workhorse of the game is the GameController class. It coordinates all of the various components, making use of the manager classes described above. In the example from Chapter 13 (MovieClipClass.fla), the job of the GameController was done by the timeline code. In fact, the main methods of the GameController class match the timeline functions from the Chapter 13 example.

The GameController knows how to get a game started, how to update scores, how to determine if a level is complete, how to spawn (create) and move all of the game objects and how to decide when collisions occur. It relies on a number of other classes, in addition to the manager classes, to do all of this, but all decision-making responsibility rests on the GameController. As explained earlier in this chapter, the GameController is instantiated by code on the Main Timeline of the FLA – on the "start" frame. It is then called whenever a new game phase is reached.

The full code listing is shown in Listing 18.5

Listing 18.5 *The GameController*

```
import ch09.Timer;
import ch09.FrameTimeManager;
import ch11.BaseObject;
import MovieClipClass.Diamond;
import KeyClass.InputManager;
import GamePhaseI.Ship;
import GamePhaseI.ObjectManager;
import GamePhaseI.ScoreManager;
import GamePhaseI.HudManager;
```

```
class GamePhaseI.GameController {
  var gameTimeline:MovieClip;
  var levelPauseTimer:Timer;
  var diamonds:Array = new Array();
  var ship:Ship;
  var pause:Boolean;
  public function GameController(game_timeline:MovieClip) {
    gameTimeline = game_timeline;
    levelPauseTimer = new Timer();
    ObjectManager.setTarget(gameTimeline);
  }
  public function start():Void {
    ship = ObjectManager.createShip(300, 340);
    ship.reset();
  }

  public function title():Void {

  }

  public function play():Void {
    HudManager.initialize(gameTimeline.hud);
    ScoreManager.reset();
  }

  public function nextLevel():Void {

    createDiamonds(10);
    ship.reset();
    ScoreManager.resetLevelTimer();
    ScoreManager.resetLevelScore();
  }

  public function mainLoop():Void {

    InputManager.processKeyboardInput();
    handleInput();

    FrameTimeManager.calculateFrameTime();

    if (!pause) {
      if (checkLevelComplete()) {
        gameTimeline.gotoAndPlay("levelComplete");
      } else {
        moveObjects("diamonds");
        moveObjects("bullets");
```

```
        ship.move();
        checkCollision("diamonds", "bullets");
    }
    HudManager.update();
  }
}

public function checkLevelComplete():Boolean{

  if (ObjectManager.arrays["diamonds"].length <= 0)
  return true;

  return false;
}

public function checkGameOver():Boolean{

  return ship.alive;
}

public function levelComplete():Void {
  levelPauseTimer.restartTimer();
  destroyObjects("bullets");
  destroyObjects("diamonds");
  ship.reset();
  ScoreManager.updateScore();
  gameTimeline.screen_level_complete.level_score_txt.
    text = ScoreManager.levelScore;
  gameTimeline.screen_level_complete.level_bonus_txt.
    text = ScoreManager.levelBonus;
  gameTimeline.screen_level_complete.total_score_txt.
    text = ScoreManager.totalScore;
}

public function win():Void {
  destroyObjects("bullets");
  destroyObjects("diamonds");
  ship.reset();
  ScoreManager.updateScore();
  gameTimeline.screen_win.score_txt.text =
    ScoreManager.score;
  gameTimeline.screen_win.bonus_txt.text =
    ScoreManager.bonus;
  gameTimeline.screen_win.total_score_txt.text =
    ScoreManager.totalScore;
}
```

```
public function gameOver():Void {
  destroyObjects("bullets");
  destroyObjects("diamonds");
  ship.reset();
  ScoreManager.updateScore();
  gameTimeline.screen_game_over.score_txt.text =
    ScoreManager.score;
  gameTimeline.screen_game_over.bonus_txt.text =
    ScoreManager.bonus;
  gameTimeline.screen_game_over.total_score_txt.text =
    ScoreManager.totalScore;
}

public function handleInput():Void {

  if (InputManager.inputState[InputManager.QUIT]) {
    gameTimeline.gotoAndPlay("gameOver");
  }

  if (InputManager.inputState[InputManager.ROTATE_LEFT]) {
    ship.rotate("left");
  }

  if (InputManager.inputState[InputManager.ROTATE_RIGHT]) {
    ship.rotate("right");
  }

  if (InputManager.inputState[InputManager.FORWARD]) {
  }

  if (InputManager.inputState[InputManager.BACK]) {
  }

  if (InputManager.inputState[InputManager.SHOOT]) {
    ship.shoot();
    pause = false;
  }
}

public function moveObjects(array_id:String):Void {
  var thisArray:Array = ObjectManager.arrays[array_id];
  for (var i:Number=0; i < thisArray.length; i++) {

    var thisObject:BaseObject = BaseObject(thisArray[i]);
    if (thisObject.alive) {
      thisObject.move();
    } else {
      thisObject.destroy();
```

```
            thisObject = null;
            ObjectManager.removeObject(array_id, i);
        }
    }
}

public function checkCollision(object_array_id:String,
                      projectile_array_id:String):Void {
    var objectArray:Array =
        ObjectManager.arrays[object_array_id];
    var projectileArray:Array =
        ObjectManager.arrays[projectile_array_id];

    for (var i:Number=0; i < objectArray.length; i++) {
        for (var j:Number=0; j < projectileArray.length;
            j++) {

            var object:BaseObject = BaseObject(objectArray[i]);
            var projectile:BaseObject =
                BaseObject(projectileArray[j]);

            if (projectile.alive) {
                if (projectile.mc.hit_target.hitTest(object.mc)) {
                    pause = true;
                    ScoreManager.updateLevelScore(100);
                    object.drawBounds();
                    projectile.mc.hit_target._visible = true;
                    object.alive = false;
                    projectile.alive = false;
                }
            }
        }
    }
}

public function destroyObjects(array_id:String):Void {

    var thisArray:Array = ObjectManager.arrays[array_id];
    for (var i:Number=0; i < thisArray.length; i++) {

        var thisObject:BaseObject = BaseObject(thisArray[i]);
        thisObject.destroy();
        thisObject = null;
    }
    ObjectManager.resetArray(array_id);
}
```

```
public function createDiamonds(count:Number):Void {
  for (var i:Number=0; i<count; i++) {
    var newDiamond:Diamond =
      ObjectManager.createDiamond(20 + (i * 55),120,50);
    newDiamond.draw();
    ObjectManager.addObject(newDiamond, "diamonds");
  }
 }
}
```

The methods and properties of the GameContoller class (for Phase I) are described in Table 18.4.

Table 18.4 *The methods and properties of the GameContoller class*

Method	Description
GameController()	The constructor method used to instantiate a GameController object.
start()	Called when the "start" frame is reached
title()	Called when the "title" frame is reached
play()	Called when the "play" frame is reached
nextLevel()	Called when the "nextLevel" frame is reached
mainLoop()	Called every time the "mainLoop" frame is reached, which happens every frame while the game is playing.
checkLevelComplete()	Checks to see if the conditions for ending a level have been met
checkGameOver()	Checks to see if the conditions for ending the game have been met
levelComplete()	Called when the "levelComplete" frame is reached
win()	Called when the "win" frame is reached
gameOver()	Called when the "gameOver" frame is reached
handleInput()	Called by the mainLoop() method to handle keyboard events
moveObjects()	Called by the mainLoop() method to move all of the game objects once per frame
checkCollision()	Called by the mainLoop() method to determine if any important collisions have occurred
destroyObjects()	Called whenever the game ends, to clean-up leftover game object
createDiamonds()	Called when the game starts to instantiate the Diamond object

Property	Description
gameTimeline	A reference to the Main Timeline
levelPauseTimer	A timer for pausing between levels
diamonds	The array of Diamond objects. This will eventually go away, when real game objects are used instead.
ship	A reference to the Space Ship
pause	A flag (Boolean) that determines if the game is paused

Analyzing the GameController Class

The GameContoller class may seem complex, at first glance, because it contains a lot of code. But very little of the code is new. The moveObject(), checkCollision(), and createDiamonds() methods are the same as the timeline functions from Chapter 13. The mainLoop() method is nearly the same as the onEnterFrame event handler from Chapter 13, except that it updates the HUDManager and has a new test to determine if the level is compete. The handleInput() method is very similar to the same method used in the KeyClass example from Chapter 14.

Phase I in Action

When all the pieces are assembled, the result is a game – an incomplete game, but a game. The Phase I version of Astro Sweeper can be seen by testing the GamePhaseI.fla in the GamePhaseI folder of the examples. Figure 18.9 shows the Phase I version of the game in action. The HUD is

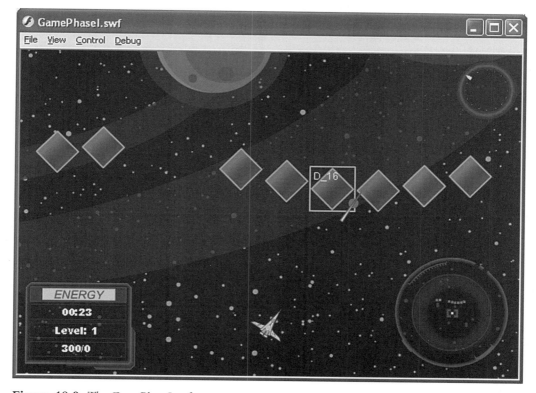

Figure 18.9 *The GamePhaseI.swf*

active and displaying the time, level, and score statistics. And the radar is active, showing blips for all of the surviving Diamond objects.

On to Phase II

Phase I is a true, ActionScript 2 foundation for a game. Phase II takes this to the next level by adding movement, powerups, and a tiny bit of AI (Artificial Intelligence).

19 Building the Game – Phase II: Movement and Powerups

Movement

Moving MovieClip instances in Flash is as easy as changing their _x and _y properties. Making them move convincingly in a game requires a small amount of math to approximate simple physics. The math is almost trivial, but it can be confusing, especially when each calculation needs to be done for both the x and y coordinate (the _x and _y properties).

Vectors and Scalars

The Astro Sweeper game makes use of a VectorMath class that simplifies some of the calculations by treating the two coordinates as one entity – a Vector. A Vector, simply put, is a mathematical entity with more than one component. In the context of vectors, normal single-component numbers are called "Scalars". The number of components is referred to as the "dimension" of the vector. A vector with two components (like x and y) is a 2-dimensional (2D) vector. A vector with three components (like x, y, and z) is a 3-dimensional vector. An n-dimensional vector has n components.

Astro Sweeper is a 2-dimensional game, so its vectors are all 2D vectors. For simplicity, they are simply called vectors.

Bounds

The VectorMath class makes use of one more kind of entity – an object that defines a bounding rectangle. Sometimes it is important to know whether an object is inbounds – inside a rectangular area. Points are vectors, because they have two components. A bounding rectangle has four components: top, left, bottom, and right. It is a kind of vector.

The VectorMath Class

The VectorMath class uses the generic ActionScript "Object" as a container for the components of its vectors. Each vector is defined as an Object with y and y properties. For example:

```
var vector:Object = new Object();
vector.x = 10;
vector.y = 20;
```

This defines a vector with two components (coordinates), x = 10 and y = 20. A shorthand way to write this is:

```
var vector:Object = {x:10, y:20};
```

This notation does the same thing as the previous example.

To use a vector, the properties of a MovieClip instance are set like:

```
tempMovieClip._x = vector.x;
tempMovieClip._y = vector.y;
```

It would be nice if MovieClips had a _coords property that could take a vector directly, but they don't.

The VectorMath class is a utility class like the built-in Math class. It is never instantiated. Instead, it serves as a container for some useful vector methods. The VectorMath class, and all of the other example classes from this chapter, can be found in the GamePhaseII folder of the examples. The full source for the VectorMath class is shown in Listing 19.1.

Listing 19.1 *The VectorMath class*

```
class GamePhaseII.VectorMath {

  public static function newVector(x:Number, y:Number)
    :Object {

    return {x:x, y:y};
  }

  public static function setVector(vector:Object, x:Number,
                                   y:Number) :Void {

    vector.x = x;
    vector.y = y;
  }

  public static function copyVector(v1:Object, v2:Object)
    :Void {

    v1.x = v2.x;
    v1.y = v2.y;
  }

  public static function addVectors(v1:Object, v2:Object)
    :Void {

    v1.x += v2.x;
    v1.y += v2.y;
  }
```

```
public static function subtractVectors(v1:Object, v2:
                                           Object):Void {

  v1.x -= v2.x;
  v1.y -= v2.y;
}
public static function scaleVector(vector:Object,
                                      scalar:Number):Void {

  vector.x *= scalar;
  vector.y *= scalar;
}
public static function multVectors(v1:Object, v2:Object)
  :Void {

  v1.x *= v2.x;
  v1.y *= v2.y;
}
public static function getDistance(v1:Object, v2:Object)
  :Number {

  var tempVector:Object = {x:0, y:0};
  copyVector(tempVector, v1);
  subtractVectors(tempVector, v2);

  return getMagnitude(tempVector);
}
public static function getMagnitude(vector:Object):Number {

  return Math.sqrt(vector.x * vector.x + vector.y *
                  vector.y);
}
public static function normalizeVector(vector:Object)
  :Void {

  var magnitude:Number = getMagnitude(vector);

  scaleVector(vector, 1 / magnitude);

}
public static function inBounds(vector:Object, bounds:
                                   Object) {

  return (vector.x >= bounds.xMin &&
          vector.x <= bounds.xMax &&
```

```
                    vector.y >= bounds.yMin &&
                    vector.y <= bounds.yMax);
        }
    }
```

The methods of the VectorMath class are described in Table 19.1.

Table 19.1 *The methods of the VectorMath class*

Method	Description
newVector()	Given two coordinates, this returns a new vector object with those coordinates as its x and y properties.
setVector()	Given a vector, this sets its x and y coordinates.
copyVector()	Copies the coordinates from one vector to another.
addVectors()	Sets the coordinates of the first vector to the sum of the coordinates of the first and second vectors.
subtractVectors()	Subtracts the coordinates of the second vector from the first.
scaleVector()	Multiplies the coordinates of a vector by a scalar (non-vector) value.
multVectors()	Sets the coordinates of the first vector to the product of the coordinates of the first and second vectors.
getDistance()	Calculates the distance between the points represented by the first and second vectors.
getMagnitude()	Calculates the magnitude of the vector (more below).
normalizeVector()	Normalizes the vector (more below).
inbounds()	Checks to see if the vector is inside a rectangle defined by the supplied bounds object.

Analyzing the VectorMath Class

As vectors are instances of the Object class, they are passed "by-reference" when they are used as parameters for methods – like the VectorMath methods. This means that when setVector(tempVector, x, y) is called, the supplied vector object is actually changed. Its coordinates are set to the given x and y values. With the exception of the newVector() method, none of the VectorMath methods returns a value. Instead they modify the value of the first vector in the list of supplied parameters.

Most of the VectorMath methods are simple. But the concept of "magnitude" and "normalization" may be unfamiliar. A vector has two components, so it can be used as a point in space. That is generally how they are used in Astro Sweeper. But in physics, a vector is like an arrow – with its tail at one point and its head x units to the right and y units up. The magnitude of the vector is the length of the arrow. Astro Sweeper also uses vectors to represent Velocity. Velocity is the direction and speed that an object is moving. Speed is a Scalar value. The speed of an object is the magnitude of its velocity vector. Figure 19.1 shows a helpful illustration.

Figure 19.1 *Calculating the length of a vector*

The vector in Figure 19.1 has an x component of 50 and y component of 100. The magnitude (length) of the vector is determined by calculating the hypotenuse of the triangle with one side of 50, and one side of 100. This may bring back memories, but the hypotenuse (as discovered by Pythagoras) is the square root of x squared plus y squared: Math.sqrt(x \star x + y \star y). Again, if the vector is being used to represent a Velocity, then its length is its Speed.

A normalized vector has a length of 1. To normalize a vector, each component is divided by the magnitude (length) of the vector. A normalized vector is essentially a direction. Normalized vectors are used in Astro Sweeper by the artificial intelligence (AI) system to point Powerups and Crystals at the Space Ship. Once a normalized vector is calculated, it can be scaled by a Speed value to get a velocity that moves an object at the given speed in the desired direction.

The VectorMath class hides all of this. Thank goodness.

The Powerup Class

Powerups are special objects that bestow special powers on the Ship. To get these powers, the Ship has to collide with the powerup. Powerups have some special features and they use special MovieClips from the library, but they also have a lot of features in common with other game objects. For this reason, the Powerup class extends the BaseObject class.

Powerups have a special autoPilot() method that serves as a primitive AI movement controller. The autoPilot() method periodically checks to see where the Ship is located. It then calculates a normalized vector in the direction of the Ship and applies a small amount of acceleration in this direction. This causes the Powerup to seek out the Ship. The full Powerup source code is shown in Listing 19.2.

Listing 19.2 *The Powerup class*

```
import ch09.Timer;
import ch09.FrameTimeManager;
import ch11.BaseObject;
import GamePhaseII.AIManager;
import GamePhaseII.VectorMath;
import GamePhaseII.ObjectManager;
import GamePhaseII.PowerupManager;

class GamePhaseII.Powerup extends BaseObject {
  var type:String;
  var autoPilotTimer:Timer;
  var durationTimer:Timer;
  public function Powerup (pu_type:String, x:Number,
                          y:Number, movie_clip:MovieClip,
                          name:String) {
    super(x, y, movie_clip, name);
    type = pu_type;
    autoPilotTimer = new Timer();
    durationTimer = new Timer();
    durationTimer.restartTimer();
  }
  public function move():Void {
    autoPilot();
    updateCoords();
    mc._visible = true;
    mc._x = coords.x;
    mc._y = coords.y;
    if (durationTimer.milliseconds() >
        PowerupManager.POWERUP_DURATION) {
      alive = false;
    }
  }
  public function updateCoords():Void {
    var newLocation:Object = new Object();
    VectorMath.copyVector(newLocation, coords);
```

```
        VectorMath.addVectors(newLocation, velocity);
        coords = newLocation;
    }

    public function autoPilot() {
        if (autoPilotTimer.milliseconds() >
            AIManager.PU_AI_INTERVAL) {
          var acceleration:Object = {x:0, y:0};
          var accelerationScalar =
            50 * AIManager.PU_AI_AGGRESSION *
            FrameTimeManager.getFrameSeconds();
          VectorMath.copyVector(acceleration,
                              ObjectManager.ship.coords);
          VectorMath.subtractVectors(acceleration, coords);
          VectorMath.normalizeVector(acceleration);
          VectorMath.scaleVector(acceleration,
                              accelerationScalar);

          VectorMath.addVectors(velocity, acceleration);

          autoPilotTimer.restartTimer();
        }
      }
    }
```

The autoPilot() method is the first to fully use the VectorMath class. It starts by creating a new acceleration vector. It then sets this vector to the difference between the Ship's coordinates and its own coordinates. This creates a long vector pointing directly at the Ship. It then normalizes this vector to get a small, 1–unit-long vector that is still pointing at the Ship. Then it scales this vector by a speed value (a Scalar). The speed is determined by the PU_AI_AGGRESSION value provided by the AIManager class. It is then multiplied by the frame time, which is a fraction of a second, to get a one-frame-long burst of acceleration. This is added to the current velocity, causing the Powerup to nudge in the direction of the Ship. Finally the autoPilotTimer is restarted. This correction happens at a frequency determined by the PU_AI_INTERVAL property of the AIManager.

All of this is a very rough approximation of the physics that really makes objects move. But it works in a simple game like Astro Sweeper.

The PowerupManager Class
The PowerupManager is responsible for two things: activating and deactivating powerups, and controlling the powerup timer in the top right corner of the heads up display (HUD).

Activating and Deactivating Powerups
Activating a powerup means assigning the special powers to the ship. Of course, the Ship class has to have this hidden power already. Activating it simply allows it to be used. There are two powerups

available in Phase II: multiShot and shield. The Ship class already had a shield capability, controlled by its setShielded() method. This method sets the Ship's shieldOn property which can be used to protect the Ship from collisions with other objects. In Phase II, the Ship also has a multiShot property (Boolean) which is used to determine whether multiple Bullets should be fired simultaneously. The PowerupManager sets the shieldOn and multiShot properties appropriately when a Powerup is activated or deactivated.

Controlling the Powerup Timer

The powerup timer, in the top right corner of the HUD, is a MovieClip (powerup_timer) that displays the amount of time remaining until the activePowerup is deactivated. The display is in the form of an analog timer with a needle that sweeps in a clockwise manner. In the center of the timer is another MovieClip (powerup_timer_pu_list) that displays the currently activePowerup. This MovieClip has frame labels that correspond to the names of the various powerups. When a powerup is activated, the PowerupManager tells this MovieClip to go to the corresponding frame label. Figure 19.2 shows the powerup_timer_pu_list MovieClip.

Figure 19.2 *The powerup_timer_pu_list MovieClip*

The PowerupManager class is initialized and called from the HUDManager class. The full source code for the PowerupManager class is shown in Listing 19.3.

Listing 19.3 *The PowerupManager class*

```
import ch09.Timer;
import GamePhaseII.Powerup;
import GamePhaseII.ObjectManager;

class GamePhaseII.PowerupManager {
  public static var TOTAL_FRAMES:Number = 107;
  public static var POWERUP_LIFESPAN:Number = 10000;
  public static var POWERUP_DURATION:Number = 15000;

  public static var mc:MovieClip;
  public static var currentFrame:Number;
  public static var elapsedTime:Number;
  public static var powerupTimer:Timer;
  public static var activePowerup:Powerup;

  public static function initialize(movie_clip:MovieClip) {
    mc = movie_clip;
    currentFrame = 1;
    mc.gotoAndStop(currentFrame);
    powerupTimer = new Timer();
  }

  public static function reset():Void {
    activePowerup = undefined;
    mc.pu_list.gotoAndPlay("none");
    mc.gotoAndStop(1);
  }

  public static function update():Void {
    if (activePowerup != undefined) {
      elapsedTime = powerupTimer.milliseconds();
      currentFrame = TOTAL_FRAMES *
          (elapsedTime / POWERUP_DURATION);
      currentFrame = Math.floor(currentFrame);

      if (currentFrame >  TOTAL_FRAMES) currentFrame =
        TOTAL_FRAMES;

      if (mc._currentframe != currentFrame) {
        mc.gotoAndStop(currentFrame);
      }
      if (elapsedTime > POWERUP_DURATION) {
        deactivatePowerup();
```

```
      }
    }
  }

  public static function activatePowerup(powerup:Powerup)
    :Void {
    activePowerup = powerup;
    invoke(activePowerup.type);
    powerupTimer.restartTimer();
    mc.pu_list.gotoAndPlay(activePowerup.type);
  }

  public static function deactivatePowerup():Void {
    revoke(activePowerup.type);
    activePowerup = undefined;
    mc.pu_list.gotoAndPlay("none");
    mc.gotoAndStop(1);
  }

  public static function invoke(type:String):Void {
    switch (type) {
      case ("pu_multishot_type"):
        ObjectManager.ship.multiShot = true;
        break;
      case ("pu_shield_type"):
        ObjectManager.ship.setShielded(true);
        break;
      default:
        break;
    }
  }

  public static function revoke(type:String):Void {
    switch (type) {
      case ("pu_multishot_type"):
        ObjectManager.ship.multiShot = false;
        break;
      case ("pu_shield_type"):
        ObjectManager.ship.setShielded(false);
        break;
      default:
        break;
    }
  }
}
```

The methods and properties of the PowerupManager class are described in Table 19.2.

Table 19.2 *The methods and properties of the PowerupManager class*

Method	Description
initialize()	Sets the mc property, sets the timer display, and instantiates the powerupTimer.
reset()	Resets the timer display.
update()	If there is an activePowerup, keeps the timer updated and deactivates the powerup when time runs out.
activatePowerup()	Sets the activePowerup property and restarts the timer, and invokes the powerup feature.
deactivatePowerup()	Unsets the activePowerup property and resets the timer, and revokes the powerup feature.
invoke()	Turns the powerup feature on.
revoke()	Turns the powerup feature off.

Property	Description
TOTAL_FRAMES	The number of frames in one full sweep of the timer.
POWERUP_LIFESPAN	The amount of time that a powerup will stay in the game world waiting to be picked up.
POWERUP_DURATION	The amount of time that a powerup is effective once it is picked up.
mc	A reference to the powerup_timer MovieClip instance.
currentFrame	The current frame of the timer's sweep.
elapsedTime	The elapsed time since the current powerup was activated.
powerupTimer	The Timer instance that keeps track of elapsed time.
activePowerup	A reference to the currently activePowerup.

The AIManager Class

The AIManager class is really just a container for some AI-related parameters. Actually, to call it AI is an overstatement. But, calling anything AI is an overstatement. The term is used generally for any kind of autonomous control system. In Astro Sweeper, Powerups and Crystals have a limited amount of autonomous control. The properties of the AIManager class determine how effective this control will be. Listing 19.4 shows the complete (and brief) source code.

Listing 19.4 *The AIManager class*

```
class GamePhaseII.AIManager {

    public static var PU_AI_INTERVAL:Number = 500;
    public static var PU_AI_AGGRESSION:Number = 1;
}
```

The properties of the AIManager class include:

PU_AI_INTERVAL	The frequency at which Powerup objects will control themselves
PU_AI_AGGRESSION	The degree to which this control will influence the movement of the Powerup objects

There are no methods.

The Ship Class in Phase II

The Ship class in Phase II has two new properties and several new or updated methods. The new properties include:

multiShot Indicates whether or not the multiShot feature is enabled
bounds Defines the rectangle where the ship is allowed to go

The new or updated methods include:

move() Now includes calls to friction() and updateCoords()
friction() Applies friction to the Ship so that it will slow down over time (inexplicably, because there is no friction in space)
updateCoords() Updates the Ship's coordinates according to its current velocity. Checks to see if new coordinates are valid.
thrust() Applies acceleration to the Ship
shoot() Now it can shoot multiple Bullets

The code for these new Ship methods is shown in Listing 19.5.

Listing 19.5 *The new or modified methods of the Ship class*

```
public function move():Void {

    friction();
    updateCoords();
    mc._visible = true;
    mc._x = coords.x;
    mc._y = coords.y;
    setAnimation();
}

public function friction():Void {

    var frictionVector:Object = {x:0, y:0};
    var frictionCoefficient:Number = -.05;
    VectorMath.copyVector(frictionVector, velocity);
    VectorMath.scaleVector(frictionVector,
                           frictionCoefficient);
    VectorMath.addVectors(velocity, frictionVector);
}

public function updateCoords():Void {

    var newLocation:Object = new Object();

    VectorMath.copyVector(newLocation, coords);
    VectorMath.addVectors(newLocation, velocity);
```

```
    if (VectorMath.inBounds(newLocation, bounds)) {
      coords = newLocation;
    } else {
      VectorMath.scaleVector(velocity, -.1);
    }
  }

  public function thrust(direction:Number):Void {

    var acceleration:Object = {x:0, y:0};
    var accelerationScalar = 50 * direction;
    accelerationScalar *= FrameTimeManager.
      getFrameSeconds();
    MathTables.setVelocity(angleIndex, accelerationScalar,
      acceleration)
    VectorMath.addVectors(velocity, acceleration);
    thrustOn = true;
  }

  public function shoot():Void {

    var tempBullet:Bullet

    if (alive && !shooting) {

      shooting = true;
      tempBullet =
          ObjectManager.createBullet(coords.x, coords.y,
                                     600, angleIndex);
      ObjectManager.addObject(tempBullet, "bullets");
      if (multiShot) {
        tempBullet =
            ObjectManager.createBullet(coords.x, coords.y,
                                       400, angleIndex-1);
        ObjectManager.addObject(tempBullet, "bullets");
        tempBullet =
            ObjectManager.createBullet(coords.x, coords.y,
                                       400, angleIndex+1);
        ObjectManager.addObject(tempBullet, "bullets");
      }
    }
  }
```

Analyzing the New Ship Code

friction()

The friction() method uses the VectorMath class to generate a new vector in the opposite direction to the Ship's motion. It does this by copying the Ship's velocity property and multiplying it by a negative Scalar value. This value is some small fraction of the Ship's velocity. This small, negative velocity is added to the Ship's velocity every frame until the Ship's velocity is whittled away to nothing. Without this, the Ship would fly around like a puck on an air hockey table. It would be very hard to control. There is, of course, no friction in space, but try telling that to Luke Skywalker as his X–Wing gets bounced around by … turbulence? Sometimes realistic is too realistic.

updateCoords()

The updateCoords() method simply updates the Ship's coordinates by adding its current velocity to the current location. It then uses the VectorMath.inBounds() method to make sure the new location is valid. If so, it updates the Ship's location. If not, it reverses the Ship's velocity so that it bounces off the imaginary boundary. It also scales the velocity so that the Ship slows down a lot.

thrust()

The thrust() method uses the angle of the Ship to generate a unit-vector (vector with length = 1) in the direction that the Ship is heading. It does this using the MathTables.getVelocity() method which looks up the sine and cosine components of the Ship's current angle. Vectors made up of sine and cosine components of a given angle are always unit-vectors. This unit-vector is scaled by a speed value to get a velocity. Velocity and acceleration are similar. Acceleration is the rate at which Velocity changes over time. By scaling the thrust velocity by the frame time and adding it to the current velocity, the Ship is accelerated. There is really no easier way to explain it. There are plenty of funky non-vector ways to arrive at the same result, but using vectors keeps the code the simplest.

shoot()

Finally, the shoot() method checks to see if the multiShot property is true. If it is, it fires two extra Bullets at an angle index one greater and one less than the current Ship angleIndex.

The Object Manager in Phase II

The ObjectManager in Phase II has one new method for creating powerups:

```
public static function createPowerup(x:Number, y:Number,
                                     type:String):Powerup {

  var depth = GameDepthManager.getNextObjectDepth();
  var name = type + "_" + depth;
  var tempMovieClip:MovieClip =
     movieClipTarget.attachMovie(type, name, depth);
```

```
var newPowerup:Powerup =
    new Powerup(type, x, y, tempMovieClip, name);

return newPowerup;
}
```

Phase II in Action

The Phase II version of Astro Sweeper can be seen by testing the GamePhaseII.fla in the GamePhaseII folder of the examples. Figure 19.3 shows the Phase II version of Astro Sweeper in action.

Figure 19.3 *The GamePhaseII.swf*

The Complete Game – Phase III

In the next chapter, the Astro Sweeper game is completed.

20 Building the Game – Phase III: The Complete Game

The Final Components

In Phase III, the final components of the Astro Sweeper game are added. These include:

- A scrolling background
- Debris and Crystals instead of Diamonds
- More Powerups
- Audio

The three new classes that are introduced in Phase III are:

- The BGManager class
- The Debris class
- The Crystal class

Reorganized Code

In Phase III, the code has been reorganized. Instead of referencing classes from previous chapters, all of the code is now organized in one code library – a game-specific folder hierarchy. All of the code is now in one of two folders within the examples folder:

 org/rapo/games/astro
 org/rapo/games/astro/managers

These folders (and their paths) are often referred to as "packages". All of the game code is either in the org.rapo.games.astro package or the org.rapo.games.astro.managers package. This refers to the fact that this organization is a much more portable way to package code. For one thing, it is all in one folder hierarchy. But also, there is only one rapo.org. If all the code generated by rapo.org is in packages that start with org.rapo.*, there will never be any ambiguity or confusion about which Debris or BGManager class is being referenced. The identifier, "org.rapo.games.astro.managers.BGManager" can only refer to one, specific class. This will avert any confusion about "com.microsoft.games. astro.managers.BGManager". That would be a totally different class. Figure 20.1 shows the package hierarchy as it is displayed in the Eclipse IDE (referred to in Chapter 1).

The FLA used in this chapter is called GamePhaseIII.fla and it can be found in the GamePhaseIII folder of the examples. The FLA has changed very little over the last three chapters. In fact, the most significant difference is that the code on frame 8 – the "start" frame – now refers to the

Figure 20.1 *The Astro Sweeper package hierarchy as it is displayed in the Eclipse IDE*

org.rapo.games.astro.GameController class:

```
import org.rapo.games.astro.GameController;

GC = new GameController(this);
GC.start();
```

In addition to this change, several sounds have been added to the Library, and three of these sounds have been incorporated into the Ship's "Ship_anim" MovieClip. Other than that, the FLA for Phase III is the same as the FLA for Phase I. The code, however, has several significant improvements.

Additions to the VectorMath Class

The VectorMath class, introduced in Phase II, provides very helpful utility functions for manipulating vector objects like, coordinates, velocities, accelerations, and even rectangular bounds. To make it even more useful, the inbounds() method has been modified, and three new bounds methods have been added. The inbounds() method now modifies the given coords object so that its

coordinates will be in bounds. This simplifies the Ship's updateCoords() method and allows the Ship to slide smoothly along the edges of the world. To simplify some of the calculations necessary to make the scrolling background work, methods for creating and copying bounds objects have been added. In addition, a method to "inset" a bounds rectangle has been added. Insetting a rectangle means shrinking it, pulling in its borders. The insetBounds() method takes two values, one for the amount that the vertical borders will be inset (xinset), and one for the amount that the horizontal borders will be inset (yinset). The code for the new VectorMath methods can be seen in Listing 20.1.

Listing 20.1 *Additions to the VectorMath class*

```
public static function inBounds(vector:Object,
                                bounds:Object):Boolean {

  var inBounds:Boolean;
  inBounds = (vector.x >= bounds.xMin &&
              vector.x <= bounds.xMax &&
              vector.y >= bounds.yMin &&
              vector.y <= bounds.yMax);

  if (vector.x < bounds.xMin) vector.x = bounds.xMin;
  if (vector.x > bounds.xMax) vector.x = bounds.xMax;
  if (vector.y < bounds.yMin) vector.y = bounds.yMin;
  if (vector.y > bounds.yMax) vector.y = bounds.yMax;

  return inBounds;
}

public static function newBounds(xMin:Number, xMax:Number,
                          yMin:Number, yMax:Number):Object {

  return {xMin:xMin, xMax:xMax, yMin:yMin, yMax:yMax};
}

public static function copyBounds(b1:Object, b2:Object):
Void {
    b1.xMin = b2.xMin;
    b1.xMax = b2.xMax;
    b1.yMin = b2.yMin;
    b1.yMax = b2.yMax;
}

public static function insetBounds(bounds:Object, xinset:
                            Number, yinset:Number):Void {
    bounds.xMin += xinset;
    bounds.xMax -= xinset;
    bounds.yMin += yinset;
    bounds.yMax -= yinset;
}
```

The BGManager Class

The BGManager class implements a scrolling background. Instead of having the Ship's movement limited to a rectangle the size of the game window, as in Phase II, the Ship will now be able to move within much larger world. The background and all the other game objects will scroll relative to the Ship. The game window has become a small view port into the larger game world. This is accomplished by modifying the Ship class so that it maintains two sets of coordinates: word coordinates (coords) and screen coordinates (screenCoords). The ship's movement on the screen is constrained to the BGManager.shipScreenBounds rectangle. When the ship gets to this boundary, the background, along with the other game objects, begins to scroll. This makes it appear as though the ship is continually moving around in a large area.

Every other object's move() method is modified to position it on the screen relative to the background. Each frame, the BGManager.sync() method is called and this positions the background relative to the Ship. Listing 20.2 shows the full source code for the BGManager class.

Listing 20.2 *The BGManager class*

```
import org.rapo.games.astro.Ship;
import org.rapo.games.astro.VectorMath;

class org.rapo.games.astro.managers.BGManager {

  public static var mc:MovieClip;
  public static var SCREEN_ORIGIN:Object = {x:400, y:300};
  public static var shipBounds:Object;
  public static var shipScreenBounds:Object;
  public static var worldBounds:Object;

  public static function initialize(bg_clip:MovieClip){

    mc = bg_clip;
    mc._x = SCREEN_ORIGIN.x;
    mc._y = SCREEN_ORIGIN.y;
    worldBounds = VectorMath.newBounds(-1350, 1350, -1025,
                                        1025);
    shipBounds = new Object();
    VectorMath.copyBounds(shipBounds, worldBounds);
    VectorMath.insetBounds(shipBounds, 100, 100);
    shipScreenBounds = VectorMath.newBounds
                    (SCREEN_ORIGIN.x - 300,
                     SCREEN_ORIGIN.x + 300,
                     SCREEN_ORIGIN.y - 200,
                     SCREEN_ORIGIN.y + 200);
  }
```

```
public static function sync(ship:Ship):Void {

    mc._x = ship.mc._x - ship.coords.x;
    mc._y = ship.mc._y - ship.coords.y;

  }
}
```

The methods and properties of the BGManager class are described in Table 20.1.

Table 20.1 *The Methods and Properties of the BGManager class*

Method	Description
initialize()	Sets the mc property and positions the background at the SCREEN_ ORIGIN. Sets up the bounding rectangles for the world and for the ship's movement on the screen.
sync()	Moves the background relative to the Ship.

Property	Description
mc	The background MovieClip instance.
SCREEN_ORIGIN	The coordinates of the center of the view port (screen).
shipBounds	The bounding rectangle inside which the Ship can travel in the world. This rectangle is defined so that the ship won't move to a point that would make the edges of the background visible.
shipScreenBounds	The bounding rectangle inside which the Ship can travel on the game screen.
worldBounds	The bounding rectangle inside which other objects can travel.

The sync() method is the heart of the BGManager class. It calculates the difference between the Ship's screen coordinates and its world coordinates to determine the correct offset for the background. It then moves the background to this offset. The ship stays stationary on the screen, and the background moves around it.

The Debris Class

The Debris class is simple. It extends the BaseObject class so it has all of the usual properties and methods that game objects have. It has the familiar move() method, with a modification for the BGManager that positions the MovieClip relative to the center of the background. The full source code is shown in Listing 20.3.

Listing 20.3 *The Debris class*

```
import org.rapo.games.astro.BaseObject;
import org.rapo.games.astro.MathTables;
import org.rapo.games.astro.VectorMath;
import org.rapo.games.astro.managers.FrameTimeManager;
import org.rapo.games.astro.managers.BGManager;

class org.rapo.games.astro.Debris extends BaseObject {
```

```
var size:Number;

public function Debris(x:Number, y:Number, debris_size:
                      Number, debris_speed:Number,
                      angle_index:Number,movie_clip:
                      MovieClip, name:String) {
   super(x, y, movie_clip, name);
   setAngleIndex(angle_index);
   speed = debris_speed;
   setSize(debris_size);
   mc.owner = this;
}

public function move():Void {
   MathTables.setVelocity(angleIndex, speed, velocity);
   VectorMath.scaleVector(velocity, FrameTimeManager.
                      getFrameSeconds());
   VectorMath.addVectors(coords, velocity);
   mc._x = coords.x + BGManager.mc._x;
   mc._y = coords.y + BGManager.mc._y;

   if (!VectorMath.inBounds(coords, BGManager.
                      worldBounds)) {
      alive = false;
   }
}

public function setSize(size:Number):Void {
   this.size = size;
   mc._width = size;
   mc._height = size * (53/60); //aspect ratio of the Debris
                      symbol
}
}
```

World Coordinates vs. Screen Coordinates

The game "world" is the total area in which game objects can exist and move. The screen is a small "view port" that shows a portion of the world from the point of view of the Ship – the player. In Phase III, the view port (the screen) is 800 pixels wide by 600 pixels tall. The world area is bigger than that, so the background and all the game objects need to scroll within the view port relative to the Ship.

The move() method of the Debris class – and of all Phase III game objects – has two lines that allow this scrolling to work:

```
mc._x = coords.x + BGManager.mc._x;
mc._y = coords.y + BGManager.mc._y;
```

The game keeps track of each object's world coordinates using the coords property, as usual. But instead of using these coordinates directly as screen coordinates, they are offset by the location of the background's center point. If the background MovieClip (BGManager.mc) is centered on the screen, its screen coordinates will be (400, 300): its _x property will be 400 and its _y property will be 300. If a game object, like a Debris instance, has world coordinates (0, 0), then it should be positioned on the screen at the center of the BGManager.mc MovieClip. To accomplish this, the screen coordinates of BGManager.mc are added to the world coordinates of the object to get the object's screen coordinates.

The Crystal Class

The Crystal class is also simple. It, too, extends the BaseObject class so it has all of the usual properties and methods that game objects have. It also has the familiar move() method, with the modification for the BGManager that positions the MovieClip relative to the Ship. The Crystal's move() method is just like the Powerup's move() method. It calls an autoPilot() method that gives the Crystal some autonomous control. Its AI settings are kept in the AIManager class.

The full source code of the Crystal class is shown in Listing 20.4.

Listing 20.4 *The Crystal Class*

```
import org.rapo.games.astro.BaseObject;
import org.rapo.games.astro.Timer;
import org.rapo.games.astro.VectorMath;
import org.rapo.games.astro.managers.FrameTimeManager;
import org.rapo.games.astro.managers.BGManager;
import org.rapo.games.astro.managers.AIManager;
import org.rapo.games.astro.managers.ObjectManager;

class org.rapo.games.astro.Crystal extends BaseObject {

  var size:Number;
  var autoPilotTimer:Timer;

  public function Crystal(x:Number, y:Number, angle_index:
                          Number, movie_clip:MovieClip,
                          name:String) {

    super(x, y, movie_clip, name);
    setAngleIndex(angle_index);
    mc.gotoAndStop(angleIndex);
    mc.owner = this;
    autoPilotTimer = new Timer();
  }

  public function move():Void {

    autoPilot();
```

```
        friction();
        updateCoords();
        mc._x = coords.x + BGManager.mc._x;
        mc._y = coords.y + BGManager.mc._y;
    }

    public function friction():Void {
        var frictionVector:Object = {x:0, y:0};
        var frictionCoefficient:Number = -.01;
        VectorMath.copyVector(frictionVector, velocity);
        VectorMath.scaleVector(frictionVector,
                               frictionCoefficient);
        VectorMath.addVectors(velocity, frictionVector);
    }

    public function autoPilot() {
        if (autoPilotTimer.milliseconds() >
            AIManager.CRYSTAL_AI_INTERVAL) {
          var acceleration:Object = {x:0, y:0};
          var accelerationScalar =
            50 * AIManager.CRYSTAL_AI_AGGRESSION *
            FrameTimeManager.getFrameSeconds();
          VectorMath.copyVector(acceleration,
                                ObjectManager.ship.coords);
          VectorMath.subtractVectors(acceleration, coords);
          VectorMath.normalizeVector(acceleration);
          VectorMath.scaleVector(acceleration,
                                 accelerationScalar);

          VectorMath.addVectors(velocity, acceleration);

          autoPilotTimer.restartTimer();
        }
    }
}
```

Using the New BGManager, Debris, and Crystal Classes

Scrolling the background and getting instances of Debris and Crystals into the game is the responsibility of the GameController. The GameController's mainLoop() method has been modified to include calls to BGManager.sync() and to two new spawnDebris() and spawnCrystals() methods:

```
public function mainLoop():Void {

    FrameTimeManager.calculateFrameTime();
```

```
InputManager.processKeyboardInput();
handleInput();

if (!pause) {

  if (checkGameOver()) {
    gameTimeline.gotoAndPlay("gameOver");
  } else if (checkLevelComplete() && !ship.over) {
    gameTimeline.gotoAndPlay("levelComplete");
  } else {
    moveObjects("objects");
    moveObjects("bullets");
    ship.move();
    checkCollision("objects", "bullets");
    checkShipCollision("objects");
    BGManager.sync(ship);
  }
  HudManager.update();
  spawnPowerups();
  spawnDebris();
  spawnCrystals();
  }
}
```

The call to BGManager.sync() lets the BGManager move the background to the correct position relative to the Ship. The calls to spawnDebris() and spawnCrystals() check to see if it is time to create new Debris and Crystal objects. The code for these new methods looks like:

```
public function spawnDebris():Void {

  if (debrisTimer.milliseconds() >
    LevelManager.getDebrisInterval()) {

    var info:Object = new Object;
    LevelManager.setSpawnInfo(info);
    var tempDebris:Debris =
      ObjectManager.createDebris(info.x,info.y,
                                   info.angle);
    ObjectManager.addObject(tempDebris, "objects");
    tempDebris.move();
    debrisTimer.restartTimer();
  }
}

public function spawnCrystals():Void {

  if (crystalTimer.milliseconds() >
    LevelManager.getCrystalInterval()) {
```

```
    var info:Object = new Object;
    LevelManager.setSpawnInfo(info);
    var tempCrystal:Crystal =
      ObjectManager.createCrystal(info.x,info.y,
                                  info.angle);
    ObjectManager.addObject(tempCrystal, "objects");
    tempCrystal.move();
    crystalTimer.restartTimer();
  }
}
```

Two new timer properties, debrisTimer and crystalTimer are used to determine when new Debris and Crystals are needed. Both spawnDebris() and spawnCrystals() make use of a new LevelManager method called, LevelManager.spawnInfo(). This is method randomly chooses a spawn point, a direction of movement, and a powerup type – in case the new object is a powerup. The code (from the LevelManager) looks like:

```
public static function setSpawnInfo(info:Object):Void {

  var random:Number = Math.floor(Math.random() * 4);

  switch (random) {
    case 0:
        info.x = BGManager.worldBounds.xMin;
        info.y = BGManager.worldBounds.yMin;
        info.angle = 11;
        info.type = "pu_energy_type";
        break;
    case 1:
        info.x = BGManager.worldBounds.xMax;
        info.y = BGManager.worldBounds.yMin;
        info.angle = 18;
        info.type = "pu_multishot_type";
        break;
    case 2:
        info.x = BGManager.worldBounds.xMin;
        info.y = BGManager.worldBounds.yMax;
        info.angle = 5;
        info.type = "pu_shield_type";
        break;
    case 3:
        info.x = BGManager.worldBounds.xMax;
        info.y = BGManager.worldBounds.yMax;
        info.angle = 27;
        info.type = "pu_tailgun_type";
```

```
      break;
    default:
      break;
  }
}
```

More Powerups

The PowerupManager class – in Phase III – is slightly modified to handle two more powerup types: "energy" and "tailgun". The energy powerup restores the Ships energy to its full capacity. The tailgun powerup enables the ship to shoot directly backwards as well as forwards. The Ship's shoot() method has been retrofitted to allow this. The modified invoke() method from the PowerupManager class looks like:

```
public static function invoke(type:String):Void {
  switch (type) {
    case ("pu_energy_type"):
      ScoreManager.lives = ScoreManager.MAX_LIVES;
      break;
    case ("pu_multishot_type"):
      ObjectManager.ship.multiShot = true;
      break;
    case ("pu_shield_type"):
      ObjectManager.ship.setShielded(true);
      break;
    case ("pu_tailgun_type"):
      ObjectManager.ship.tailGun = true;
      break;
    default:
      break;
  }
}
```

The GameController has also been modified to include a spawnPowerups() method that is called from the mainLoop() method. The spawnPowerups() method checks to see if it is time to create a new powerup. If so, it calls LevelManager.spawnInfo() to get a random location and a random type of powerup. Then it calls the ObjectManager.createPowerup() method to get a new powerup instance.

```
public function spawnPowerups():Void {

  if (powerupTimer.milliseconds() >
    LevelManager.getPowerupInterval()) {

    var coords:Object = new Object;
    LevelManager.setSpawnInfo(coords);
```

```
    var tempPowerup:Powerup =
      ObjectManager.createPowerup(coords.x,coords.y,
                                  coords.type);
    ObjectManager.addObject(tempPowerup, "objects");
    tempPowerup.move();
    powerupTimer.restartTimer();
  }
}
```

Audio

To add audio to the game, both the GameController class has been modified to use the AudioController class from Chapter 15 and the SoundtrackController from Chapter 16. The GameController has two new properties for audio:

```
var effectsAudio:AudioController;
var soundtrackAudio:SoundtrackController;
```

The effectsAudio property is for an AudioController instance that will control sound effects like explosions and powerup sounds. The soundtrackAudio property is for a SoundtrackController instance that will control ambient music loops. These two audio properties are initialized in the GameController constructor. As the effects sounds are small, they are included in the FLA's Library. The soundtrack loops are large so they are loaded from the file system as needed. The SoundtrackController gets its playlist information from the "soundtrack.xml" file .

```
effectsAudio = new AudioController(gameTimeline);
effectsAudio.registerSound("explode");
effectsAudio.registerSound("powerup");
effectsAudio.registerSound("powerup_die");

soundtrackAudio =
   new SoundtrackController (gameTimeline,"soundtrack.xml");

effectsAudio.setSoundVolume("explode", 100);
effectsAudio.setSoundVolume("powerup", 100);
effectsAudio.setSoundVolume("powerup_die", 100);
```

The GameController methods that control game phase transitions have been modified to use the SoundtrackController instances. For example, the title() method looks like:

```
public function title():Void {

  soundtrackAudio.playTrack("title_loop", true);
}
```

The same has been done in the nextLevel(), levelComplete(), win(), and gameOver() methods.

The two collision-checking methods, checkCollision() and checkShipCollision(), have been modified to play sounds when certain collisions occur. For example, when Bullets collide with Debris the "explode" audio is played:

```
effectsAudio.playSound("explode");
```

The Ship class has been modified in the same way, with a new property for audio:

```
var shipAudio:AudioController;
```

This AudioController instance is used to play the looping "thrust" sound. It is initialized in the Ship's constructor:

```
shipAudio = new AudioController(mc);
shipAudio.registerSound("thrust");
```

The Ship also uses three more sounds that are played directly from its MovieClip's timeline. As the shooting sound always needs to sync up with the Ship's "shoot" animation, it has been added to the "audio" layer in the ship_anim MovieClip. The same is true for the "hit" sound (audio_hit) and the "over" sound (audio_explode). Figure 20.2 shows the Ship's modified timeline and the Library containing the sounds that are included in the FLA.

Figure 20.2 *Sounds added to the Ship_anim MovieClip*

A Minor HUDManager Modification

In Phase II, the HUD was treated like the other game screens on the timeline and it was placed manually on the screens layer at the "play" frame label. This was convenient while designing the HUD and getting its elements lined up on the screen. But it has the unwanted side effect of leaving it underneath all of the dynamically created game objects. In Phase III, the HUD MovieClip is created dynamically and given a depth that places it above the other game objects, where it should be. A new setHudVisibility() method is used to hide and show the HUD as appropriate. The code to accomplish this looks like:

```
public static function initialize(game_timeline){

  if (mc == undefined) {
    var depth:Number = GameDepthManager.HUD_DEPTH;
    game_timeline.attachMovie("hud_type", "HUD", depth);
    mc = game_timeline["HUD"];
    mc._x = BGManager.SCREEN_ORIGIN.x;
    mc._y = BGManager.SCREEN_ORIGIN.y;
  }
  setHudVisibility(false);
  RadarManager.initialize(mc.radar);
  registerStatsTextFields();
  PowerupManager.initialize(mc.powerup_timer);
}

public static function setHudVisibility(visible:Boolean):
  Void {
  mc._visible = visible;
}
```

The Final Game in Action

The Phase III version of Astro Sweeper can be seen by testing the GamePhaseIII.fla in the GamePhaseIII folder of the examples. The "final" game can be seen in Figure 20.3.

Using a SWF as an External Code Library

Included in the examples is a special version of the final game, "GamePhaseIII_no_source.fla", that loads a tiny (13k) "AstroSweeperEngine.swf". This SWF contains all of the code for the game in a precompiled form. The code for importing and instantiating the GameController class is included in this SWF. In fact, the only thing in the AstroSweeperEngine.swf is the application code. It is otherwise empty. When the game is played – either in the Flash Player or from the authoring environment during testing – the AstroSweeperEngine.swf is dynamically loaded into a dummy MovieClip on the game's Main Timeline. This dummy MovieClip has the instance name, "Engine". Since the Engine dummy MovieClip is dynamically replaced by the contents of

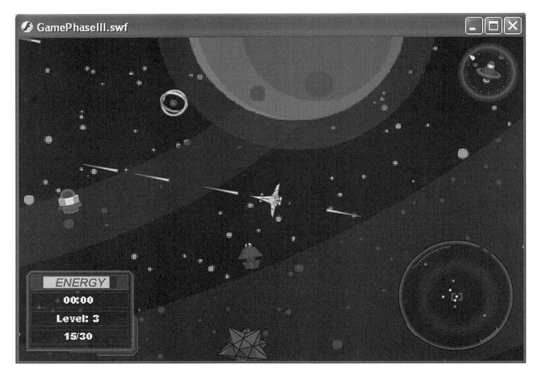

Figure 20.3 *The Phase III "final" game*

AstroSweeperEngine.swf, it becomes a container for the game code. The code can then be invoked from within the FLA by referencing it through the Engine MovieClip instance. For example, the code on the game's "start" label looks like:

```
Engine.GC.start();
```

Instead of:

```
GC.start();
```

An extra line in the pre-loader code takes care of loading the dynamic library SWF into the "Engine" MovieClip instance:

```
Engine.loadMovie("AstroSweeperEngine.swf");
```

This simple change has a very powerful and useful implication. It means that the FLA file can be recompiled and tested without needing the actual ActionScript 2 source code. Instead, it dynamically loads a precompiled version of the code. This technique addresses several desires and concerns that all developers share:

1. It makes it easier to distribute an ActionScript 2 project because the source code hierarchy does not need to be shared along with the FLA. FLA files are nice because they are a

convenient, self-contained unit. This technique preserves this by requiring that only one additional file be distributed with the FLA: the library SWF.

2. It provides some protection for the source code. A precompiled SWF can be decompiled, but the process is time-consuming and requires a level of expertise that is relatively rare. In a precompiled SWF form, the source code is hidden, but all of its functionality is still available to both end users and to collaborating developers.

3. It more closely resembles the development process in other languages which routinely make use of libraries. C++ development often uses Dynamic Link Libraries (DLLs) and Java development uses precompiled ".class" and ".jar" files.

4. It can speed up the compile time for an FLA, since the source code does not need to be recompiled whenever a visual element is updated.

5. It makes it possible to create precompiled libraries of commonly used code that can be shared – at run-time – by many games and applications. As the shared code is loaded at run-time, an update can be made simultaneously to every participating game/application simply by updating the common library SWF.

There are many potential uses for this technique. The GamePhaseIII_no_source.fla and the AstroSweeperEngine.fla files in the GamePhaseIII folder of the examples illustrate a simple implementation relevant to the Astro Sweeper game.

Phase IV

At the end of Phase III, Astro Sweeper is real game, but it is just the beginning. The foundational mechanics are in place, but in many ways the slate is clean. By replacing the assets in the FLA and upgrading a few classes, like the LevelManager, a new game could quickly emerge. In fact, by swapping out the GameController with an ApplicationController, the AstroSweeper classes could easily be re-purposed to implement a very dynamic user interface for any interactive application.

Games employ a lot of programming techniques that are universally applicable. In fact, games tend to be among the most complex and challenging applications that are developed in any programming language. And at the same time, they are often the most compelling projects for developers because the results can be especially satisfying. The programming techniques presented in this book help to unleash the power of ActionScript 2. Some of the necessary initial hard work has been done. Now the real fun work can begin.

**APPENDIX A:
GLOSSARY**

**APPENDIX B:
LETTERS A TO Z
AND STANDARD
NUMBERS 0 TO 9**

Appendices

Appendix A: Glossary

action(s)	a Flash term for a script or a part of a script
architecture	in the context of programming, architecture is the structure of an application's components, the organization of classes, methods and properties.
Array	a collection of values, each of which can be accessed (set or retrieved) by means of a numerical index
AS files	an ActionScript class file in the form of an external text file
ASDT	ActionScript Development Tool, a plugin for the Eclipse IDE available at sourceforge.net/projects/aseclipseplugin/
authoring environment	in the context of Flash, the application and respective tools that are used to create SWF files
binary numbers	numbers represented using only two symbols, typically 0 and 1
bit	one digit of a binary number
bitwise operators	operators used to set or manipulate the individual bits of a binary number
Boolean	a data type used to store a true or false (binary) value
byte code	a compact representation of a computer program that can be efficiently interpreted and executed on a variety of hardware platforms
class	a data type used to encapsulate (group) related data and functions. Classes can be instantiated, and the instances of a class are referred to as Objects.
class file	a text file that defines a class
code hint	a context-sensitive popup that provides reference information about selected code
collaboration	working together, simultaneously, on the source files of an application. Typically the most challenging collaboration is between programmers and designers who each need to leverage the work of the other.
collision detection	determining when game objects "collide". In 2D games this is understood to occur when visual elements overlap to some extent.

compiler	the authoring environment tool that converts human-readable ActionScript text into a machine-readable byte code
constant	a variable or property that doesn't change during the execution of a program
constructor	a special function in a class definition that is responsible for initializing (constructing) class instances
debugger	the authoring environment tool used to examine a program as it executes, to discover flaws
decimal numbers	numbers represented using ten symbols, typically 0, 1, 2, 3, 4, 5, 6, 7, 8, and 9.
decompiler	a program used to turn machine-readable byte code back into human-readable source code when the original source code is not available
distributable files	files that can be distributed to users without compromising the value or security of source files
Eclipse IDE	an open source (free) authoring environment used to create text-based source files for a variety of computer languages including ActionScript. Available a www.eclipse.org
error checking	part of what the compiler does before it generates byte code. ActionScript 2 makes it possible for the compiler to find and report many more programming errors than ActionScript 1.
event	unpredictable (asynchronous) input such as a mouse click or keystroke
event handler	a function designated to respond to a particular kind of event
expression	a statement or statements that can be evaluated; which return a value in the form of an ActionScript data type or class instance
factory	a function that generates instances of the appropriate class based on the context of the request
FLA files	Flash source files, usually having a .fla extension
Flashout	A 3rd-party tool for generating SWF files from within the Eclipse IDE
frame	a segment of time during which code can execute and the Stage can be redrawn
frame rate	the number of frames that can occur in one second
function	a way to group code that performs a certain task so that that code can be easily invoked repeatedly. Classes provide a way to group related functions.
IDE	Integrated Development Environment; another term for the set of tools that make up an authoring environment
identifier	a name used to identify a function, variable, class, etc.

inheritance	a class can inherit the functions and properties of another class. Inheritance makes it possible for a subclass to extend the behavior of a superclass.
instance	a class definition is a blueprint for an Object that has a set of methods (functions) and properties (variables). Objects that are created from a class definition are called instances.
keyframe	a frame of a MovieClip timeline that contains code, symbols, etc.
layer	a layer of a MovieClip timeline contains a sequence of frames. The vertical ordering of layers determines which elements will be drawn on top of others. Elements on the top most layer are drawn on top of all others.
Library	in an FLA file, the collection of symbols that can be added to the Stage
loop	in a program, a control statement that causes code to be executed repeatedly
Main Timeline	the primary set of layers and frames in an FLA file
methods	the functions in a class definition are referred to as methods
MovieClip	a collection of layers and frames
MTASC	the Motion Twin ActionScript Compiler, a 3rd-party tool for generating SWF files, available at www.mtasc.org
native code	as opposed to byte code, code that is generated for (and will only execute on) a specific hardware platform
Object	a collection of methods (functions) and properties (variables) as specified by a class definition
Object Oriented Programming	a programming style which organizes related functions and properties into classes of objects. In Object Oriented Programming, inheritance is used to minimize the amount of code that has to be written by allowing class definitions to extend existing class definitions.
OOP	see Object Oriented Programming
operand	a value that is evaluated or manipulated by an operator
operator	operators perform calculations and comparisons on operands. i.e. the "+" operator is used to add the values of two operands, as in "2 + 3"
operator precedence	the order in which operators are applied to operands.

playhead	In the Flash authoring environment, the playhead is used to determine which frame is currently active
polling	executing code repeatedly to check the status of a value
polymorphism	the ability for an Object to have many forms. When an Object is constructed from a class that inherits behavior from a superclass, the object can be treated as an instance of either the subclass or the superclass(es)
properties	variables that are part of a class definition
publish	to take source files (an FLA and AS files) and generate a distributable file (a SWF)
race condition	a situation where the result of executing code is different when the order of execution is different, and the order of execution is inconsistent. Race conditions can result in bugs that are difficult to track down.
reserved word	an identifier that is used by ActionScript and should not be used by user-defined code
scalar	a value with a single component
source code	human-readable text that is converted into machine-readable code by a compiler
source files	the original files that are use to create a distributable file, such as a SWF or EXE
Stage	in the Flash authoring environment, the portion of the FLA that represents the viewable content of the resulting SWF
String	an ActionScript data type used to hold text ("strings" of characters)
SWF files	the distributable content file that is generated from an FLA, usually having a ".swf" extension
symbol	in an FLA, a container that is used to group visual elements
text editor	a tool that is used to create and edit the text files that make up the class files of a Flash project
types	kinds of data recognized by the ActionScript compiler, i.e. String, Number, Boolean, etc., as well as user-defined classes
variable	a container used to store a value
vector	a value with multiple components such as coordinates (x, y)
workspace	in the Flash authoring environment, the window that contains the various authoring tools and sub-windows
XML	eXtensible Markup Language, a convenient way to encapsulate data in the form of text

Appendix B: Letters A to Z and Standard Numbers 0 to 9

The following table lists the keys on a standard keyboard for the letters A to Z and the numbers 0 to 9, with the corresponding ASCII key code values that are used to identify the keys in ActionScript.

Letter or number key	Key code
A	65
B	66
C	67
D	68
E	69
F	70
G	71
H	72
I	73
J	74
K	75
L	76
M	77
N	78
O	79
P	80
Q	81
R	82
S	83
T	84
U	85
V	86
W	87
X	88
Y	89
Z	90
0	48
1	49
2	50
3	51
4	52
5	53
6	54
7	55
8	56
9	57

Keys on the Numeric Keypad

The following table lists the keys on a numeric keypad, with the corresponding ASCII key code values that are used to identify the keys in ActionScript.

Numeric keypad key	Key code
Numbpad 0	96
Numbpad 1	97
Numbpad 2	98
Numbpad 3	99
Numbpad 4	100
Numbpad 5	101
Numbpad 6	102
Numbpad 7	103
Numbpad 8	104
Numbpad 9	105
Multiply	106
Add	107
Enter	108
Subtract	109
Decimal	110
Divide	111

Function Keys

The following table lists the function keys on a standard keyboard, with the corresponding ASCII key code values that are used to identify the keys in ActionScript.

Function key	Key code
F1	112
F2	113
F3	114
F4	115
F5	116
F6	117
F7	118
F8	119
F9	120
F10	121
F11	122
F12	123
F13	124
F14	125
F15	126

Other Keys

The following table lists keys on a standard keyboard other than letters or numbers, with the corresponding ASCII key code values that are used to identify the keys in ActionScript.

Key	Key code
Backspace	8
Tab	9
Clear	12
Enter	13
Shift	16
Control	17
Alt	18
Caps Lock	20
Esc	27
Spacebar	32
Page Up	33
Page Down	34
End	35
Home	36
Left Arrow	37
Up Arrow	38
Right Arrow	39
Down Arrow	40
Insert	45
Delete	46
Help	47
Num Lock	144
; :	186
= +	187
- _	189
/ ?	191
\Q ~	192
[{	219
\ \|	220
] }	221
" '	222

Index

Page numbers in *italics* refers to figures and tables.

Focal Press

www.focalpress.com

Join Focal Press online
As a member you will enjoy the following benefits:

- browse our full list of books available
- view sample chapters
- order securely online

Focal eNews
Register for eNews, the regular email service from Focal Press, to receive:

- advance news of our latest publications
- exclusive articles written by our authors
- related event information
- free sample chapters
- information about special offers

Go to www.focalpress.com to register and the eNews bulletin will soon be arriving on your desktop!

If you require any further information about the eNews or www.focalpress.com please contact:

USA
Tricia La Fauci
Email: t.lafauci@elsevier.com
Tel: +1 781 313 4739

Europe and rest of world
Lucy Lomas-Walker
Email: l.lomas@elsevier.com
Tel: +44 (0) 1865 314438

Catalogue
For information on all Focal Press titles, our full catalogue is available online at www.focalpress.com, alternatively you can contact us for a free printed version:

USA
Email: c.degon@elsevier.com
Tel: +1 781 313 4721

Europe and rest of world
Email: L.Kings@elsevier.com
Tel: +44 (0) 1865 314426

Potential authors
If you have an idea for a book, please get in touch:

USA
editors@focalpress.com

Europe and rest of world
ge.kennedy@elsevier.com